A New Life

The Lyndhurst Series
on the South

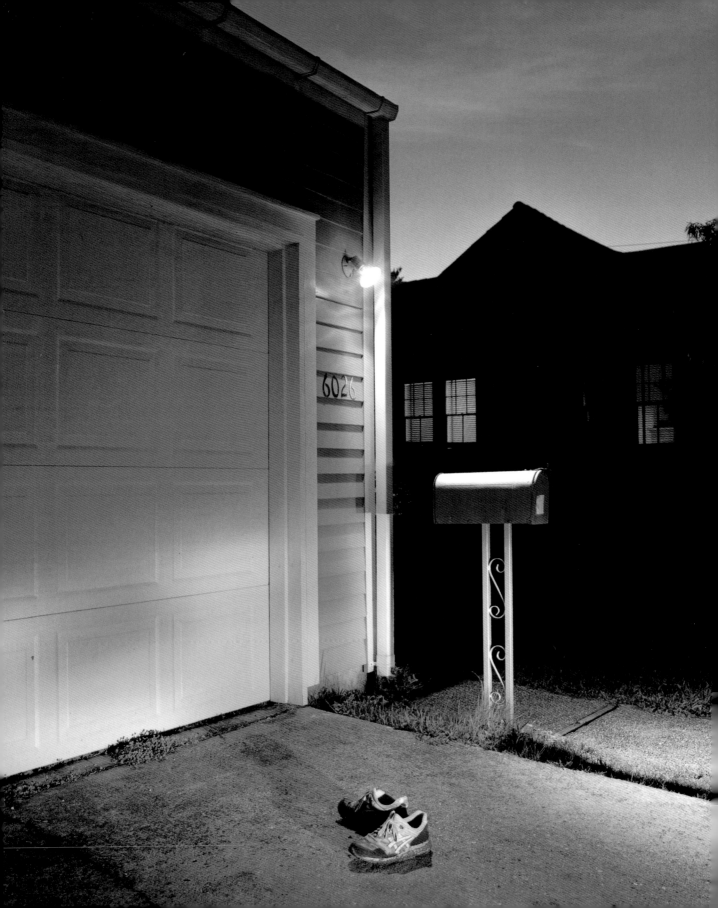

A New Life

Stories and Photographs from the Suburban South

Alex Harris, Editor

Alice Rose George, Coeditor for Photography

Afterword by Allan Gurganus

A DoubleTake Book
published by the Center for Documentary Studies
in association with W. W. Norton & Company
New York • London

The text of this book is composed in Bodoni Book with the display set in
Bodoni Book and Akzidenz Grotesk.
Manufacturing by Tien Wah Press
Book design and typesetting by Mills/Carrigan/Harrell Design
Cover photograph by Margaret Sartor

Frontispiece: New Orleans, Louisiana, 1993.
Photograph by William K. Greiner, from the series *Homefront*.

Library of Congress Cataloging-in-Publication Data
A new life: stories and photographs from the suburban South / Alex Harris,
editor; Alice Rose George, coeditor for photography; afterword by
Allan Gurganus.
 p. cm.
"A DoubleTake book."
1. Southern States—Social life and customs—Fiction. 2. Suburban
life—Southern States—Pictorial works. 3. Short stories. American—
Southern States. 4. Suburban life—Southern States—Fiction.
I. Harris, Alex, 1949– . II. George, Alice Rose, 1944– .
PS551.N44 1996
96-22858
813'.0108975—dc20
ISBN 0-393-04030-5

W. W. Norton & Company, Inc.
500 Fifth Avenue, New York, New York 10110
http://web.wwnorton.com
W. W. Norton & Company, Ltd.
10 Coptic Street, London WC1A 1PU
0 1 2 3 4 5 6 7 8 9

DoubleTake Books & Magazine publish the works of writers and
photographers who seek to render the world as it is and as it might be,
artists who recognize the power of narrative to communicate, reveal,
and transform.

DoubleTake
Center for Documentary Studies at Duke University
1317 West Pettigrew Street
Durham, North Carolina 27705
http://www.duke.edu/doubletake/

To order books, call W. W. Norton at 1-800-233-4830.
To subscribe to *DoubleTake* magazine, call 1-800-234-0981, ext. 5600.

Acknowledgments

For their support of this book and the Lyndhurst Series on the South, I want to thank the trustees and staff of the Lyndhurst Foundation of Chattanooga, Tennessee. I'm especially grateful to Jack Murrah at the foundation for his encouragement, his patience, and his friendship.

Thanks, also, to Alice Rose George, my colleague at *DoubleTake* magazine, who responded so enthusiastically to the idea of this project. Alice has been an equal partner both in the search for photographers working in the suburban South, as well as in the choosing and editing of the photographic essays in this book. Of the thousands of Southern short stories written since 1990, only a few hundred had suburban settings. For his help in finding, screening, and advising me on these stories, I particularly want to thank Brad Kellam at North Carolina State University. Brad worked closely with me for two years on this project. I also want to thank Jessica Weitz for her help with stories in the summer of 1994. A number of people shared their knowledge of contemporary Southern stories. Special thanks go to Shannon Ravenel, Lois Rosenthal, Dave Smith, Richard Bausch, C. Michael Curtis, and Lee Smith.

I'm grateful to Caroline Nasrallah, the assistant editor for photography at *DoubleTake* magazine, for her extraordinary work organizing this project. At *DoubleTake* and the Center for Documentary Studies, Robert Coles, Iris Tillman Hill, Molly Renda, Rob Odom, Margaret Sartor, Joni Lane, Sue Halpern, Darnell Arnoult, Susan Ketchin, and Alexa Dilworth gave me invaluable advice and help.

Thanks to my sister, Jill Harris Brown, for reading and advising me on my introduction. Thanks also to Jim Mairs and Tabitha Griffin at W. W. Norton for their encouragement and work on this book, and for sharing our vision for DoubleTake Books.

Alex Harris

for Eliza and Will

Contents

Introduction

Alex Harris

From the driveway of my wife's childhood home in Monroe, Louisiana, I drove north through suburban streets, past minimalls, an industrial park or two, then out into flat, open country and the April smoke of burning rice fields and patches of loblolly pine. In less than an hour, closing in on the Arkansas border, I slowed down and parked across the street from the Magnolia Shopping Center on the outskirts of Bastrop, a large paper-mill town.

The day before, I had passed this metal-and-neon sign, with its peeling flower symbol of the old South looming over the new. Now, with my color film and view camera, I made four exposures before driving back to Monroe, where I hoped there might be more pictures to make later that day.

This picture of a shopping center is part of an extended series of photographs I made in Louisiana, South Carolina, and North Carolina between 1984 and 1985. At the

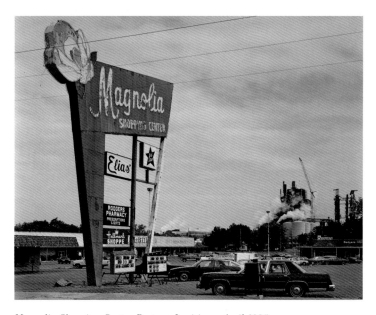

Magnolia Shopping Center, Bastrop, Louisiana, April 1985

time, I was exploring the South with my view camera and color film, but never quite knew what I was looking for or—by the end of the project—what I had found. I stored my negatives in a freezer at home, filed the contact prints away in a drawer in my office desk, and promptly forgot them.

A decade later, in the process of putting together this book—of reading hundreds of contemporary Southern short stories, and, with my colleague Alice Rose George, looking at dozens of portfolios of Southern photographs—I didn't think to consider my own. Then, in the final stages of editing this book, I was searching for something in my desk and stumbled on a pile of color contact prints. The Magnolia Shopping Center was on top.

Avoiding the work I should have been doing, I began to select pictures that interested me. Before long I had a small pile of prints in front of me, a few of which are reproduced here. Almost all the photographs I'd chosen were of houses, Southern suburban houses. I began to understand what I had been doing while wandering with my camera. I had been trying see how to live a new life in the South.

In 1979 I was looking for a home. I was ready to buy a place and settle down. After almost fifteen years living away from the South, first in Massachusetts for high school and then Connecticut for college, and later as a photographer in Alaska and New Mexico, I had come back South for what seemed like my first real job, to teach documentary photography at Duke University in Durham, North Carolina. It was early Au-

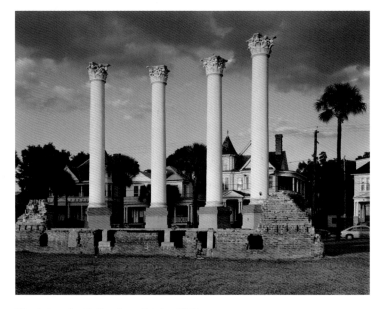

Charleston, South Carolina, October 1984

gust, the temperature in the high 90s, and I had two weeks to close a deal before flying to New Mexico to get my things and drive back for the fall semester.

There were plenty of houses to choose from. Most of the advertisements in the *Durham Morning Herald* read like this: *Transitional Ranch, like-new, Stonehenge estates, great lot, must see.* Or like this: *Glen Eden: New, exclusive Durham subdiv; traditional 3BR, garage, lg. family room, cul de sac, ready now.* Or this: *AWE-*

SOME: *$2000 moves you in, executive home in prestigious Forest Creek, lrg corner lot, 3br, 2ba, lrg ktc, custom deck, master w/great room.* I contacted a realtor, and for a few days we drove through these suburban neighborhoods. Mostly I refused to get out of the car. I couldn't say exactly why, but I knew *this* wasn't what I was looking for. Exasperated, the realtor tried older suburban neighborhoods closer to downtown Durham. She spent the better part of a week showing me listings on quiet tree-lined streets near Duke, neighborhoods of well-preserved wood-frame homes on small manicured lots. Though I seriously considered several of these houses, somehow I couldn't reconcile myself to living so close to the campus and to the students I would be spending so much time with.

A few days later—on my own—on a country road minutes from downtown, I found an old two-story, wood-frame farmhouse with a front porch that wrapped around one side of the house, pecan trees in the yard, a defunct water tower, and a well-preserved tobacco-drying barn. On three sides of the house, I could see only fields and trees. In the front yard was a hand-painted sign: "For sale by owner." The next day, the farmhouse was mine.

My choice to live outside suburbia was unusual. In Durham, no one bothered to advertise anything except suburban homes. Since 1970, the United States has been a suburban nation. In the South, as in the rest of the country, more people live and work in suburban communities than in either city or country settings. And Southern suburbs, along with the incomes of Southern suburban families, have for many years been growing at a faster rate than those in the rest of the nation.

Southern writers have long been celebrated for their ability to render the life of this region. As a nation, our sense of the South as a place with its own unique language, character, and culture has been shaped largely by fiction writers who grew up in the pretelevision, front-porch South, writers like William Faulkner, Zora Neale Hurston, Flannery O'Connor, and Eudora Welty. But if we are to believe what we read in the bulk of contemporary Southern novels and short stories, the South is stuck somewhere in the legendary past of antebellum homes, poor black servants, struggling white farmers, river baptisms, clear moonshine, sadistic sheriffs, and inbred mountaineers. Southern photographers, along with newspaper editors and magazine publishers, seem to have joined this conspiracy to recycle old images of the South.

Several years ago I read an essay by Walker Percy in which he challenged a new generation of Southern writers to get clear of the "vast mythic twilight," and urged them "to humanize the life around [them], to formulate it for someone else, to render the interstates, to tell the truth, to show how life is lived, and therefore to affirm life, not only the lives of poor white people or poor black people in the

Georgia countryside and in Mississippi towns and hamlets, in Faulkner country, in Welty country, but even life in a condo on a golf course." This, at least in part, is what I hope *A New Life* will accomplish, through stories and photographs that "tell the truth," and give the reader and viewer a better sense of life in the contemporary South.

A New Life aims to be a new kind of anthology. The book includes ten short stories and the work of eleven photographers. Each story and photographic essay is presented as an independent piece of work. Though there are geographical, thematic, and even emotional connections to be made between the stories and photographs, no story or photograph is meant to illustrate the other. By publishing stories and photographs together in this book, I have tried to create a richer and more complex portrait of the South than either alone would afford.

The stories, culled from hundreds I read over the last two years, have been written or published since 1990. They provide a broad range of perspectives on the Southern suburban landscape. From Lee Smith's renderings of a saleswoman's dreams in a North Carolina mall to Richard Bausch's story of a desperate clown on a suburban Virginia lawn, the stories published here give a sense of how it feels to be alive at this time and in this region. Similarly, the photographs are part of a long narrative tradition. The visual essays presented here are also set in Southern suburbs, often the result of years of focused work on the part of the photographer. From the Vietnamese neighborhoods of east New Orleans, to the mixed-race suburbs of Atlanta, to the hills above Knoxville, Tennessee, each photographer tells a story, hints at the complexity and diversity of life in the South.

When I arrived in North Carolina in 1979, I came as a photographer to start a Center for Documentary Photography at Duke University. I was charged by the university, and by the Lyndhurst Foundation that provided the funding for the center, to bring the language of photography into a highly verbal place, to connect photography to the humanities, to the way in which we live.

As a teacher my methodology was fairly simple. I asked my students to attempt what I had for many years been trying to do—to enter particular communities and to spend sufficient time to get to know individuals and families. Students made photographs on an ongoing basis over the semester. They edited and sequenced their images so that they themselves, others in the class, and the people they were photographing might see and understand that community in a new way.

As part of my research for the class, I studied the tradition of documentary photography, particularly the work of photographers like Walker Evans, Dorothea Lange, Ben Shahn, and Russell Lee, who had produced an extensive body of

work in the 1930s South for Roosevelt's Farm Security Administration. I showed my students these images of the Depression along with the more positive and personal portraits of the South of that era by Richard Samuel Roberts and Eudora Welty. As a class we began to realize that what gets called "documentary" photography is highly subjective. In order to understand the South of that era—or any era—we would have to consider the work of a number of photographers together, as a kind of group portrait of a region.

Though my students responded to these photographers, particularly to the work of Dorothea Lange, Walker Evans, and Eudora Welty, I never had the feeling that they got as much out of the pictures as I had. Unlike them, I was also reading the accompanying texts, by a thoughtful economist named Paul Schuster Taylor, by the brilliant reporter James Agee, and by an extraordinary novelist, Eudora Welty, introducing her own book of photographs. These combinations of photographs with writing were more powerful, more instructive, more convincingly real, than either photographs or writing alone.

When in 1984, the Lyndhurst Foundation provided the center a grant to publish a series of books about the contemporary South, it made sense to give equal emphasis to writing and photography. In the first book, *A World Unsuspected* (1987), I turned to a new generation of Southern novelists, asking eleven of them to use family snapshots as a catalyst for telling their own childhood stories. The book reproduced some of these family photographs along with the writers' accounts.

Archibald, Louisiana, April 1985

Though *A World Unsuspected* was ostensibly a book about the contemporary South, from my own perspective it was a book I'd put together to help me understand my own childhood in the South. Several of these writers—Padgett Powell, Robb Forman Dew, Barry Hannah, and Dave Smith—had, like me, grown up in Southern suburban neighborhoods in the 1950s and 1960s.

When I was a child, there were probably a dozen houses on our street in north-west Atlanta, each with several acres of land, several cars, and several children. The road stretched a few miles from the small gas station at the entrance to the brand-new downtown freeway all the way to the Chattahoochee River bridge, where a Civil War–era ferry once operated. My family lived at the beginning of the downslope of the road, at first in an old three-story stone Tudor home, and later, next door in a rambling, modern wood and brick house extended by an architect friend of my mother's from what used to be our pool house.

My older brother had a best friend named Annie, and her brother, Morris, was a great pal of mine. They lived through the woods on one side of our house. Their father was a leading Atlanta attorney. Across the street lived my younger sister's best friend, Marsha; she and my sister loved to ride horses together. Marsha's father was the president of Atlanta's

Wake Forest, North Carolina, October 1984

largest plumbing supply company. Next door to Marsha lived another buddy of mine named Roger. His father headed a successful commercial real estate firm in town. His uncle was the mayor. Our own father ran a large paper company. Our mother, having given up a budding acting career in New York to move to Atlanta, now, like the other mothers on the street, raised the children and carted us from one activity and lesson to another. She still found time to volunteer in numerous religious, civic, and charitable organizations. It was that kind of neighborhood.

Though my parents divorced before I was seven years old, I don't recall ever seeing them fight. From my perspective, my friends' families seemed as stable and happy as my own. But when I left Atlanta for prep school in Massachusetts at fifteen, most of their parents were also divorced. By the time I graduated from college, not one of the families I knew from my childhood still lived on the street. My suburban neighborhood had mysteriously vanished.

My father had gone to Yale, and I had followed in his footsteps. While he studied

French literature, became a lawyer, and then a businessman, I studied psychology, stumbled into a course in the art and architecture building with Walker Evans, and became a photographer. For years I thought of Evans as my role model. Not only did his work have an extraordinary authority for me, he was, in fact, the only person I knew who was living the life of a photographer. After a successful career in business, my own father retired at sixty-five and was living on a golf course in Florida. Evans at sixty had begun a new career teaching at Yale and was still very engaged in his first career—one he'd started in the late 1920s—the business of making photographs. I particularly liked the idea of living a life that, like Evans, I wouldn't want to retire from.

Recently I've come to realize that another photographer had a great influence on me, a freelance photojournalist from Atlanta named Jay Leviton. Forty years ago, Jay's work was published in *Time* and *Life, Fortune,* and *Forbes,* but he made much of his income doing annual reports and other work for corporate clients. My father's company was one of his clients. In 1956, my parents had asked Jay to spend a weekend at our house to photograph my brother, sister, and me.

What he produced was an oversized leather album of black-and-white prints mounted on gray construction paper. In the years I lived at home, I'm sure I spent more hours studying Jay's photographs than I've ever spent looking at any other photographer's work. It's not that Jay made us look particularly handsome or happy or heroic. With careful attention to light and framing and a straightforward, magazine-style layout, he created what amounts to a very believable, candid portrait of our lives together. There are my brother and sister and me, with our dogs, at play, doing homework, laughing, fighting, pouting—a whole range of emotions and activities. In none of the pictures can you sense the photographer's presence. And whether or not my suburban street remained the same, that street and neighborhood is the understood background to all these pictures. It is there—intact.

In retrospect I've spent much of my adult life both running away from and, at the same time, trying to understand the suburban community I lost. It must be more than coincidence that my work with the writer and physician Robert Coles has given me a chance to live and photograph in the oldest and perhaps the most established communities in North America: in small Eskimo villages on the southern Bering Sea Coast of Alaska as well as in the Hispanic villages of the Sangre de Cristo mountains of northern New Mexico.

In both places, I made a record of community life. In Alaska, that meant living with Eskimo families in several different villages, often for months at a time, making hundreds of exposures. Later, through the process of editing my work over a six-year period, I made sense of those experiences. In New Mexico, at first on my own, and

later with my own family, I became very involved in the life of the village I was photographing. My photography was my excuse, not only to record, but to live a certain kind of stable community life. And even as these old villages began to transform in the 1970s and 1980s, with my camera I've been able to hold on to my experiences and those of my friends and neighbors, and to publish a series of books, much as Jay Leviton did in that leather album, to keep intact certain moments.

In a fundamental way *A New Life* is a departure from all of this. Here, with photographer Clarissa Sligh, we stare directly at the changing neighborhoods of Atlanta; with Mark Steinmetz on the edge of several Southern cities, we sense difficulty and pain. Though some of the characters in the stories look back over their lives—as recently widowed Elizabeth does in Mary Ward Brown's title story to this collection; as the troubled father named Richard does in Jonathan Bowen's "Pulling Jane"—they look back in order to comprehend the past, not to dwell in it. These characters make important decisions and manage to move on. While a few of the photographers in this book include symbols of the old South in their images, like Margaret Sartor with her white-columned cover photograph, they place the symbols in the context of a South that's coming of age and growing up. Growing up, Jackie Holmes comes to understand, in Bobbie Ann Mason's "Tobrah,"

is about living in the present and looking toward the future. The future in the South, Patricia Richards shows us in her images of Early Morn Drive, can be found right outside the front door on any suburban street. This book is quite literally about a new life in the South.

My wife and I have two young children, a boy and a girl. We still live in Durham, North Carolina. Recently we bought the last lot on a quiet suburban street.

Turbeville, South Carolina, March 1985

A New Life

Gretna, Louisiana, 1993

William K. Greiner *from the series* Homefront

Bogalusa, Louisiana, 1992

Metairie, Louisiana, 1993

Above: New Orleans, Louisiana, 1994

Right: Metairie, Louisiana, 1994

Gentilly, Louisiana, 1994

Mandeville, Louisiana, 1994

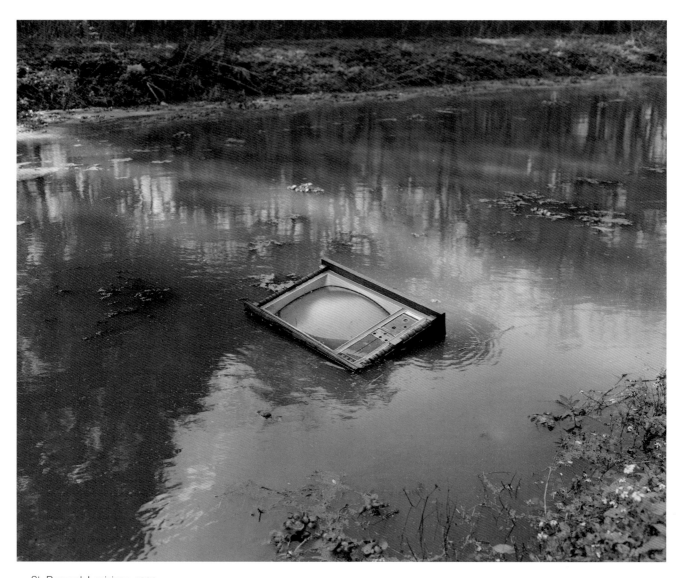

St. Bernard, Louisiana, 1993

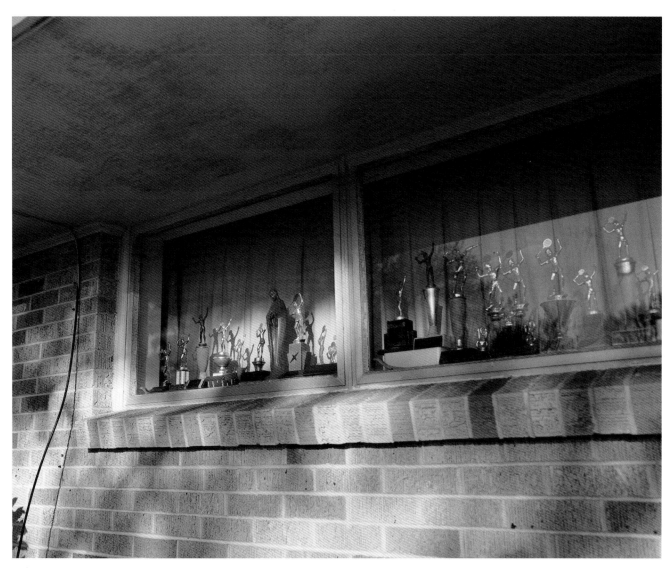

Metairie, Louisiana, 1994

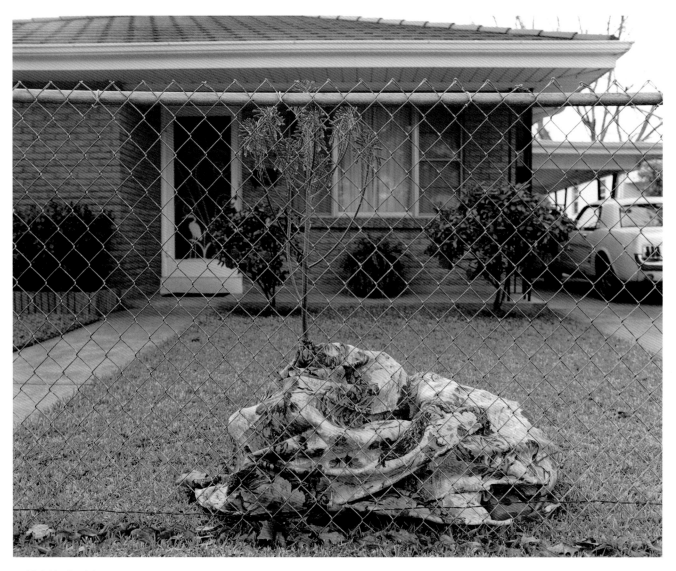

Metairie, Louisiana, 1994

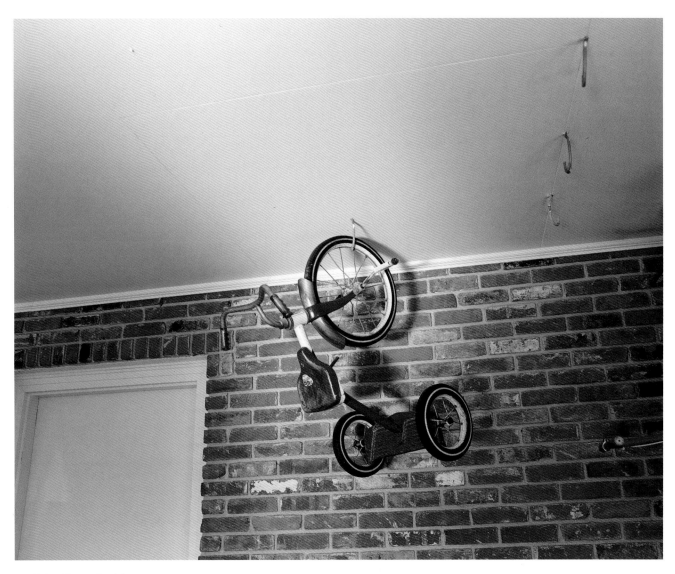

Baton Rouge, Louisiana, 1994

New Orleans, Louisiana, 1994

And All Our Wounds Forgiven

Julius Lester

i do not know where the story begins. though i am integral to it, i am not sure i know even what the story is as neither my life nor death constitutes *the* story.

nor is the story always the one we recall. rarely is it the one we tell.

in its etymological root, *story* means to see. hi-story is, then, the record of what was seen. there's the rub, to coin a phrase. what constitutes seeing? is such profundity even possible? *who* is seeing determines what is seen. can we hope, then, for more than awareness of what we *think* we see, though what we see may not be there at all?

example: in the mid-fifties i *saw* that the time had come to end racial segregation in the south. the 1954 supreme court decision outlawing racial segregation in public schools was like a second emancipation proclamation for us. the highest court in the land was, at long last, ready to uphold the constitutional principle of equality under the law. by decreeing segregation in public schools unconstitutional, the court, wittingly or unwittingly, had declared segregation illegal in every aspect of american life.

i was under no illusion that ending segregation on buses, in restaurants and in other areas of public accommodation would be easy. i and others would give our lives. dying for the right to sit on a torn seat at the front of a bus was not an even exchange. but such obscene inequity was inherent to the story. i thought that was all i needed to understand.

how little i knew about the nature of *story*. i still believed stories had the calming order of beginnings, middles and ends, with unambiguous heroes, heroines and villains. if i acted for the good, the good would prevail and justice would roll through the land with the meandering majesty of a mighty river.

what gave me such confidence to think i knew what the good was? i equated recognition of injustice with apprehension of the good. such elegant symmetry is only in the minds of political ideologues. whatever judgement history makes of my life, it will not record that john calvin marshall was an ideologue.

yet, i, too, was guilty of oversimplifying, of trying to contain the story within the parameters of my subjective landscape. i believed that if you sincerely and honestly acted for the good, goodness would be the consequence.

how little i knew.

once set in motion, social change, regardless of its noble intent and pure righteousness, cannot be controlled. you think you are changing "this" and you are. but you did not anticipate "that" changing also. by the time recognition of the unanticipated consequences comes, it is too late to do anything—except hope you survive.

i thought social change meant the enactment of laws to modify behavior and eliminate or at least reform institutions that acted unjustly and punish those who refused to alter their behavior, if not their attitudes.

i learned:

social change is the transformation of values by which a group and/or nation has defined and known itself. such change is like pregnancy; a woman is aware of it only a month after conception. a nation becomes cognizant of a shift in its values only when facing a phenomenon it does not understand and can find no precedent for.

example: 1956: i was 26 years old, a harvard ph.d. andrea and i had been married for a year. congress authorized the construction of an interstate highway system. i'm sure we read about it in the paper. i have no doubt that huntley-brinkley men-

tioned it one evening in their droll, offhand way that made cynicism not only acceptable but attractive. there was probably a picture in the atlanta constitution of president eisenhower in the rose garden or oval office using thirty pens to sign the bill into law. we did not pay attention because we thought it was a wonderful idea. we remembered the drive from boston to atlanta the year before. part of the new jersey turnpike had been built by then and what a treat it was to drive at 65 miles an hour for unbroken stretches. but most of that journey was made on two lane highways through small southern towns where the speed limit was 35 and, if you were colored, you got arrested for doing 34. i greeted the projected inter-state highway system with anticipation. that i did so indicated a transmutation of my values of which i was as yet unaware.

like all other americans in the fifties, i had become a believer in the ethic of sav-ing time. (bear with me if i appear to be rambling. i am not. for some the exer-cise of logic means moving straight ahead. on this side of the veil, we tend to go sideways but are no less logical.)

saving time is a peculiar concept. what does it mean? and how do you do it?

theoretically, you reduce the time used for one task and free time for other activ-ities. sounds reasonable. but is it? shakespeare "wasted" a lot of time because he wrote in long hand with quill pens. it would be logical to conclude that if he had had a ballpoint pen, typewriter or computer, he would have written more plays and perhaps, greater ones. yet, no user of a ballpoint pen, typewriter or computer has equaled or excelled him in applying the english language to human exper-ience. it is possible shakespeare would have written less and less well had he used a computer.

perhaps shakespeare neither spent or saved time but lived in different relation-ship to it. perhaps he wore time. perhaps it wore him.

the twentieth-century metaphor for our relationship to time implies ownership. "how much time do we have?" is a common question. "i wasted a lot of time sit-ting in traffic," is a daily plaint. "i have some free time tomorrow afternoon." we conceive of time as a commodity to be expended, hoarded or wasted. the marxist —when such existed—would have said the metaphor reflects capitalism. it is not so simple.

the interstate highway system was created to save time. how much time? if two cars leave new york city for albany at noon, one driving 65, the other 55, the first car will arrive twelve minutes before the second. i suppose if you had to go to the bathroom badly, knocking twelve minutes off a three hour drive would be helpful. otherwise, what would one do with the twelve minutes saved?

but what one does with the time saved is not the issue. an american axiom: better to have wasted the time you've saved than not to have saved it at all. some are so conscientious about saving time they drive 80 and 90 miles an hour and save themselves the most time of all—the rest of their lives.

what was not anticipated was the enormous social change the interstate highway system would bring into being. for centuries we had been rooted to place. home and work and leisure occurred in one place and created a whole—community. the interstate highway system made it possible to live thirty, forty, fifty, sixty miles from where you worked. work and home and place ceased to be interrelated. you could work in a city whose people and institutions were alien to you. you could live in a place and be indifferent to its people and institutions. you could live and be unknown at work and at home. you could live without belonging to a community. (enter the nuclear family as locus of society. but the family is too small an entity to withstand the intricate permutations of relationship. the pressures of family are alleviated only if the family knows itself as part of a community. when it does not, we should not be surprised that one out of two marriages end in divorce.)

the interstate highway system brought into being a geo-political entity called sub-urbs as people discovered they could have the amenities of country living on city incomes. eventually, stores and corporations moved to where their workers and consumers had gone. the middle-class white collar workforce and corporations that had provided the tax base for the urbs took their tax dollars to the sub-urbs. the cities deteriorated because the majority of the inhabitants remaining were blacks, hispanics and poor whites who did not have incomes to generate sufficient tax revenues. america became a nation of predominantly white sub-urbs encircling black and poor urbs. why? is it too harsh to conclude that we cared more about saving time than about the structure of our society?

saving time became a national priority. the fifties saw the introduction of ball-point pens, minute rice, tv dinners and fast food restaurants—mcdonald's,

kentucky fried chicken and pizza hut. why did we become obsessed with *saving* what cannot be saved?

world war ii. it taught us that we could die—not individually, each in his and her own time, but all at once, together, with no one left to remember who we had been, or even that we had been.

truman said he slept peacefully after he made the decision to drop the atomic bombs on hiroshima and nagasaki, that he never had a second thought because the decision shortened the war and saved american lives. that is good. but it is a good encompassing so little. we see only the magic circle we draw around us and ours, and by definition, whatever protects us and ours is the intrinsic good. we remain oblivious to the intrinsic evil snoring quietly on the other side of the circle.

truman's limited good changed the fundamental definition of how we lived on the planet. i was 15 when the bombs were dropped. a profound difference between me and those young people who gathered around me in the civil rights movement was they grew up knowing sentient existence on the planet could be destroyed by human volition. they grew up numbed by the second world war, which deliberately, willfully, knowingly made civilians the objects of mass destruction. dresden, auschwitz, hiroshima, nagasaki. 54,800,000 people, mostly civilians, died in world war ii. the object of war was no longer territory; the object of war became death. how could anyone born after 1946 trust life?

being born in 1930 i grew up in a world in which the continuity of life was unquestioned. after hiroshima and auschwitz i could not trust life naively anymore, but neither did I distrust it. instead, my generation was infected by a virus called existential anxiety. we were not comfortable with life or death and lived in fear of both.

those born after hiroshima were beyond anxiety. anxiety implies that life can be trusted if you learn how to relate to it. the post-hiroshima citizen trusts only death, because it is the singular and ultimate security, the one experience that can be depended on to be what it claims to be. those of us whose consciousness predates hiroshima retain an ancestral memory of the nobility of the human experiment. our angst is leavened by faith in the dignity of the human being. when faulkner stood at stockholm in 1949 and declared "man will prevail," he affirmed the secular catechism that had held the west together since the renaissance. then he went and had a bourbon-and-branch.

that first generation of post-hiroshima youth loved me, for a while, because they longed for this secular faith.

however, during the last days of my life, i saw them swallowed alive by the idolization of race. blacks placed racial exaltation above a love of humanity and did not understand: their love of race was passion for death, a passion ignited in the extermination camps, and at hiroshima and nagasaki.

when civilians became the targets of government weaponry, whatever semblance of safety government represented was destroyed. it did not matter that it was our government against someone else's. truman miscalculated the extent to which people were willing to go to save american lives. we saw photographs of the mushroom clouds in life magazine and read the stories of women and children vaporized from the face of the earth leaving behind only their shadows burned into the ground. no shots were fired on american soil in ww ii. no bombs fell on american cities. yet, americans seemed to understand inchoately that murder carried to its logical extreme is self-murder. when the soviet union acquired a nuclear capability, it became clear: governments were now willing to destroy the world to save the nation.

after auschwitz, after hiroshima, saving time became an obsession because we could no longer assume that the human experiment on planet earth would continue until its natural end was reached hundreds of millions of years later when the sun's heat consumes the planet. our descendants were no longer guaranteed to us. we were compelled to save *time* because at auschwitz and at hiroshima, time was destroyed.

we mistake for the Good the limited good we see—or think we see—or rationalize that we see—or lie about. we do not want to see that what is good today may spawn evil tomorrow. evil is not an absolute. evil is ambiguous, and sometimes, it does not seek to negate the good but merely hold its hand. for many of us, this is worse. good that is ashamed of itself loses its vitality. it should not. good and evil are not distinct. they interpenetrate each other continually until it is unclear which is which. if one is patient, you eventually understand that it does not matter. good or evil are merely opinions we offer based on notions of what is convenient and inconvenient to us, our group, our nation.

and if i had known . . .

Patricia D. Richards

from the series Scenes from Early Morn Drive: Teen Years

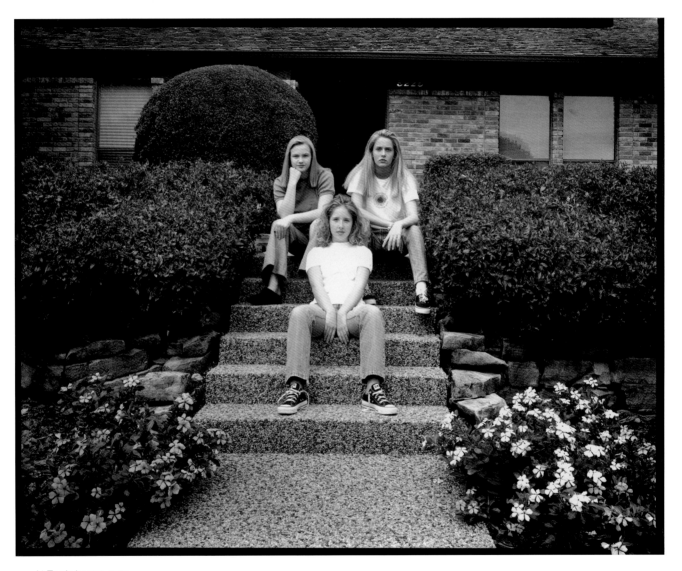

At Tara's house, 1993

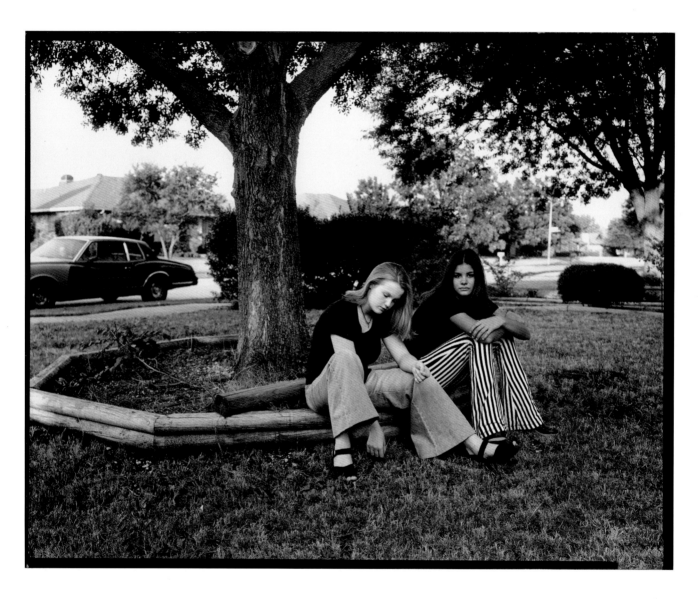

Above: Ali and Vicki at fourteen, 1993

Right: Lance, at eighteen, 1994

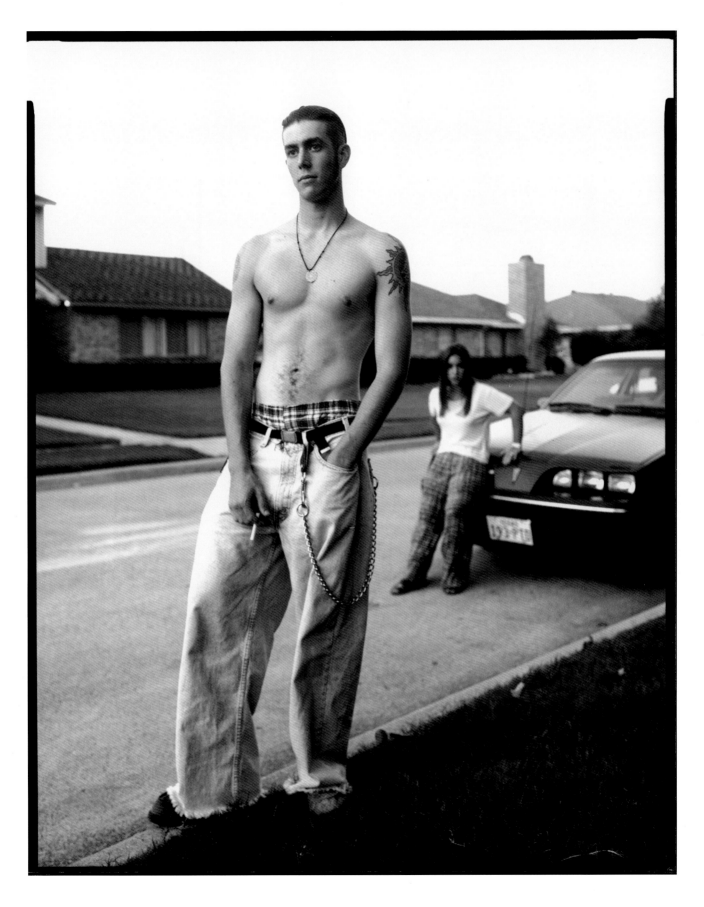

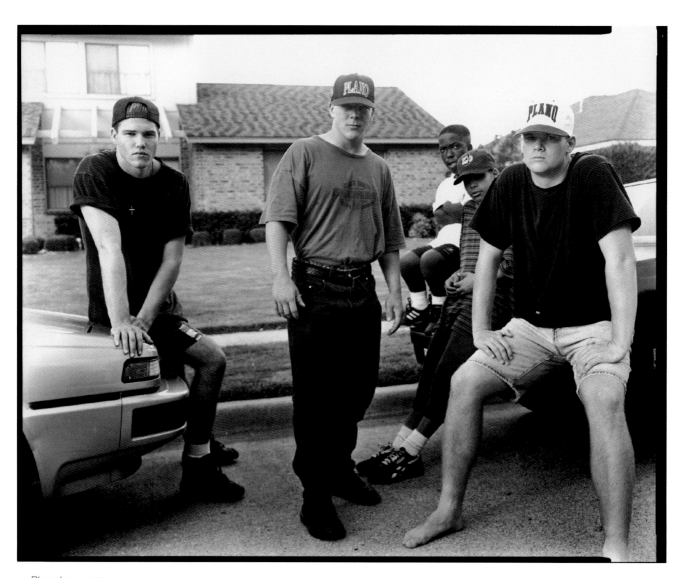

Plano boys, 1993

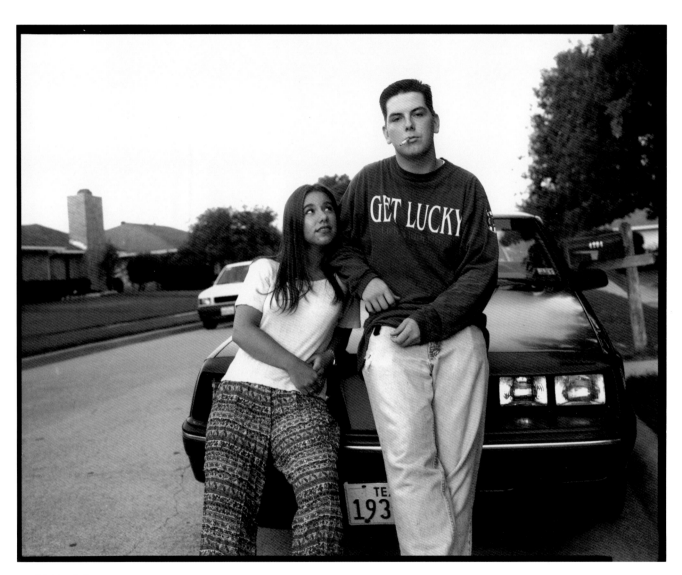

"Get Lucky," 1994

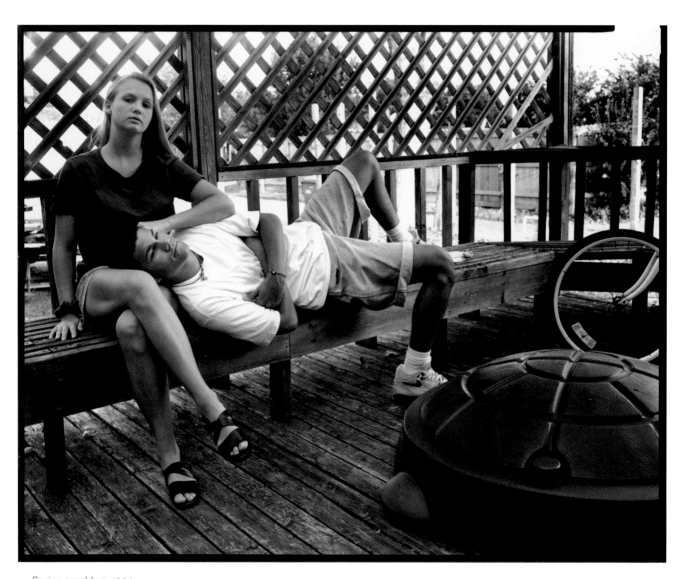

Saying good-bye, 1994

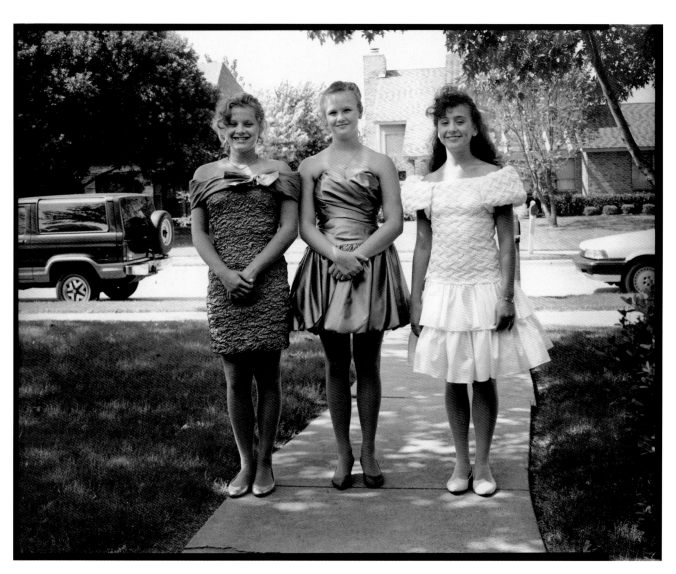

The girls at thirteen, 1992

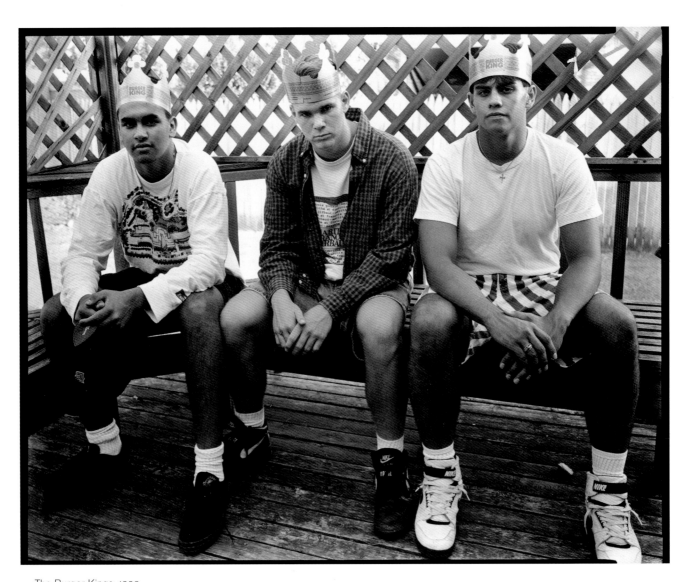

The Burger Kings, 1993

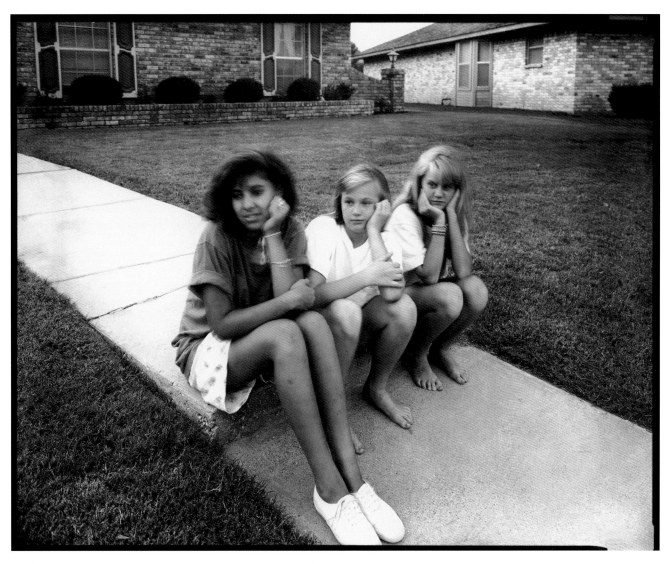

On the step, 1990

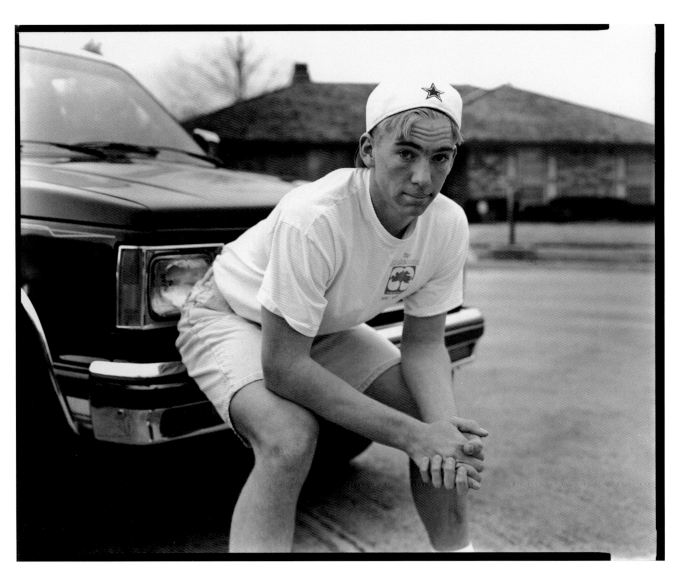

Chris, at sixteen, 1993

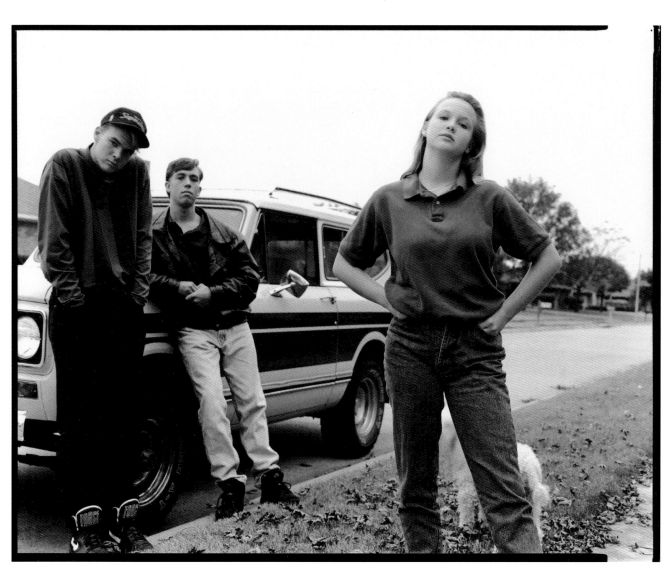

Fourteen, fifteen, and sixteen, 1993

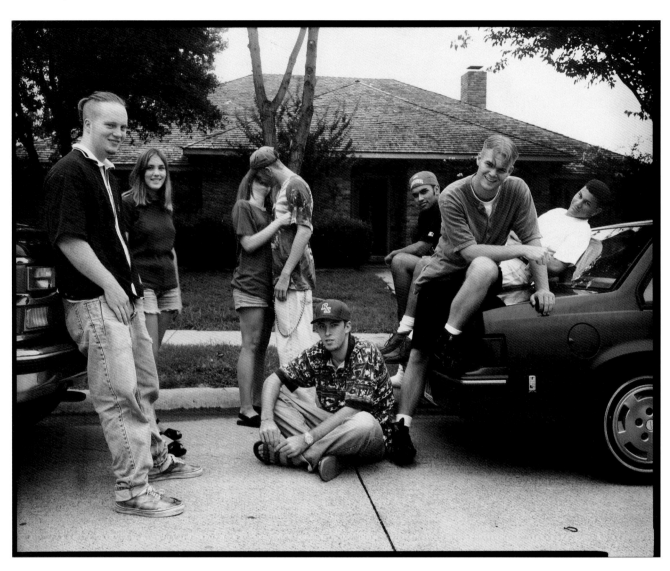

Hanging out front, 1994

Tandolfo the Great

for Stephen & Karen & Nicholas Goodwin

Richard Bausch

"Tandolfo," he says to his own image in the mirror over the bathroom sink. "She loves you not, oh, she doesn't, doesn't, doesn't."

He's put the makeup on, packed the bag of tricks—including the rabbit that he calls Chi-Chi, and the bird, the attention getter, Witch. He's to do a birthday party for some five-year-old on the other side of the river. A crowd of babies, and the adults waiting around for him to screw up—this is going to be one of those tough ones.

He has fortified himself, and he feels ready. He isn't particularly worried about it. But there's a little something else he has to do first. Something on the order of the embarrassingly ridiculous: he has to make a delivery.

This morning at the local bakery he picked up a big pink wedding cake, with its six tiers and scalloped edges and its miniature bride and groom on top. He'd ordered it on his own; he'd taken the initiative, planning to offer it to a young woman he works with. He managed somehow to set the thing on the back seat of the car, and when he got home he found a note from her announcing, excited and happy, that she's engaged. The man she'd had such difficulty with has had a change of heart; he wants to get married after all. She's going off to Houston to live. She loves her dear old Tandolfo with a big kiss and a hug always, and she knows he'll have every happiness. She's so thankful for his friendship. Her magic man. Her sweet clown. She actually drove over here and, finding him gone, left the note for him, folded under the door knocker—her notepaper with the tangle of flowers at the top. She wants him to call her, come by as soon as he can, to help celebrate. *Please*, she says. *I want to give you a big hug.* He read this and

then walked out to stand on the sidewalk and look at the cake in its place on the back seat of the car.

"Good God," he said.

He'd thought he would put the clown outfit on, deliver the cake in person, an elaborate proposal to a girl he's never even kissed. He's a little unbalanced, and he knows it. Over the months of their working together at Bailey & Brecht department store, he's built up tremendous feelings of loyalty and yearning toward her. He thought she felt it, too. He interpreted gestures—her hand lingering on his shoulder when he made her laugh; her endearments, tinged as they seemed to be with a kind of sadness, as if she were afraid for what the world might do to someone so romantic.

"You sweet clown," she said. She said it a lot. And she talked to him about her ongoing sorrows, the man she'd been in love with who kept waffling about getting married, wanting no commitments. Tandolfo, a.k.a. Rodney Wilbury, told her that he hated men who weren't willing to run the risks of love. Why, he personally was the type who'd always believed in marriage and children, lifelong commitments. It was true that he had caused difficulties for himself, and life was a disappointment so far, but he believed in falling in love and starting a family. She didn't hear him. It all went right through her, like white noise on the radio. For weeks he had come around to visit her, had invited her to watch him perform. She confided in him, and he thought of movies where the friend stays loyal and is a good listener, and eventually gets the girl: they fall in love. He put his hope in that. He was optimistic; he'd ordered and bought the cake, and apparently the whole time, all through the listening and being noble with her, she thought of it as nothing more than friendship, accepting it from him because she was accustomed to being offered friendship.

Now he leans close to the mirror to look at his own eyes through the makeup. They look clear enough. "Loves you absolutely not. You must be crazy. You must be the Great Tandolfo."

Yes.

Twenty-six years old, out-of-luck Tandolfo. In love. With a great oversized cake in the back seat of his car. It's Sunday, a cool April day. He's a little inebriated. That's the word he prefers. It's polite; it suggests something faintly silly. Nothing could be sillier than to be dressed like this in broad daylight and to go driving across the bridge into Virginia to put on a magic show. Nothing could be sillier than to have spent all that money on a completely useless purchase—a cake six tiers high. Maybe fifteen pounds of sugar.

When he has made his last inspection of the clown face in the mirror, and checked the bag of tricks and props, he goes to his front door and looks through the screen at the architectural shadow of the cake in the back seat. The inside of the car will smell like icing for days. He'll have to keep the windows open even if it rains; he'll go to work smelling like confectionery delights. The whole thing makes him laugh. A wedding cake. He steps out of the house and makes his way in the late afternoon sun down the sidewalk to the car. As if they have been waiting for him, three boys come skating down from the top of the hill. He has the feeling that if he tried to sneak out like this at two in the morning, someone would come by and see him anyway. "Hey, Rodney," one boy says. "I mean, Tandolfo."

Tandolfo recognizes him. A neighborhood boy, a tough. Just the kind to make trouble, just the kind with no sensitivity to the suffering of others. "Leave me alone or I'll turn you into spaghetti," he says.

"Hey guys, it's Tandolfo the Great." The boy's hair is a bright blond color, and you can see through it to his scalp.

"Scram," Tandolfo says. "Really."

"Aw, what's your hurry, man?"

"I've just set off a nuclear device," Tandolfo says with grave seriousness. "It's on a timer. Poof."

"Do a trick for us," the blond one says. "Where's that scurvy rabbit of yours?"

"I gave it the week off." Someone, last winter, poisoned the first Chi-Chi. He keeps the cage indoors now. "I'm in a hurry. No rabbit to help with the driving."

But they're interested in the cake now. "Hey, what's that? Jesus, is that real?"

"Just stay back." Tandolfo gets his cases into the trunk and hurries to the driver's side door. The three boys are peering into the back seat. To the blond boy he says, "You're going to go bald, aren't you?"

"Hey man, a cake. Can we have a piece of it?" one of them says.

"Back off," Tandolfo says.

Another says, "Come on, Tandolfo."

"Hey, Tandolfo, I saw some guys looking for you, man. They said you owed them money."

He gets in, ignoring them, and starts the car.

"Sucker," the blond one says.

"Hey man, who's the cake for?"

He drives away, thinks of himself leaving them in a cloud of exhaust. Riding through the green shade, he glances in the rearview mirror and sees the clown

face, the painted smile. It makes him want to laugh. He tells himself he's his own cliché—a clown with a broken heart. Looming behind him is the cake, like a passenger in the back seat. The people in the cake store had offered it to him in a box; he had made them give it to him like this, on a cardboard slab. It looks like it might melt.

He drives slow, worried that it might sag, or even fall over. He has always believed viscerally that gestures mean everything. When he moves his hands and brings about the effects that amaze little children, he feels larger than life, unforgettable. He learned the magic while in high school, as a way of making friends, and though it didn't really make him any friends, he's been practicing it ever since. It's an extra source of income, and lately income has had a way of disappearing too quickly. He has been in some travail, betting the horses, betting the sports events. He's hung over all the time. There have been several polite warnings at work. He has managed so far to tease everyone out of the serious looks, the cool study of his face. The fact is, people like him in an abstract way, the way they like distant clownish figures: the comedian whose name they can't remember. He can see it in their eyes. Even the rough characters after his loose change have a certain sense of humor about it.

He's a phenomenon, a subject of conversation.

There's traffic on Key Bridge, and he's stuck for a while. It becomes clear that he'll have to go straight to the birthday party. Sitting behind the wheel of the car with his cake behind him, he becomes aware of people in other cars noticing him. In the car to his left, a girl stares, chewing gum. She waves, rolls her window down. Two others are with her, one in the back seat. "Hey," she says. He nods, smiles inside what he knows is the clown smile. His teeth will look dark against the makeup.

"Where's the party?" she says.

But the traffic moves again. He concentrates. The snarl is on the other side of the bridge, construction of some kind. He can see the cars in a line, waiting to go up the hill into Roslyn and beyond. Time is beginning to be a consideration. In his glove box he has a flask of bourbon. More fortification. He reaches over and takes it out, looks around himself. No police anywhere. Just the idling cars and people tuning their radios or arguing or simply staring out as if at some distressing event. The smell of the cake is making him woozy. He takes a swallow of the bourbon, then puts it away. The car with the girls in it goes by in the left lane, and they are not looking at him. He watches them go on ahead. He's in the wrong lane again; he can't remember a time when *his* lane was the only one moving. He told her once that he considered himself of the race of people who

gravitate to the nonmoving lanes of highways, and who cause green lights to turn yellow merely by approaching them. She took the idea and ran with it, saying she was of the race of people who emit enzymes which instill a sense of impending doom in marriageable young men.

"No," Tandolfo/Rodney said. "I'm living proof that isn't so. I have no such fear, and I'm with you."

"But you're of the race of people who make mine relax all the enzymes."

"You're not emitting the enzymes now. I see."

"No," she said. "It's only with marriageable young men."

"I emit enzymes that prevent people like you from seeing that I'm a marriageable young man."

"I'm too relaxed to tell," she said, and touched his shoulder. A plain affectionate moment that gave him tossing nights and fever.

Because of the traffic, he's late to the birthday party. He gets out of the car and two men come down to greet him. He keeps his face turned away, remembering too late the breath mints in his pocket.

"Jesus," one of the men says, "look at this. Hey, who ordered the cake? I'm not paying for the cake."

"The cake stays," Tandolfo says.

"What does he mean, it stays? Is that a trick?"

They're both looking at him. The one spoken to must be the birthday boy's father—he's wearing a party cap that says DAD. He has long, dirty-looking strands of brown hair jutting out from the cap, and there are streaks of sweaty grit on the sides of his face. "So you're the Great Tandolfo," he says, extending a meaty red hand. "Isn't it hot in that makeup?"

"No, sir."

"We've been playing volleyball."

"You've exerted yourselves."

They look at him. "What do you do with the cake?" the one in the DAD cap asks.

"Cake's not part of the show, actually."

"You just carry it around with you?"

The other man laughs. He's wearing a T-shirt with a smiley face on the chest. "This ought to be some show," he says.

They all make their way across the lawn, to the porch of the house. It's a big party, bunting everywhere and children gathering quickly to see the clown.

"Ladies and gentlemen," says the man in the DAD cap. "I give you Tandolfo the Great."

Tandolfo isn't ready yet. He's got his cases open, but he needs a table to put everything on. The first trick is where he releases the bird; he'll finish with the best trick, in which the rabbit appears as if from a pan of flames. This always draws a gasp, even from the adults: the fire blooms in the pan, down goes the "lid"—it's the rabbit's tight container—the latch is tripped, and the skin of the lid lifts off. Voilà! Rabbit. The fire is put out by the fireproof cage bottom. He's gotten pretty good at making the switch, and if the crowd isn't too attentive—as children often are not—he can perform certain sleight-of-hand tricks with some style. But he needs a table, and he needs time to set up.

The whole crowd of children is seated in front of their parents, on either side of the doorway into the house. Tandolfo is standing on the porch, his back to the stairs, and he's been introduced.

"Hello, boys and girls," he says, and bows. "Tandolfo needs a table."

"A table," one of the women says. The adults simply regard him. He sees light sweaters, shapely hips, and wild hair; he sees beer cans in tight fists, heavy jowls, bright ice-blue eyes. A little row of faces, and one elderly face. He feels more inebriated than he likes, and tries to concentrate.

"Mommy, I want to touch him," one child says.

"Look at the cake," says another, who gets up and moves to the railing on Tandolfo's right and trains a new pair of shiny binoculars on the car. "Do we get some cake?"

"There's cake," says the man in the DAD cap. "But not that cake. Get down, Ethan."

"I want that cake."

"Get down. This is Teddy's birthday."

"Mommy! I want to touch him."

"I need a table, folks. I told somebody that over the telephone."

"He did say he needed a table. I'm sorry," says a woman who is probably the birthday boy's mother. She's quite pretty, leaning in the door frame with a sweater tied to her waist.

"A table," says still another woman. Tandolfo sees the birthmark on her mouth, which looks like a stain. He thinks of this woman as a child in school, with this difference from other children, and his heart goes out to her.

"I need a table," he says to her, his voice as gentle as he can make it.

"What's he going to do, perform an operation?" says DAD.

It amazes Tandolfo how easily people fall into talking about him as though he were an inanimate object or something on a television screen. "The Great

Tandolfo can do nothing until he gets a table," he says with as much mysteriousness and drama as he can muster under the circumstances.

"I want that cake out there," says Ethan, still at the porch railing. The other children start talking about cake and ice cream, and the big cake Ethan has spotted; there's a lot of confusion and restlessness. One of the smaller children, a girl in a blue dress, approaches Tandolfo. "What's your name?" she says, swaying slightly, her hands behind her back.

"Go sit down," he says to her. "We have to sit down or Tandolfo can't do his magic."

In the doorway, two of the men are struggling with a folding card table. It's one of those rickety ones with the skinny legs, and it probably won't do.

"That's kind of shaky, isn't it?" says the woman with the birthmark.

"I said, Tandolfo needs a sturdy table, boys and girls."

There's more confusion. The little girl has come forward and taken hold of his pant leg. She's just standing there holding it, looking up at him. "We have to go sit down," he says, bending to her, speaking sweetly, clownlike. "We have to do what Tandolfo wants."

Her small mouth opens wide, as if she's trying to yawn, and with pale eyes quite calm and staring she emits a screech, an ear-piercing, non-human shriek that brings everything to a stop. Tandolfo/Rodney steps back, with his amazement and his inebriate heart. Everyone gathers around the girl, who continues to scream, less piercing now, her hands fisted at her sides, those pale eyes closed tight.

"What happened?" the man in the DAD cap wants to know. "Where the hell's the magic tricks?"

"I told you, all I needed is a *table.*"

"What'd you say to her to make her cry?" DAD indicates the little girl, who is giving forth a series of broken, grief-stricken howls.

"I want magic tricks," the birthday boy says, loud. "Where's the magic tricks?"

"Perhaps if we moved the whole thing inside," the woman with the birthmark says, fingering her left ear and making a face.

The card table has somehow made its way to Tandolfo, through the confusion and grief. The man in the DAD cap sets it down and opens it.

"There," he says, as if his point has been made.

In the next moment, Tandolfo realizes that someone's removed the little girl. Everything's relatively quiet again, though her cries are coming through the walls

of one of the rooms inside the house. There are perhaps fifteen children, mostly seated before him, and five or six men and women behind them, or kneeling with them. "Okay, now," DAD says. "Tandolfo the Great."

"Hello, little boys and girls," Tandolfo says, deciding that the table will have to suffice. "I'm happy to be here. Are you glad to see me?" A general uproar commences. "Well, good," he says. "Because just look what I have in my magic bag." And with a flourish he brings out the hat that he will release Witch from. The bird is encased in a fold of shiny cloth, pulsing there. He can feel it. He rambles on, talking fast, or trying to, and when the time comes to reveal the bird, he almost flubs it. But Witch flaps his wings and makes enough of a commotion to distract even the adults, who applaud and urge the stunned children to follow suit. "Isn't that wonderful," Tandolfo hears. "Out of nowhere."

"He had it hidden away," says the birthday boy, managing to temper his astonishment. He's clearly the type who heaps scorn on those things he can't understand, or own.

"Now," Tandolfo says, "for my next spell, I need a helper from the audience." He looks right at the birthday boy—round face, short nose, freckles. Bright red hair. Little green eyes. The whole countenance speaks of glutted appetites and sloth. This kid could be on Roman coins, an emperor. He's not used to being compelled to do anything, but he seems eager for a chance to get into the act. "How about you," Tandolfo says to him.

The others, led by their parents, cheer.

The birthday boy gets to his feet and makes his way over the bodies of the other children to stand with Tandolfo. In order for the trick to work, Tandolfo must get everyone watching the birthday boy, and there's a funny hat he keeps in the bag for this purpose. "Now," he says to the boy, "since you're part of the show, you have to wear a costume." He produces the hat as if from behind the boy's ear. Another cheer goes up. He puts the hat on the boy's head and adjusts it, crouching down. The green eyes stare impassively at him; there's no hint of awe or fascination in them. "There we are," he says. "What a handsome fellow."

But the birthday boy takes the hat off.

"We have to wear the hat to be onstage."

"Ain't a stage," the boy says.

"Well, but hey," Tandolfo says for the benefit of the adults. "Didn't you know that all the world's a stage?" He tries to put the hat on him again, but the boy moves from under his reach and slaps his hand away. "We have to wear the hat," Tandolfo says, trying to control his anger. "We can't do the magic without our magic

hats." He tries once more, and the boy waits until the hat is on, then simply removes it and holds it behind him, shying away when Tandolfo tries to retrieve it. The noise of the others now sounds like the crowd at a prizefight; there's a contest going on, and they're enjoying it. "Give Tandolfo the hat. We want magic, don't we?"

"Do the magic," the boy demands.

"I'll do the magic if you give me the hat."

"I won't."

Nothing. No support from the adults. Perhaps if he weren't a little tipsy, perhaps if he didn't feel ridiculous and sick at heart and forlorn, with his wedding cake and his odd mistaken romance, his loneliness, which he has always borne gracefully and with humor, and his general dismay; perhaps if he were to find it in himself to deny the sudden, overwhelming sense of the unearned affection given this lumpish, slovenly version of stupid complacent spoiled satiation standing before him—he might've simply gone on to the next trick.

Instead, at precisely that moment when everyone seems to pause, he leans down and says, "Give me the hat, you little prick."

The green eyes widen.

The quiet is heavy with disbelief. Even the small children can tell that something's happened to change everything.

"Tandolfo has another trick," Rodney says, loud, "where he makes the birthday boy pop like a balloon. Especially if he's a fat birthday boy."

A stirring among the adults.

"Especially if he's an ugly slab of gross flesh like this one here."

"Now just a minute," says DAD.

"*Pop*," Rodney says to the birthday boy, who drops the hat and then, seeming to remember that defiance is expected, makes a face. Sticks out his tongue. Rodney/Tandolfo is quick with his hands by training, and he grabs the tongue.

"Awk," the boy says. "Aw-aw-aw."

"Abracadabra!" Rodney lets go and the boy falls backward onto the lap of one of the other children. More cries. "Whoops, time to sit down," says Rodney. "Sorry you had to leave so soon."

Very quickly, he's being forcibly removed. They're rougher than gangsters. They lift him, punch him, tear at his costume—even the women. Someone hits him with a spoon. The whole scene boils over onto the lawn, where someone has released Chi-Chi from her case. Chi-Chi moves about wide-eyed, hopping between running children, evading them, as Tandolfo the Great cannot evade the

adults. He's being pummeled, because he keeps trying to return for his rabbit. And the adults won't let him off the curb. "Okay," he says finally, collecting himself. He wants to let them know he's not like this all the time; wants to say it's circumstances, grief, personal pain hidden inside seeming brightness and cleverness. He's a man in love, humiliated, wrong about everything. He wants to tell them, but he can't speak for a moment, can't even quite catch his breath. He stands in the middle of the street, his funny clothes torn, his face bleeding, all his magic strewn everywhere. "I would at least like to collect my rabbit," he says, and is appalled at the absurd sound of it—its huge difference from what he intended to say. He straightens, pushes the grime from his face, adjusts the clown nose, and looks at them. "I would say that even though I wasn't as patient as I could've been, the adults have not comported themselves well here," he says.

"Drunk," one of the women says.

Almost everyone's chasing Chi-Chi now. One of the older boys approaches, carrying Witch's case. Witch looks out the air hole, impervious, quiet as an idea. And now one of the men, someone Rodney hasn't noticed before, an older man clearly wearing a hairpiece, brings Chi-Chi to him. "Bless you," Rodney says, staring into the man's sleepy, deploring eyes.

"I don't think we'll pay you," the man says. The others are filing back into the house, herding the children before them.

Rodney speaks to the man. "The rabbit appears out of fire."

The man nods. "Go home and sleep it off, kid."

"Right. Thank you."

He puts Chi-Chi in his compartment, stuffs everything in its place in the trunk. Then he gets in the car and drives away. Around the corner he stops, wipes off what he can of the makeup; it's as if he's trying to remove the stain of bad opinion and disapproval. Nothing feels any different. He drives to the suburban street where she lives with her parents, and by the time he gets there it's almost dark.

The houses are set back in the trees. He sees lighted windows, hears music, the sound of children playing in the yards. He parks the car and gets out. A breezy April dusk. "I am Tandolfo the soft-hearted," he says. "Hearken to me." Then he sobs. He can't believe it. "Jeez," he says. "Lord." He opens the back door of the car, leans in to get the cake. He'd forgot how heavy it is. Staggering with it, making his way along the sidewalk, intending to leave it on her doorstep, he has an inspiration. Hesitating only for the moment it takes to make sure there are no cars coming, he goes out and sets it down in the middle of the street. Part of the top sags from having bumped his shoulder as he pulled it off the back

seat. The bride and groom are almost supine, one on top of the other. He straightens them, steps back and looks at it. In the dusky light it looks blue. It sags just right, with just the right angle expressing disappointment and sorrow. Yes, he thinks. This is the place for it. The aptness of it, sitting out like this, where anyone might come by and splatter it all over creation, makes him feel a faint sense of release, as if he were at the end of a story. Everything will be all right if he can think of it that way. He's wiping his eyes, thinking of moving to another town. Failures are beginning to catch up to him, and he's still aching in love. He thinks how he has suffered the pangs of failure and misadventure, but in this painful instance there's symmetry, and he will make the one eloquent gesture—leaving a wedding cake in the middle of the road, like a sugar-icinged pylon. Yes.

He walks back to the car, gets in, pulls around, and backs into the driveway of the house across the street from hers. Leaving the engine idling, he rolls the window down and rests his arm on the sill, gazing at the incongruous shape of the cake there in the falling dark. He feels almost glad, almost, in some strange inexpressible way, vindicated. He imagines what she might do if she saw him here, imagines that she comes running from her house, calling his name, looking at the cake and admiring it. He conjures a picture of her, attacking the tiers of pink sugar, and the muscles of his abdomen tighten. But then this all gives way to something else: images of destruction, of flying dollops of icing. He's surprised to find that he wants her to stay where she is, doing whatever she's doing. He realizes that what he wants—and for the moment all he really wants—is what he now has: a perfect vantage point from which to watch oncoming cars. Turning the engine off, he waits, concentrating on the one thing. He's a man imbued with interest, almost peaceful with it—almost, in fact, happy with it—sitting there in the quiet car and patiently awaiting the results of his labor.

Nic Nicosia Portrait Commissions

Houston, Texas, 1995

Above: Dallas, Texas, 1995. Right: Houston, Texas, 1992.

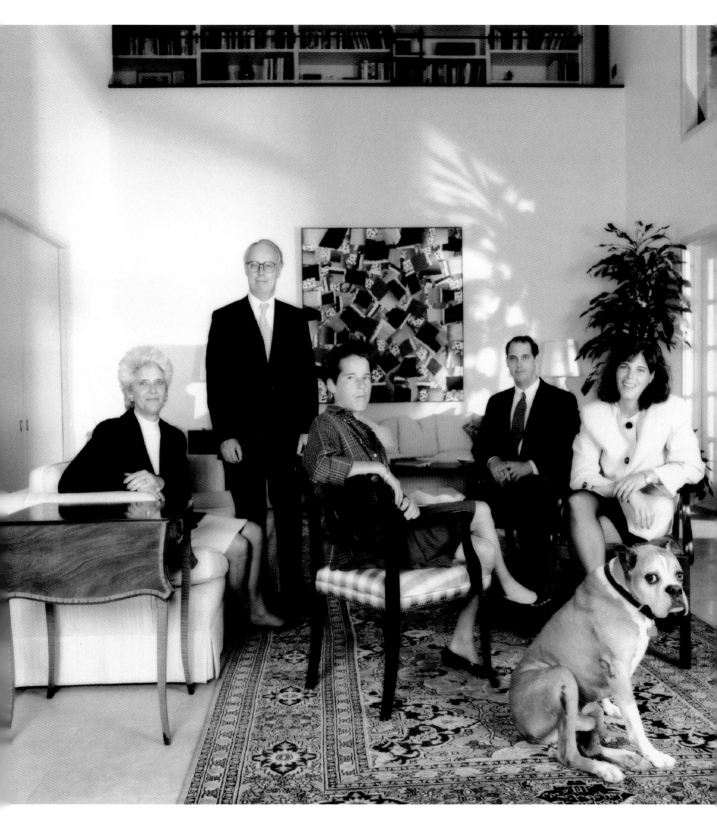

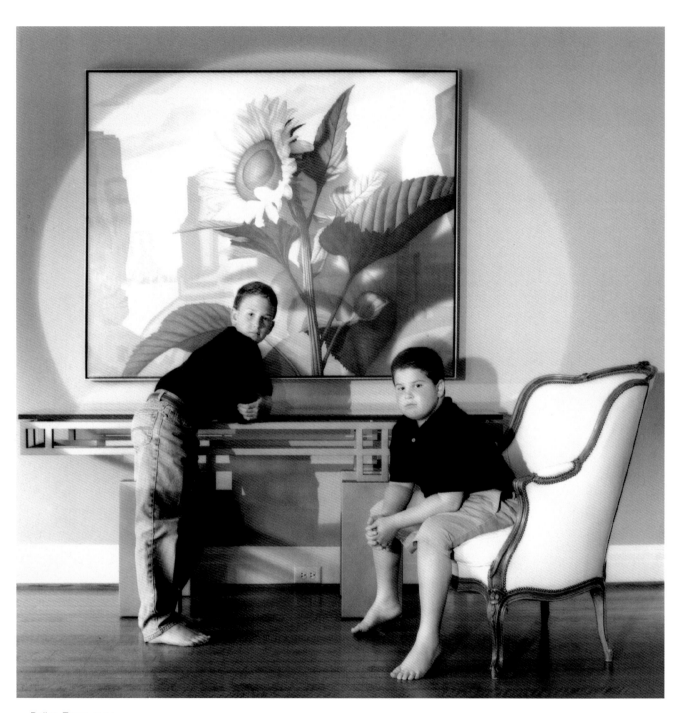

Dallas, Texas, 1994

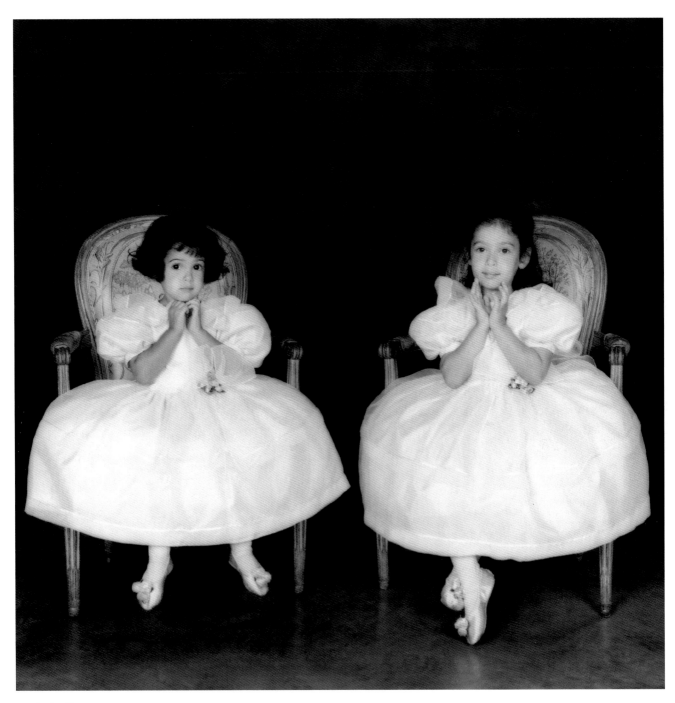

Dallas, Texas, 1993

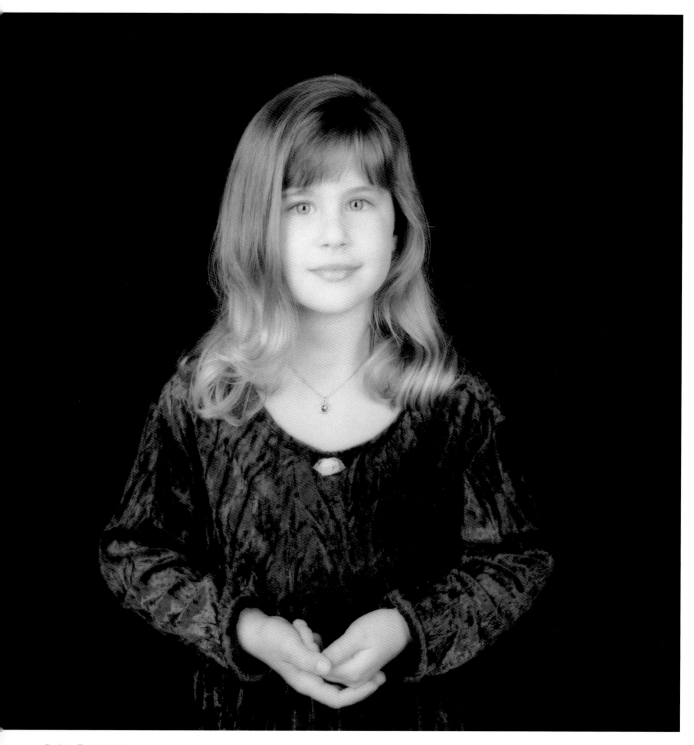

Dallas, Texas, 1994

Houston, Texas, 1992

Houston, Texas, 1991

Houston, Texas, 1993

Dallas, Texas, 1993

The Interpretation of Dreams

for Ann Moss Crowther

Lee Smith

Melanie stands dreaming against the open door, the entrance to Linens 'n Things in the outlet mall in Burlington, North Carolina. It's raining. Melanie loves how the rain sounds drumming down on the big skylight at the center of the mall right over The Potted Plant and Orange Julius, it sounds like a million horses running fast, like a stampede in a Western movie. She loves movies, she loves Clint Eastwood, now what if *he* came in the outlet mall right now and walked over to her and said, Excuse me, ma'am, I need a king-size bedspread in a western decor? She'd say, Why yes, come this way, sir, I've got exactly what you need. Only the trouble is that he won't come in probably, or any other real man either, men don't come to outlets unless of course they happen to work there, especially not to Linens 'n Things, which is where Melanie works.

She's between men. Stan left Tuesday for a new job at WRDU in Raleigh, which has a soft country format. Stan the Man, they called him on the radio, what a joke. Melanie and him didn't really get along that good anyway, it was mostly a mistake caused by too many piña coladas. Stan turned out to be real self-centered like most media personalities, at least in Melanie's experience, and she has known several. Like sometimes you'll have a boyfriend for a while and then you'll go out with his buddies after that, which was true of her and the guys at WHIT. All of their voices were so loud, plus they were kind of neurotic which is often true of artistic types. Melanie would like to steer clear of artistic types now and find a person who is basically down-to-earth, which she is.

Or maybe a healthy sports-minded man like Bobby of Bobby's Sport which is just opening up now in the corner space vacated by Pottery World. Mr. Slemp

didn't have any heart for business after his wife died, they all watched her waste away before their very eyes, Mrs. Slemp, but she kept coming into Pottery World every day until the very last, when she had to go in the hospital. Mrs. Slemp was only forty-six years old. It was tragic, what a nice long marriage the Slemps had, they'd been at the outlet mall ever since it opened.

This is what Melanie wants, a sweet regular man she can watch TV with, and not have to put on her makeup or kick up her heels. A solid sports-minded man to be a role model for her son Sean, Lord knows he could use one even though he is almost grown up now and probably it's too late anyway.

Melanie sighs, nibbling a piece of her long red hair. Her sister says she's too old (thirty-seven) to wear it long, that a woman should cut her hair by age thirty at least. But men like it long. Melanie knows this. Long hair is sexy; short hair is not. Mr. Rolette, her boss, keeps calling to her but she doesn't answer him back, she's going to act like she doesn't hear, it's still early, and speaking of husbands, she's had three.

Some people might not count the first one since it was annulled, so it was like it never happened at all, like an abortion. She's had some of those, too. But he was so sweet, her first husband. After she lost him she tried to be philosophical and think, Well, I was lucky to have him at all, but this was wrong. The fact is, he almost ruined her for anybody else. She'd been married and annulled by twenty, it was all downhill after that, or so it seems on some days like today when it's raining and she's feeling blue. He was the one she really loved. He was so intelligent. In fact he was in Army Intelligence that summer she met him, she was waiting tables at Wrightsville Beach, she'd just graduated from high school and he was a year out of college but real young, since he was so intelligent.

His name was Andrew, called Drew, he had gone to school up North. He was an only child whose parents lived in Greenwich, Connecticut, where the clocks are. Melanie never met his mother and she met his father only once, when he came down to Fayetteville to get them annulled. Drew's father looked like the guy on *Masterpiece Theater*. He gave her a thousand dollars and kissed her on the cheek and said, "No harm done." This was not exactly true. Because never again did Melanie come across a boy who was so intelligent or could make her laugh so hard. He was going to be a professor, probably he's one now at some university up North, only Melanie doesn't know this for sure because his parents' phone is no longer listed in Greenwich. Sometimes over the years when she's been drinking, she's tried to call. Her second husband was nothing but a flash in the pan but at least she got Sean out of that one. Sean is the best thing that has ever happened in Melanie's life so far. And her third husband, Gary Rasnake,

was cute but he was trouble from the word go, he wouldn't work and all he wanted to do was play, he loved equipment and gadgets for their own sake such as Weed-Eaters and remote-control toy airplanes and guns and cars and VCRs. They had the first VCR in Burlington, when nobody else had ever heard of them. A man ahead of his time.

"I'm coming," Melanie yells to Mr. Rolette. It's true she ought to go back in there now, Mr. Rolette's been nervous lately and the mall is filling up, it's getting real busy, everybody comes to the mall when it rains. The worst thing Gary Rasnake did was charge all those things on Melanie's Visa card and then leave town. She stopped payment of course, but still. Later, she found out that he'd done this before at least twice, once in Fort Walton Beach, Florida, and once in Spartanburg, South Carolina. But it wasn't all bad she guessed, they had some fun, too, even if she can't remember what they did exactly, it seems like such a long time ago.

And now she's getting old, too old to have long hair. It's time for another husband. The boyfriends she's had since Gary have not seemed like husband material, or else they just took off. Melanie is basically domestic, which is why she enjoys working at Linens 'n Things. "Coming," she calls.

But as Melanie turns to go back in the store, she catches sight of Bobby of Bobby's Sport coming to work. He wears a navy blue running suit and bounces along on his brand new athletic shoes like an advertisement for himself, which in a way he is. Melanie stands half turned in the door to watch him go by, and then to her surprise he gives her a big flashy grin. "Morning," he says. Bobby's teeth are so even and white, he must have had braces as a child.

"I saw that," says her best friend, Grace, who has been married to the same man for a million years so she is fascinated by this kind of thing.

"What? Nothing happened," says Melanie, but Grace says, "Huh!"

"Girls, girls, let's settle down now." Mr. Rolette claps his hands. They are getting ready for a back-to-school sale. Deborah Green at the cash register looks up from her book and glares at him. Deborah is an intellectual, working her way through school. Mr. Rolette sets the two black girls, LaWanda and Renée, to unloading sheets and scatter rugs for the back-to-school bin by the cash register, while Grace tidies up the bath area and Melanie waits on customers. She's good at it. Over the years she has gotten so she can match up a woman with a sheet in five minutes flat, it's like a sixth sense or something. In fact she's so good at it that she doesn't have to think much, she can go on dreaming although it's hard to say exactly what she's dreaming about, nothing special, it's still raining outside, all the people who come in Linens 'n Things are dripping wet. That's the

only bad thing about working at the mall, you miss so much weather. All you know is basically if it's raining or not raining, from the skylight which is frosted glass. Bobby of Bobby's Sport has a deep cleft chin which Melanie likes in a man.

At lunchtime she and Grace go to The Magic Pan. They always eat lunch together even though Grace is so persnickety. For instance she will say, There is too much cheese in this blue cheese dressing, or, This Coke is flat. You can't satisfy Grace, which is probably one reason she is Melanie's best friend, opposites attract, and Melanie's easily pleased. Also they have worked together every day for the past nine years.

"Do you think Bobby is cute?" Melanie asks.

"Well, yes, I do think he is sort of cute," Grace says, "but he looks like he might be real bouncy, I think you ought to look for somebody older and more stable," says Grace. You can trust her to find some fault. Grace is married to her own high school sweetheart, Gene, a tall skinny man with big black glasses who is always worrying about things, he'd be the last man in the world that Melanie would be interested in, whether he was stable or not.

Grace fixes Melanie with her watery blue-eyed stare. "I think if I was you I'd try to look at all my options," she says, "and not just fall into something else."

Melanie opens her mouth and then shuts it. Grace means the best in the world of course, she just does not have a lot of personal tact, so what. Still, Melanie feels real down as they walk back to Linens 'n Things together. Just the other day her sister said, "Melanie, you need to get a grip on things." Melanie knows her mother and her sister talk about her on the phone. They pass Shoe Town, Revco, The Casual Male, The Christmas Shoppe. Melanie thinks she would die if she worked in there and had to listen to Christmas carols all day long. They pass Deborah Green, sitting on the bench by the little fountain, reading a book. She doesn't look up. This reminds Melanie again of Drew, who was always reading.

"You go ahead," she says to Grace. "I'll catch up with you in a minute, I want to buy something to read."

Grace looks funny. "Huh!" she says.

But Melanie ducks into News and Notions anyway, it's not much bigger than a closet stuck in between The Christmas Shoppe and Marine Discount.

The very first book she picks up is a paperback named *How to Interpret Your Dreams*, by dream expert Margery Cooper Boyd. She went straight to it, it must be fate. "I'll take it," she says, and pays the old man behind the counter, who always stares at her bosom, and she buys a *USA Today* also, to find out what's going on in the world, but as soon as she reads the first page of *How to Interpret Your Dreams* she's hooked. It's like Margery Cooper Boyd wrote this book especially for her.

"Got a problem?" the book says. "Sleep on it. If you know how, you can literally dream up a solution during the night. The dreaming mind's ability to find creative and logical solutions for unresolved problems has delighted and intrigued man for as long as he has been in this world. Without the ability to dream, it's doubtful that man would have survived as long as he has. It is safe to say that he certainly would not have attained dominance." Melanie sits down on the bench in front of Belk's. "History is filled with examples of how dreams have helped men and nations to solve problems. Perhaps the best known examples are Biblical— Pharaoh's dream of the lean and fat cows or Jacob's dream of the sheaves and stars. In more modern times there are Robert Louis Stevenson, Samuel Taylor Coleridge, Edgar Allan Poe, Mark Twain, Albert Einstein, Wolfgang Mozart, and others who have had dreams." Melanie blinks, she doesn't know who all these people are, she can't remember anything about the pharaoh either. Then she reads a lot of these dreams and what they turned out to mean, and it is very interesting. Some dreams have changed the course of history. She doesn't care if she's late or not, she doesn't care if Mr. Rolette gets mad or not. Once you are able to accept your dreams as private messages from your subconscious, you open yourself up to a whole new world of self-understanding. You can get what you want!

"Listen to your dreams," writes Margery Cooper Boyd. This certainly ought to come easy to Melanie, who lives in a dream world anyway, everybody has always said so. In fact Mr. Rolette says it later that day, "Melanie, pay attention, you live in a dream world," when she marks the towels down wrong. The interpretation of dreams is done through symbols, everything you dream means something else. Melanie can't wait to start learning what they mean. Her dreams are full of symbols, sometimes at night she dreams so much she wakes up all worn out.

"Isn't it something?" she asks Sean later when they're eating dinner, tacos, something quick, she was too excited to cook much. Sean says, "Isn't *what* something, Mama?" in his normal bored voice, and she says, "Everything in your dreams means something else."

Sean smiles at her, the long slow smile which is the only characteristic he seems to have gotten from his daddy thank God, who was nevertheless attractive. "Mama," he says, "almost *everything* means something else."

Melanie just looks at him. "Well!" she says. Sean's hair is bleached and long on top, he has a rattail in back, his ears have been pierced so many times they look like Swiss cheese. Sean plays guitar, he looks like somebody who just knocked over a convenience store. But Sean is basically real smart and only a few people, mainly his teachers, know this. He'd drop dead before he'd let his friends catch him studying.

"What do you mean?" he asks, and so Melanie shows him the alphabetical listing, which is very complete, going from Abandonment, Accounts, Actor or Actress, Adultery, and Airplane all the way to Tomato, Tooth, Vault, Washing, Yellow, Youth, and Zoo. "Washing!" Sean says. "Who ever dreamed of washing?"

"Well, if they did, I'm sure it means guilt," sniffs Melanie, because it has occurred to her Sean might be making fun of her again.

"'Snow,'" Sean reads out loud. "'Snow is a symbol of purity. It can also symbolize sex. To dream of tracking through untouched snow expresses a desire for sexual intercourse.'"

"Give me that!" says Melanie, grabbing her book.

"So which is it, Mama?" asks Sean. "Sex or purity? How do you know?"

"You just have to trust your heart," Melanie says, "and go with your instincts that's all, that's what Margery Cooper Boyd says."

"Well, then it must be true."

He's teasing her all right, he's always teasing her, still they do have a wonderful relationship, considering, but sometimes it seems like it's gotten all turned around, like Sean's the grown-up here and she's the child.

"Listen, Mama," he says suddenly. "You remember Mr. Joyner?"

"Who?"

"Mr. Joyner, you know, my history teacher from last year. You met him at the end of school when you came over to see the concert."

"No, I don't believe I do," says Melanie, who can't recall even hearing the name before, of course she was busy last spring, what with Stan and the guys from WHIT.

"Well, now he's gotten a divorce, and he came up to me in the hall and asked me what my mother was doing these days."

Melanie just stares at him. A high school history teacher is not really her idea of a good time. "How old is he?" she asks.

"About forty-five." Sean lights a cigarette, he's been smoking since he was twelve, she can't do a thing with him really. "He's real nice, Mama, sort of an ex-hippie."

"Too old," Melanie says flatly, because no matter what anybody says, she's not over the hill yet. She can get somebody sports-minded and cute if she can harness her subconscious long enough to do it, but Sean stares at her through the smoke. "Maybe you could just talk to him sometime, Mama," he says, and she says, "Maybe so."

That night Melanie dreams that she is in a supermarket where a lot of men are for sale and Margery Cooper Boyd is working the cash register. She says to

Melanie in a Northern voice, "Take your pick, half-price today only, all sales are final." So in the morning Melanie dresses very carefully for work, the yellow dress with the black patent belt, the black patent shoes, she knows this dream is prophetic.

And sure enough, when he comes bouncing past Linen 'n Things that morning, Bobby gives her a big wink. His intentions are perfectly clear.

"I saw that," says Grace, right behind her, and Melanie just can't resist, she tells Grace that actually she caused that wink herself, by harnessing her subconscious. Grace asks if this is some kind of new diet or what, and Melanic says, "No, silly, don't you remember my dream book? I've learned to interpret my dreams," but Grace turns up her nose and says Melanie ought to get a grip on herself, she ought to go to a doctor, it might be PMS. Grace's big blue eyes are watering the way they do when she thinks she's on to something. Melanie looks at her carefully. "Why, Grace!" she says suddenly, "I believe you're jealous!" As soon as she says it, she knows it's true. It's been true probably for years, only she never realized it before because she wasn't listening to her heart, she wasn't going with her instincts. Right now Grace is especially jealous because Melanie can interpret dreams, but not too jealous to hang around later while Renée tells Melanie what she dreamed last night. It was all in color, which proves Renée is very intelligent, according to Mrs. Boyd.

Renée says she dreamed she was supposed to go out to dinner with her boyfriend so she got all dressed up. She wore a red dress. In this dream she did her hair and then painted her nails and then her toenails, it seemed to take forever the way things sometimes do in dreams, and she was so hungry, she kept looking at the clock. Seven o'clock, eight o'clock, nine o'clock and still he didn't come, she was starving, she'd done her nails about seven times. Then finally at ten o'clock she realized that she'd been stood up and so she went to the refrigerator and got a frozen pepperoni pizza and put it in the oven to cook for dinner.

"Then what?" asked Melanie.

"What do you mean, 'what'?" says Renée. "That's *it*, honey. That's the end of the dream." It's not much of a dream, and Renée knows it. "I don't care if you like it or not," she says, all huffy. "It's *my* dream anyway."

"No, no, it's fine, Renée, I just need to concentrate on my interpretation, that's all." Melanie is getting nervous now because Grace and Deborah Green and Mrs. Small, the bookkeeper, have all gathered around to listen.

"Look up 'Dinner,'" says Grace, "or maybe 'Pizza,'" but there's no listing for either one.

"Oh, honestly!" Deborah Green acts like she knows it all. "The meaning is perfectly obvious. Renée is afraid her relationship's nearly over. She's afraid he's losing interest or something."

"*Roy?*" snorts Renée. "Roy is doing anything *but* losing interest."

"Maybe that's just what *you* think," Deborah says, which starts a big commotion that allows Melanie some time to consult Mrs. Boyd and think about Renée's dream. The interpretation, when it comes to her, is very serious. So she doesn't tell Renée until lunchtime, when she can catch her alone at Orange Julius.

"Renée, I'm afraid I have some bad news for you." Melanie is very formal. "I believe you're pregnant."

"No way I'm pregnant," Renée says, but her pretty eyes go wider, darker.

"You better find out," Melanie tells her, "because my book says that if a woman dreams of putting something in an oven, it means she is expressing a fear that she is pregnant or that she will become pregnant, or a desire to do so."

"Lord," Renée says. "I've got a tipped uterus, anyway."

"Well, I'd find out if I was you," Melanie says. "It might be your subconscious trying to tell you something." Then Melanie's just standing there drinking her Orange Julius when Bobby comes by in a white terry-cloth jogging suit and introduces himself. He asks about business in the mall and whether she likes it here, and whether she runs.

"Runs?" Melanie says.

"You know, jog," says Bobby. "I just got in a new shipment of ladies' running clothes today."

"Oh yes, yes I do," says Melanie, who doesn't but plans to now.

"Well, I'd better get back to business," Bobby says. "Nice to meet you, see you around."

That night Melanie tells Sean that she is not a bit interested in meeting his ex–history teacher. She goes to bed early and dreams that she and Bobby are on a vacation in a tropical wonderland someplace like Hawaii, that they go swimming in the warm blue ocean and then they take a walk through a grove of orange trees and Bobby reaches up and picks some oranges which they eat and then they go dancing and so many men keep cutting in that Bobby gets jealous and makes her leave, but then her alarm goes off before she gets to the good part. It's a big rush to get Sean some breakfast and put on her makeup and concentrate on this dream, plus they are out of coffee. Melanie skims the book, Sean gets picked up by some of his friends in a hearse. Basically, water means sex and oranges mean breasts, so it's pretty clear what is going to happen next.

Melanie wears her turquoise slacks and her turquoise and white sweater with the diamond pattern, just in case she sees him.

So she's late to work, but once she gets there it's very exciting because Renée runs in all happy and tells everybody that it's true, she *is* pregnant, she took the early pregnancy test last night, and that's not all either, her and Roy are engaged! Renée is glowing she's so happy, and Melanie is so happy for her.

But now it seems like everybody has a dream to tell her, suddenly she's famous in Linens 'n Things. In fact Mr. Rolette speaks real sharp to her about it, which oddly enough reminds Melanie of another dream she had last night, it just pops back into her head all of a sudden, a dream that Mr. Rolette's house, the two-story colonial on Cedar Street where Mr. and Mrs. Rolette host the Christmas party every year, suddenly disappeared while she and Grace were walking up the driveway to it, carrying a covered dish. When Melanie tells Mr. Rolette this dream, he gets very mad at her and almost shouts, "Melanie, I think you ought to do this on your own time, it's very disruptive." Mr. Rolette has been nervous lately.

On Wednesday, everybody knows why. Mr. Rolette isn't there, but he has called Mrs. Small and said he will not be coming in for a while due to psychological factors. Mrs. Rolette has left him. When he got home last night, he found the note. And Mrs. Small, after she gathers them all together and tells them this, stares hard at Melanie. "Now how did you know?" she asks, and everybody else looks at Melanie too like there's something wrong with her, except Grace who has the morning off. Melanie spends the morning worrying whether she ought to go with her instincts so much or not, and whether Bobby is ever going to ask her out or if she ought to just go ahead and bite the bull by the horns and go up to Bobby's Sport right now and give him the opportunity.

Then Grace comes in and tells Melanie she needs to talk to her privately, so they go to the ladies' and lock the door. Grace has circles under her eyes. She has not looked too good lately. She's had this dream, she says, over and over again, and Melanie says, "Then it's probably significant." Grace smokes a Merit cigarette while she tells it. In the dream, Grace and Gene are in their living room and Gene is sitting at his desk paying the bills—"You know how worried he gets over money," Grace says, and Melanie nods—but after a little while his pen runs out of ink and he gets mad and throws it down on the floor. Then Grace brings him another pen and it happens again, several times. Then she wakes up.

Melanie flips through her book, past Owl, Park, and Peach. She pauses before she reads Pen out loud to Grace.

"Well, what does it say?" Grace is impatient, trying to see over Melanie's shoulder, but the light is bad in the ladies'.

"'Pens are phallic symbols representing the male organ,'" Melanie reads. "'If a man dreams of having a pen that has run out of ink, he may be expressing fears of impotency or that he is sterile.'"

"Well, I didn't know it was a *dirty* dream!" Grace says.

Melanie laughs. "Oh Grace, it's not, it's all in your subconscious anyway, it says the same thing about guns and nails and pencils and cucumbers."

"*Cucumbers?*" Grace is furious. "I don't have to listen to this kind of dirty stuff," she says, leaving, pushing Melanie aside.

Melanie freshens her lipstick before coming out of the ladies', she can't see why Grace is so mad, Grace is her best friend, maybe Grace has got PMS. Melanie goes back over to the bath aisle where she's supposed to be pricing the merchandise, and finds a man there waiting for her.

"Mrs. Willis?" he says.

Melanie takes one look at him—at his longish thinning gray hair and his horn-rimmed glasses and his antique blue jeans and his tweed jacket with the patches on the elbow—and knows he's not there to pick out a shower curtain. She knows immediately who he is, Sean's ex–history teacher, Mr. Joyner. Mr. Joyner says he's been meaning to get in touch with her. He'd like to buy her a cup of coffee some time soon and talk over Sean's future. He says Sean really ought to go to college and there is plenty of scholarship aid available if you apply in time and the right way. Melanie gives him a big smile. So this is all about Sean basically, it would be great if Sean went on to college which she hasn't thought too much about, she somehow thought he'd go straight into rock and roll. "I think it's real nice of you to be so interested," she says, and then Mr. Joyner makes a move. He steps closer and says, "I am interested. I'm very interested," in a significant way, and then he says, "Let's make it dinner."

"Well, I don't know." Melanie backs into the towels. Mr. Joyner's dark quick eyes make her uncomfortable. It's like he can see straight into her mind. He's grinning at her, he has a nice wide-open grin, she likes that in a man. "I'll call you," he says. Then he's gone, off down the mall, he's wearing Hush Puppies. Hush Puppies! Melanie would rather die than go out with a sixties person, they never have any money, and they're so old.

She's so upset she decides to walk right on up to Bobby's Sport and tell Bobby she's interested in his new line of women's running outfits, so she does, she doesn't even tell anybody in Linens 'n Things where she's going, who cares, Grace is mad at her and Mr. Rolette is at home having a nervous breakdown.

Bobby's Sport is neat and clean. It even *smells* new, like paint. What Melanie needs is a new start in life and a new running suit like this pink velour one. "How much?" she asks the girl, meanwhile looking and looking for Bobby, who doesn't seem to be anyplace around. "Eighty-nine ninety-five," the girl says, "but it'll last forever, I run in mine every day." This girl is wearing a white tennis outfit now so you can see her small firm breasts and her tight butt and the muscles in her arms and legs, men don't like too many muscles. She's very young, with a plain, friendly face. "You'll need to try it on," she says. "You might take a Large in that one."

Well! Melanie starts to say, who has never taken a Large in anything yet, but here comes Bobby suddenly, all smiles.

"I see you girls are getting acquainted," he says. "Linda, this is Melanie Willis, who works in Linens 'n Things. Melanie, this is my fiancée, Linda Lewis."

"So pleased to meet you," Melanie says. Then she doesn't remember what she says next or how she gets out of that store, Bobby can just go to hell, suddenly she's out in the mall again and there's poor Mr. Slemp in front of Bobby's Sport looking so sad, looking the way she feels. She knows he's out there mourning Mrs. Slemp and thinking about all those years when Bobby's Sport was Pottery World.

"Why, Mr. Slemp, how are you?" Melanie makes a big effort, she feels so blue. Mr. Slemp looks terrible. He has egg stains on his white shirt.

"Well actually, Melanie, I'm pretty lonely," Mr. Slemp says, he sort of spits when he talks, in a very unattractive way, it's some kind of speech defect. "And I've been wondering if you'd care to come over and watch a movie on the VCR sometime."

Without one word Melanie turns and runs back to Linens 'n Things, past Orange Julius and The Potted Plant and The Christmas Shoppe and News and Notions and The Casual Male, suddenly she can't even breathe anymore, too much is happening too fast.

Linens 'n Things is very disorganized with Mr. Rolette gone, Melanie sees this right away. Deborah Green is reading a book, and Renée and LaWanda are giggling. Grace rushes up to Melanie and says, "Oh, Melanie, I'm so sorry I got mad at you, you're my best friend. Please forgive me. It wasn't even you I was mad at, I was just upset."

Melanie tries hard to forget about Bobby and Mr. Slemp and concentrate on Grace, who looks like she's still upset. "That's okay, honey," she says.

Grace pauses and looks all around and then steps closer. "It's Gene," she says. "Gene is impotent, Melanie, he hasn't been able to do it for over a year."

"Well that's *awful*, Grace," Melanie says. "Has he been to a doctor?"

"He won't go," Grace says. "He won't talk about it either, not even to me. He walks right out of the room."

"Then I think *you* ought to go to a doctor," Melanie says, but Grace says he won't let her. She says Gene keeps the checkbook and there's no way she can go without him finding out. Grace's pale blue eyes look absolutely desperate.

"I'll loan you the money," Melanie says. "You can pay the doctor cash."

"Well, I don't know," Grace says. "I feel so *sorry* for him, Melanie. You know we went to the junior-senior together, we grew up practically next door, I don't know if I could go behind his back or not."

"Just think about it honey." Melanie hugs her. "Let me help you any way I can." She can feel Grace's shoulder bones sticking out.

Then Grace straightens up and smooths out her skirt. "I feel a lot better since I told you about it," she says, but Melanie doesn't.

In fact she feels worse and worse as the afternoon goes by, and her customers say it's raining. So when things slack off she goes to stand by the door, feeling trembly and blue. When LaWanda comes out to ask her what it means if you dream you're flying, Melanie snaps at her, "I don't know," and LaWanda gives her a funny look and goes back inside. Melanie wonders what she would even wear if she did decide to go out with Mr. Joyner, not that she would. Jeans? She'd have to buy some. The rain drums down on the skylight. *As soon as he walks past Orange Julius she sees him, wearing a blue windbreaker and nice khaki pants and loafers, he looks sports-minded but not too sports-minded, he has that rugged all-American quality she loves in a man, a square jaw, a strong nose, his hands are not too small either. He notices her right away and comes toward her, his eyes never leave her eyes, he's smiling. "I'm relocating to this area from California," he says. "I've just bought one of those new townhouses out on Old Mill Road, it's furnished, but I need to buy everything else for it. Everything." "Come right this way, sir," says Melanie. "I've got exactly what you need."*

Fran Bitett Beck *from the series* Relationships

Robby and Zaggy, Miami Shores, Florida, 1994

Neta and Gigi, Lake Placid, Florida, 1993

Leisa's parrot, Pembroke Pines, Florida, 1993

David and Snuggles, Pembroke Pines, Florida, 1992

James and his lizards, North Miami Beach, Florida, 1995

Kevin and friend, North Miami Beach, Florida, 1995

Melissa and Indy, Cooper City, Florida, 1995

Paul, Sen-Toi, and Pi-Chzug, Hollywood, Florida, 1994

Merrill and Walter, North Miami Beach, Florida, 1994

John, his cat, and his dog, North Miami, Florida, 1993

Tobrah

Bobbie Ann Mason

Jackie Holmes had taken two trips by airplane. The first one, in 1980, from Kentucky to California, included dinner—a choice between short ribs and cannelloni. Jackie ordered cannelloni because she didn't know what it was. It seemed so unreal to be up there above the clouds—where as a child she had imagined God lived. In Los Angeles, her cousin took her to Disneyland, the stars' homes, and Universal Studios. They drove down Sunset Boulevard, where the palm trees were tall and majestic. Jackie felt privileged, as if all her life, until then, she had been deprived of anything grand.

The second trip, to Oklahoma, not long ago, was different. In Tulsa Jackie arranged her father's funeral. She hadn't heard from him in more than thirty-five years, since her parents divorced and he left for the West. She hardly recognized the man lying in the casket. Her father's eyes had been his most memorable feature—dark and deep-set, like her own. But his eyes were shut, impervious to her questions. The mourners, men he had worked with at a meat-packing plant, didn't tell her much. He had been drinking, and his pickup slid down an embankment. No one seemed surprised. He left no money or possessions of worth. She brought home a tattered army blanket she remembered from her childhood and had not thought of since.

But there was something else. Her father had left a child. The little girl was being cared for by a neighbor, a woman with three children of her own. She told Jackie that the child's mother had died the year before and that he had been despondent. He left a will naming Jackie as godparent. Miraculously, after some red tape in a rose-brick court building, Jackie left Oklahoma with the child.

Jackie was forty-four and her half-sister was almost five. Jackie, long accustomed to the disappointment of having no children of her own, realized that children scared her a little. She felt like a kidnapper.

Tobrah, the child, was not taken to the funeral, and she didn't seem curious about where her father was. On the airplane, escaping Jackie's questions, she zipped up and down the aisle, talking to passengers. Jackie wasn't used to a child's random energy—the way she squirmed and bounced in the seat, her hands and body busy but her manner oblivious. In the dark apartment that Jackie had cleaned out, she found only a few possessions of Tobrah's—some small toys, a doll and a teddy bear, several T-shirts, and pairs of shorts.

"Aren't you cold?" Jackie asked, as she reached up to swivel the air stream away.

"No."

"When we get home I'll buy you some jeans," Jackie said. "And a sweatshirt. What's your favorite color?"

"Green."

"Green? Mine's blue."

"I don't like blue."

When Tobrah dropped off to sleep, Jackie located a blanket in the overhead compartment and draped it over the little girl. The army blanket was in a bag Jackie had purchased to bring back Tobrah's things. The airline blanket was bright blue and made of some kind of foamy synthetic material. Outside, the clouds billowed like a bubble bath.

"How are you going to afford to bring up a kid?" Jackie's mother asked when Jackie brought Tobrah to meet her. Tobrah was on the back porch playing with the mop-like lap dog Lorraine kept in her small wood-frame house in an old section of town.

Jackie ignored the question. Her mother said that about anything—a new car, an appliance, even splurging on a night out. She had a Depression mentality.

"Do you reckon that hair's bleached?" Lorraine asked.

"We'll just have to wait and see," Jackie said impatiently.

Tobrah had a dark complexion, and her hair was a short, tight mass of light curls, darker at the roots. Her eyes were topaz, and her new green T-shirt made flecks of green sparkle in them.

"That name sounds foreign," said Lorraine.

She kept tapping her cigarette in a crowded ashtray. Her gray laminated table had cigarette burns on it. The walls were yellowed from gas-furnace fumes.

Jackie's mother had let her place go since she retired from work. She had been a floorlady for thirty years, and now all she wanted to do was sit. She got on Jackie's nerves.

Tobrah crashed through the door, the dog yapping excitedly at her heels. She demanded a drink of water, and as she gulped from the glass Jackie gave her, she continued to play with the dog—nudging and poking, twisting her body at the dog.

"Honey, tell me something," said Lorraine, hugging Tobrah. "Where did you get that name of yours? Did your mama give it to you?"

"From a story," she said, holding the glass up for Jackie to take.

"Does it mean something?"

Tobrah wriggled out of Lorraine's grasp and grabbed a ragged piece of chewed rawhide that belonged to the dog.

"Do you want us to call you Toby?" Lorraine asked.

"No." Tobrah pulled at her hair. She scooped up the dog and went out the back door again.

"Well!" said Lorraine, with a sigh of smoke. "What do you make of that?"

"She won't talk about her mother—or about Daddy either," Jackie said. "I already tried."

Tobrah had told Jackie she didn't remember her mother. She said her father was away on a long trip. He might not be back, she said.

It was true that Jackie couldn't afford much for a child, but it seemed to her that nowadays children had too much. Her California cousin's children had a room full of expensive stuffed animals that they never played with. Jackie's house was a modest brick ranch dating from her second marriage. She cleared out her sewing room for Tobrah. Jackie's uncle and aunt let her have an old twin bed they weren't using, and from yard sales she found toys and furnishings. She collected hand-me-down clothing from friends. Baby talk didn't come naturally to Jackie, and she stood around awkwardly at store counters and in checkout lines while people burbled enthusiastically to the little girl, as though she were a pet on a leash. They actually said she looked good enough to eat. Being seen with Tobrah, Jackie began to feel an unfamiliar pride. People asked the typical questions: "Whose little girl are you?" and "How old are you?" and "What grade are you in?" Jackie, who was guilty of asking kids the same kinds of questions, had never before realized how trite they were. Yet they were real and important questions. Whose little girl are you? she wanted to know. Where did you get that hair?

Sometimes in the night, Jackie heard Tobrah stirring and thought of prowlers, then remembered. One night she awoke to find Tobrah curled close to her. She felt that the child had waited until Jackie had gone to sleep before crawling in with her, as if she didn't want her to know her need. Jackie had so many questions. What did Tobrah's mother look like? Did her father love her? Did he buy her Christmas presents, play dolls with her? When Jackie was small, about Tobrah's age, her father came home once after a weekend trip to Tennessee. She had waited eagerly all day, and when she was exhausted with the excitement of waiting, he finally appeared. He had forgotten to bring her a present. He had promised to bring her a souvenir with the name "Tennessee" written on it. When only a year or two later he left for good, she was glad. Her mother encouraged her to forget him.

Jackie pieced together a few facts about Tobrah. She couldn't read. She had never been to preschool but had been to some kind of day-care facility, a large place where hundreds of children lined up for ice cream bars in the afternoons. They napped on mats. The woman in charge had "fuzzy hair, big glass eyes, and a fat butt," according to Tobrah.

"Do you miss going there?" Jackie asked one morning a few days after her return from Oklahoma. Jackie was returning to work after her bereavement leave. Bereavement was a joke, she kept thinking.

Tobrah kicked her feet against the kitchen chair rungs. She was eating cereal straight from the box. "It smelled like bad soap."

"I have a surprise," Jackie said. "I have a place for you to go while I'm at work. It'll be nicer than that place in Oklahoma."

"I don't want to go."

"Yes, you do. It'll be fun."

"They won't say my name right."

"Well, people around here have a different accent than Oklahoma. They don't always pronounce things right. You'll have to be patient."

Tobrah disappeared into her room, and when Jackie went to get her she found that the child had made up her own bed like a polite guest and placed her doll and bear on the pillow. The bedspread was crooked and the sheet trailed to the floor.

"Don't you move till I get back," she said to the toys.

When Jackie left Tobrah at Kid World, she wondered what a mother would feel, letting go of her child like this for the first time. During the day, she thought about Tobrah's parting glance. She seemed eager, not afraid or shy, as if she were used to being dumped somewhere strange. At the end of the day, Mrs. Burn, the day-care director, told Jackie that Tobrah had a high energy level and tended to

be bossy. "Her cooperative-play attributes need attention," the woman said. At a table alone, Tobrah was engrossed in coloring a xeroxed pig red. Her jeans and T-shirt were dirty and her hair was tangled.

When they arrived at the house, Tobrah ran straight to her room. Jackie could hear her from the kitchen, where she was unloading the groceries. Tobrah was talking to the toys. "I told you to stay right there! But you've been up dancing. I said you couldn't dance. But all you want to do is dance!"

In the doorway, Jackie watched Tobrah dash the doll and the bear around, banging them together until the doll's hat fell off. After she had whipped their behinds and threatened them with no supper, she placed them back on the pillow and gave them new orders.

"No dancing. No walking around!"

Jackie had been married twice, once in her twenties and once in her thirties. The husbands were a blur. The first, Carl, was generous but immature. He saw them as a "fun couple." Her second husband, Jerry, was quiet and sweet, but he hid too much—an attachment to his mother, his secret drawer, even lapses of memory. He frightened her when he began locking himself in the bathroom for hours. She still saw him around town, and they spoke cordially, much the way they had done when they lived together. For the past several years now, she had been going with Bob Fields. They had an understanding. They knew their relationship was wrong from the point of view of the church, which they attended together, but they both decided that the legality of marriage was really just a piece of paper. They had worked that out in their minds, and it left them free to love each other, Jackie thought. She wanted to keep up with the times, within reason.

"I can't spend the weekend at your apartment," she told Bob on the telephone a couple of weeks after Tobrah's arrival. Jackie said, "You'll have to come here. I can't drag her around everywhere. I want her to know where she lives."

"Are you sure you want me there? I might just confuse her."

"No. I want you here. I need you."

Bob still wore the same size jeans he wore in high school and even had an old pair of Sunday pants to prove it. He golfed and didn't drink. He was divorced and had two grown daughters, one in the Air Force and the other in Louisville, pregnant. He seemed to find becoming a grandfather a spooky idea, and Jackie had been nervous about how he would adjust to her new situation. As they spoke on the phone now, she gazed at the window decal of a brightly colored unicorn she had put there for Tobrah. Nowadays Jackie seemed to dwell on things she hadn't noticed before—small things at a child's eye level, like the napkin holder

and the cabinet-door handles. She tried to tell Bob about this feeling. She said, "It makes me think about Jack Frost. Remember those beautiful designs in the windows? Is that something only kids see? I used to see them at my grandmother's."

"Jack Frost doesn't come around anymore."

"How come? Pollution?"

"No. Double-glazed windows and central heating. You saw Jack Frost in old, uninsulated houses with a single layer of glass. The frost was moisture condensed on the inside."

"I'm amazed. Is that supposed to be progress?"

She always counted on Bob to know things.

When he came over on Friday, he was anxious, fuming over something that had happened on the job. He said, "I waited at the loading platform for an hour and a half for this bozo to show up and then come to find out he's with his girlfriend at the mall picking out a china pattern. He forgot to bring that shipment over."

"I imagine he had more important things on his mind than a load of cement," said Jackie, taking his cap from his hand. He always took it off indoors, a fact she found interesting and unusual. Most men she knew wore their caps with almost fanatic devotion, indoors and out.

"You can't count on young people these days," said Bob as he searched for a Band-Aid in Jackie's medicine cabinet. He had a paper cut from junk mail.

"Young people? Why, you're not so old! I hope when I'm fifty I don't feel like my life is over."

After supper, when Jackie was washing the dishes, Tobrah suddenly started flattening pillows on the couch with a spatula.

"Beat 'em good, hon," said Jackie. "They need it."

"I'm going out to the drugstore to get some antihistamines," Bob said, looking for his cap. "Does anybody want to come?"

"Are you allergic to something here?" asked Jackie.

"No. My nose has been itching all day."

"If your nose itches it means somebody's coming with a hole in his britches," Jackie said teasingly.

"I've got a hole in my britches," said Tobrah, giggling.

Bob pulled on his cap. "Are y'all coming?"

Jackie said, "No, we've got work to do." She found a second spatula in the kitchen and started whacking the drapes. "The hard part is the places up high," she said to Tobrah.

"Aren't you supposed to beat rugs outside?" Bob asked as he went out the door. They were hitting the couch, the chairs, the shag rug. On their hands and knees they smacked the rug, sending up fibers and dust.

Jackie sneezed and Tobrah said, "This is fun!" Jackie felt one of those rushing sensations of blissful abandon that she thought only a child could feel. She remembered feeling this way once when she was small—the meaningless happiness of jumping up and down on a bed, bouncing off the walls, chanting, "Little Bo Peep is fast asleep."

Tobrah had a way of moving jerkily as if she were imitating some old comedian, mocking a private memory. She skipped ahead down the strawberry rows, then stooped to pluck a bright berry.

"Gotcha!" she cried. She had picked up the expression at Kid World and had been applying it to everything.

Jackie's friend Annabelle had brought her and Tobrah to a friend's place in the country to pick strawberries. It was the last of the crop and the patch was drying out. Tobrah had been collecting all sorts of berries—green ones, deformed ones, rotten ones, as well as ripe ones. Jackie felt warm and peaceful. Tobrah's tan skin glowed bright in the hot morning sun, and now and then she tugged at a handful of hair, stretching the curls.

"Don't pick the green ones," Jackie said but Tobrah didn't hear. Jackie said to Annabelle, "I'm not sure when to correct her or when to just let her go."

"Wait till she starts school," Annabelle said sympathetically. "You won't be able to keep up with her."

"She's always busy with something," said Jackie. "She's got a great attention span."

"She must not have seen much TV," said Annabelle.

"I don't know. She won't tell much."

"She's repressing her grief." Annabelle worked in the typing pool at the social services agency and liked to talk knowledgeably about the cases she had typed up.

"What does a little child know about grief?" Jackie asked. She threw a rotten berry across a couple of rows.

Annabelle shook her head skeptically. "You can take a child that's been through a trauma and give it all the love in the world and it might take years for the child to start to trust you."

"That's ridiculous!"

Instantly, Jackie regretted her tone. Annabelle's son was in a chemical-dependency program, and Jackie knew Annabelle felt herself to blame. But Jackie felt as though some kind of safety valve had broken in her. She was be-

coming impatient with adult ideas. All she wanted to do was play with Tobrah. They had been reading—stacks and stacks of storybooks from the library. Tobrah was rapidly learning to recognize words. They watched videotapes together. They made paper villages and building-block malls, with paper dolls as shoppers. They were collecting stuffed animals, yard-sale bargains. Yesterday they had a tea party. Tobrah had wrapped a ball of yarn around the table and chairs, making a large green spider web. Jackie had to cut it apart, and the yarn—five dollars' worth—was ruined. When Jackie was a child, she would have been punished for wasting yarn, but she couldn't even scold Tobrah. Jackie was too much amazed that anyone would have thought of draping yarn in that fashion. It was a creation.

Now Tobrah was coming toward her, where Jackie was working her hands through strawberry plants. A spider jumped away from her hand. She looked up. Tobrah, clutching several red berries, had red stains on her mouth. Her hair was bright in the loud sun.

"I want to go," she whined. "I'm hot."

"I'm ready," Annabelle said. "My handy's full."

After they took their handies of strawberries to the owner's house to pay, they poured the berries into large metal pots and plastic dishpans they had brought. Carefully, Jackie set the pans of berries in the back seat of the car, next to Tobrah. Jackie fastened the seat belt for her. As she clasped the buckle and pulled the belt tight, Tobrah's fingernail accidentally scratched against Jackie's wrist, drawing blood. It had never occurred to Jackie that a child's fingernails would need to be trimmed. She stared at the little nails, transparent as fish scales.

"Does she remind you of when I was little?" Jackie asked her mother.

"You weren't that sure of yourself."

"Do you think I looked like her?"

"I can't see you in her. Maybe I don't want to. All I see is him."

Lorraine paused from glazing a cake to light a cigarette. She tapped it on the counter the way Jackie remembered her father doing his unfiltered cigarettes. Lucky Strikes. LSMFT, she recalled, from out of nowhere. Lorraine, in a voice hoarse from smoking, said, "Believe me, she's better off without her daddy."

"Why are you still so bitter?"

"I reckon I want to be. It's my privilege."

Jackie ducked her mother's smoke stream. "Did you hate Daddy?"

"I guess I did, finally. I made him go. I couldn't stand it anymore. He was always complaining, never enjoying anything." Lorraine shuddered. "That was the

worst part. He was such a sourpuss. He thought he was better than anybody else. He was always growling about the way the world was going to hell. You can't put up with people like that."

Jackie stood over the sleeping child, searching for resemblances between herself and Tobrah. She could see a faint repetition of her own upper lip, the narrow forehead, a certain dark shadow under her eyes. Jackie had heard that computers could create new faces by combining photographs. It amused her to imagine President Bush crossed with Joan Collins; Sylvester Stallone and Barbra Streisand. Sensations from her own childhood floated forth: the taste of grapes from the trellis in the backyard, the sour green taste of the pulp in contrast to the sweet purple lining of the skin; the sandy texture of a pink marshmallow bunny squatting in Easter grass; the distasteful odor of Sloppy Joes in the first-grade lunchroom.

Bob was supposed to come over, but he was late and Tobrah had fallen asleep. He had taken his mother to town. It was social-security-check day. His mother didn't drive, and since his father's death, Bob had to run errands for her and take her places. His mother kept asking them what his arrangement with Jackie was called. She said she couldn't keep track of the new alternatives to marriage. When Bob and Jackie and Tobrah showed up at church together one Sunday, Bob's mother was embarrassed and confused, and the congregation itself seemed shaken. Jackie hadn't been back to church with Tobrah since then.

Bob came in at ten minutes after nine, bringing ice cream for Tobrah—pistachio, because of the color.

"She's already asleep," said Jackie. "She ate a hot dog but I haven't eaten yet. I waited for you—but the pot roast is drying out."

"I like it dried out," he said with a grin. "Like jerky."

"Oh, you're just saying that."

"No, it's true!"

"You know what Tobrah said? She said bananas smell like fingernail polish." Jackie thrust a banana under his nose and he sniffed it. "Isn't that funny?"

"She's right," said Bob, sniffing the banana again.

He set the ice cream in the freezer and took a fingerful of whipped cream from a bowl on the counter. Jackie was making a sinful dessert.

"I think childhood has changed," Jackie said. "The way I remember it, any kid who said that about bananas would just be laughed at, but nowadays they call that 'creative.'"

"True," Bob said. "What I remember is how everything you thought about depended on what you could afford. Nowadays kids have everything so their minds just run wild."

"Yeah. The sky's the limit." Jackie slapped down place mats. "I don't understand it," she said. "I don't understand where it all leads."

After supper, they watched TV in her bedroom. Jackie was afraid Tobrah would catch them in bed. Tonight they watched a videotape of *The Big Easy* that Jackie had rented that afternoon. The movie had a remarkably sexy scene in it, but neither of them stirred. It was after midnight when the movie ended, and they still had their clothes on.

"I'll be back in a minute," said Jackie, starting to get out of bed. "I'm going to check on Tobrah."

Bob caught her arm. "You check on babies—not five-year-old girls."

"I want to see if that fan is too much air for her." She flinched. "Do you think I'm being too protective?"

"I'm afraid you'll let yourself get too attached to her." He reached his arm around her tenderly. "Kids are a mess," he said. "They always know how to hurt you." He shooed a curl away from her forehead.

"But Dad gave her to me. Maybe that was his way of making up to me after all these years." She sat up straight against the backrest. "The bastard," she said. "He left me when I wasn't much older than Tobrah. And now he ups and leaves her too. Well, we'll show *him!*"

"You're going a little overboard, Jackie."

"Bull noodles! What has my life amounted to? No kids. Two lousy marriages —I'm sure it was his fault, ruining things right at the start."

"You're too hard on yourself, Jackie," Bob said. "Maybe you shouldn't be the one to bring her up."

She opened her paperback and started reading. Words raced before her eyes. She was conscious of the book, wondering if it was upside down. She saw herself sitting there, not concentrating, not grasping what was in the book or what was going on with Bob. Tobrah and Bob and Jackie, an oddball little family. Jackie pictured them in a movie—the wacky mom, the long-suffering dad, the precocious child. Or, the desperate mom, the sad-sack dad, the devil child.

Jackie usually slept late on weekends, and one Saturday she woke up to find that Tobrah had eaten most of a jar of peanut butter. Jackie didn't know what prevented the child from walking out the door, running away. Sometimes the little girl seemed filled with secret knowledge—probably only stuff learned from TV,

Jackie thought—and at other times she seemed to have just come out of a hole. Her favorite books were *The Hungry Princess* and *The Foolish Cat*, which Jackie thought were for younger children, but she wasn't sure anymore what was appropriate. At the grocery one day Tobrah had wanted to buy cat food and stationery and Jackie had had to stop and try to think why they couldn't buy them. Jackie started liking pizzas and tacos, kid food. One evening they even had fluffer-nutters and Cokes for supper. That was Tobrah's worst day at Kid World. Melissa McKay had brought her My Little Pony and wouldn't let anyone comb its tail. Several of the children had broken into tears over the toy.

That evening, Tobrah soberly colored in her coloring book, working with fierce concentration. The crayons lay scattered on the kitchen table. As she shifted position, a burnt-sienna crayon rolled over the edge of the table. Jackie caught it. Tobrah was coloring a ballerina surrounded by clowns. When Jackie asked, Tobrah explained, "This lady is telling the clowns about her comb she lost, and they said the man who found the comb would be a prince. If she could find him and he had the comb she would be a princess."

"That sounds like Cinderella."

Tobrah shook her head vigorously. "This lady don't have no mean sisters. Nobody makes her work."

"But Cinderella wanted to work," said Jackie. "Cinderella decided not to marry the prince. She decided to go to medical school and be a doctor."

"No, she didn't! You always tell it that way. You don't tell it right."

"Everybody has to work," Jackie said, rolling a green crayon between her fingers. "My mother worked at the same plant where I work. She had to be on her feet eight hours a day. And she didn't have a prince. It was just her and me."

"Can we have a gerbil?"

They had seen gerbils in the pet section at Wal-Mart the day before.

"We can't have pets here. It's not allowed in a house this small."

Jackie felt guilty about the lie, but she couldn't imagine cleaning up after an animal. She remembered the summers her mother went to work and left her alone all day, when she was still too young to be left alone. She watched TV and listened to records and played solitaire. She hadn't minded. She liked it. Nobody bothered her. Tobrah never seemed lonely either. It pleased Jackie to recognize this kinship with her sister. She remembered playing by herself, working on long, absorbing projects. Her paper dolls lived in shoe-box houses on a cardboard street, with house plants for trees. She had created a whole town once, with streets made of neckties and stores full of tiny objects (thimbles, buttons, and candy). The names came drifting back to her. Mulberry Street, Primrose Street. The town was named

Wellsville, because nobody ever got sick there. Jackie had had pneumonia the winter she built Wellsville.

"Jackie, jack-in-the-box, Jackie-O," said Tobrah now.

"How do you know jack-in-the box?" asked Jackie. "And what do you mean by Jackie-O?"

"Jackie Jackie Jackie," Tobrah chanted, shifting her attention to some cassette tapes Jackie had been organizing into a shoe box. Tobrah's green sweatshirt featured new snags and smears of chocolate syrup.

A month after Tobrah's arrival, Jackie realized she might be pregnant. The notion seemed absurd, too ridiculously coincidental for a five-year-old to enter her life, followed by a baby. But Jackie was thrilled, eager to believe it. She felt stirred up. Silent with her secret, Jackie shopped with friends, went walking with women in the subdivision in the mornings for exercise. She woke up early, waiting for that stir of nausea that was supposed to come, but she felt only anticipation. She felt as if her blood had been carbonated.

By the time of her doctor's appointment, Jackie calculated that she could be six weeks pregnant. She took an early-morning urine specimen with her—in a jelly jar, enclosed politely in a paper sack. She had read in a women's magazine that she should do this. The same magazine said that having a baby late in life was a healthy way of rejuvenating the system.

"I appreciate that," the doctor said briskly as he set the sack aside. "But we don't do those anymore. We do blood tests instead. They're more accurate."

It bothered Jackie that scientific knowledge seemed to change like fashion trends. You can never trust the times you live in, she thought.

As he explored her arm, trying to find a vein, the doctor said, "It would be highly unusual at your age—if you've never been pregnant before. Still, healthy babies have been born to women your age." By his tone, Jackie thought he may as well have said, "People your age have been said to fly, but I've personally never seen it."

The tube attached to the needle was enormous. Her blood was dark, almost black. As she felt the blood rush into the tube, a wave of nausea hit her and she saw the room go dim. She tried to lie still and think of something peaceful. Her stomach knotted.

"We'll dispose of that urine sample for you," the nurse said.

After work, she picked up Tobrah at day care. Tobrah had been getting premium stars almost every day. "She's just original, not screwed up," Jackie had in-

formed Annabelle. Tobrah was sitting at a table, her head bent over a finger painting. Splotches of blue paint streaked her face.

Swabbing at the paint on Tobrah's cheek, Jackie said, "Hey, that's not your color. Your color is green."

On the way home they stopped at the videotape store. Jackie held Tobrah's hand as they crossed the shopping-center parking lot. At the curb, Tobrah burst free, and inside the store she stared at a woman on crutches.

"Don't stare," Jackie said quietly.

Tobrah whispered, "I think she fell out of an airplane."

"Where did you get such an idea?"

Tobrah was already looking at videotape boxes on display.

"Let's see *The Love Bug*," Jackie suggested.

Tobrah made a "yuck" face. "I want to see *E.T.*"

"But we've seen that twice. Don't you want to see something else?"

To avoid a scene, Jackie abruptly checked out *E.T.* She didn't want anything to spoil the evening. She felt almost romantic about it. Once or twice she felt fleeting, squirming sensations inside her abdomen. She didn't want Bob to know. It was too private.

During the movie, Jackie kept her eyes on Tobrah's activities—beating her heels against the couch, coloring pictures, dressing her doll, searching under the couch cushions for lost doll jewelry. The little girl seemed self-possessed, as if each small action had a meaning and intent. Jackie knew Tobrah was haphazardly testing out the world, but she wondered if the little girl was actually being brave, in face of the knowledge that she was an orphan. As Tobrah mouthed some of the dialogue along with the movie, Jackie washed the popcorn bowls and put away the popper. She found a half-popped kernel in her shirt pocket.

At the end of the movie, Jackie grabbed Tobrah, squeezing her in an urgent hug.

"Who do you love?" she asked, but Tobrah squirmed and pushed her away.

A Tinker Toy wheel skittered across the kitchen floor, making tap-shoe sounds.

The next afternoon, during her break, Jackie called the clinic from the pay phone at work for the results of the test.

The doctor said, "The test shows you're not pregnant, and we could run some hormonal studies." He paused, then said, "But my guess is that you're going through normal mid-life changes."

Jackie saw a supervisor pass by with a cup of coffee. The coffee sloshed on the floor and he didn't notice. The man didn't even realize he had spilled it on his pants.

When she hung up, she slammed the telephone receiver so hard it jumped off the hook. The sudden dial tone was like a siren.

Jackie and Tobrah walked the full length of the mall, stopping at every store that interested Tobrah. She was easily entertained by the spectacle, but Jackie, in a daze, hardly noticed what was before her. Tobrah ate pizza, drank an Orange Julius, got a bag of Gummi Bears. They tried on sneakers, looked unsuccessfully for a My Little Pony purse, cruised through a store of kitchen paraphernalia, caressed piles of summer cotton sweaters and T-shirts, hit every toy section.

"I had a good time," Tobrah said in the car on the way home. She might have been a little visitor, politely thanking the lady of the house.

"Where did you learn to say that?" Jackie couldn't imagine her father as a model of good manners.

Tobrah didn't answer. She played with a cassette tape, opening and closing the plastic box. She opened the glove compartment and shut it. It was growing dark, and the Friday night traffic swirled around them. Ahead, a car made a left turn in front of an oncoming car. The night was alive, full of lights and speed, and Tobrah was straining against her shoulder harness, moving in the seat restlessly, as if she had to see everything.

At the house, the telephone was ringing. It was Bob, wanting to know where they had been. He was excited. "Let's all go to the Bigfoot competition over in Sikeston tomorrow. We can take the camper and spend the night."

"We were at the mall after work and we're tired."

"We'll go tomorrow. I'll bring a cooler and we'll get some barbecue."

"I'm afraid if I bring Tobrah, you'll get stressed out."

"Don't be silly! Tobrah and me are buddies."

"Those monster trucks might scare her."

"Kids love that stuff. Hey, Jackie, you're making excuses. You need to get ahold of yourself."

"Everybody seems to know what I need."

"Let me come and get you and Tobrah. We'll start out early and make a day of it. I'll pick you up at eight o'clock."

"I don't really want to go."

"Did I do something wrong?"

"No. I can't explain. I'm just tired." Jackie realized that even if she had been pregnant she wouldn't have told Bob. Did all women feel this, that they had to shut everyone else out when it came to their love for a child?

With Bob still insisting he was coming over early, Jackie said good-bye, then noticed the mail she had brought in. There was a letter from someone named Carnahan in Arkansas. She didn't know anyone in Arkansas.

Dear Miss Holmes,

My sister was Becky Songs Holmes, Tobrah's mother. My sister was deceased on August 8, 1987 (cancer). I understand you have custody due to terms in Ed Holmeses' will. In the interest of the child, I am applying to be her legal guardian. I can give Toborah the home she deserves. My husband and I have three children—ages eight, ten and twelve, and Tobrah would be the youngest. I'm sure they would be happy to have a new little sister. We have met Tobrah before, when my dear sister passed away, and we did not want to take the little child from her daddy. He seemed to need her so much after losing his wife. We have only just now heard about her daddy's unfortunate fat and heard how Tobrah was taken to Kentucky.

Fat? Then Jackie realized the letter was written on one of those word processors and that "fat" was just a mistake. Toborah? She continued reading details of the arrangements to have Tobrah brought to Arkansas, and what they had to offer: her own room, a dog, a brother and sisters. Mr. Carnahan was a textile worker, and his wife, Linda, who wrote the letter, worked for the telephone company. The letter was so pretty. Jackie was overwhelmed by its authority. But the one little mistake blew it. Jackie wadded it and tossed it into the wastebasket. She ran water into a plastic watering jug and watered the plants. She cleaned up the sink and loaded the dishwasher. With a paper towel she wiped up a spot of cranberry-juice drink from the floor. Then she heard Tobrah in the bathtub, splashing and singing loudly, playing with some rubber toys.

"Stand up," Tobrah was saying. "Your hands against the wall."

Jackie hurried down the hall to check on her. She didn't know at what age a child could take a bath alone. She had been so unprepared. Tobrah was like a dream, just a desire for a child—a desperate last wish that had come to Jackie late in life. She had to catch up somehow, read some textbooks, do it right.

Jackie was up before sunrise, packing a small bag. She hurried Tobrah out of bed, through a bowl of cereal, into the car. Jackie drove toward the lake, forty miles east. After it grew light, they stopped at a mini-market. Jackie had coffee

and a muffin and Tobrah had a doughnut and milk. By eight o'clock, when Bob would be pulling up at her house, they had reached the lake. It was a place Jackie had visited many times years ago, between husbands. When she used to go there, she gazed at the lake and it would seem peaceful and vacant, without variety and possibility. It soothed her because it made no demands on her. But now it seemed charged with life, confusing and complicated. A coal-filled barge headed toward the locks. A flock of birds flew over noisily, like a cheering section. Pleasure boats were already shooting through the water.

At the nature center they got a brochure with maps of the nature trails. Jackie guided Tobrah down a short trail called the Waterfowl Loop. They saw geese gathered at the shore. As they approached, the geese trundled into the water like pull toys.

Tobrah said, "A mother goose takes off flying backwards to teach its baby goose not to fall. If you fly backwards, you can't never fall."

She flapped her arms and ran backwards.

"Watch where you're going, honey," said Jackie, reaching out to catch her.

Three deer enclosed in a pen moved shyly away from the fence as Tobrah staggered past and whirled to a stop. She stared at the deer. Later, outside the nature center, Jackie and Tobrah observed a small owl tethered to a post. The owl swiveled his neck, his eyes following them curiously, like anxious moons. Jackie imagined that he was amazed by the sight of Tobrah. The park guide stared at her too. People would think the child was hers, Jackie thought. They might think that she had been with some strange man and created this child. She wished it were true.

The park guide said, "At night we take the owl inside so a great horned owl won't swoop down and catch him."

"What's his name?" Jackie said.

"We don't give the wildlife names here because we don't want to encourage keeping wild animals as pets."

Inside the nature center, they saw stuffed animals. The park guide said, "All the animals you see here were road kills. That bobcat was a road kill from last summer. He weighed twenty-two pounds, I'd say."

"I want a kitty like that," said Tobrah.

"My mother's cat is part wildcat," a fat woman said to the ranger. "He's got those whiskers and big cheeks." She puffed out her own cheeks, becoming the cat for an instant.

"I don't believe a bobcat would ever mate with a housecat," said the park ranger.

"Well, you might change your mind if you saw my mother's cat," said the woman indignantly.

Jackie smiled and squeezed Tobrah's hand. Tobrah jerked away. Her body was rigid, vibrating, as though she were on the verge of convulsions.

"What do you want, Tobrah?" Jackie asked, squatting down to look into the child's face.

"Kitty," Tobrah said, in a voice as close to despair as Jackie had ever heard from a child. Tears rolled down Tobrah's cheeks.

Jackie held her close and tried to soothe her. In a few minutes, Tobrah was over the outburst, and by the time they reached the car she seemed to have forgotten about the cat. It was just something Tobrah thought she wanted, but she could live without it, Jackie told herself. A child's whim. Who wasn't a child? she wondered. Adulthood was just a role people played. They forgot that they were just pretending. It was all bluff and fluff. A man at work used to say his long-haired orange tomcat was "all bluff and fluff." He would say it a couple of times a week, as if trying to convince everyone of his own superiority over his cat, a pathetic thing for someone to have to do.

She had parked the car in the shade, and some gummy pollen from the tree had dotted the windshield. She wiped at it with a Kleenex. Tobrah was singing to herself, echoing the bird song coming from the woods. A pickup angled into a nearby parking spot.

When her father wrecked his pickup he was probably driving recklessly, childishly, Jackie thought. He took her to the carnival once, she remembered, and she rode the bumper cars. She remembered that he thrust a cloud of cotton candy into her hand and left her at the bumper cars with a string of tickets while he flirted with a woman at the merry-go-round ticket booth. For an hour Jackie rode, bumping and steering with devilish glee, happy with her freedom. Her father disappeared from sight. Her steering wheel was sticky from the cotton candy. When he came back for her, all he said was, "I'll bet you qualify for a driver's license by now, Little Bean." She had forgotten the nickname until now, and she didn't know where it came from.

Tobrah got in the car, crushing a paper cup in the seat. Without being told, she fastened her seat belt, fumbling for only a moment.

"I'm ready," she said.

Mark Steinmetz *from the series* At the Edge of the City

Knoxville, Tennessee, 1992

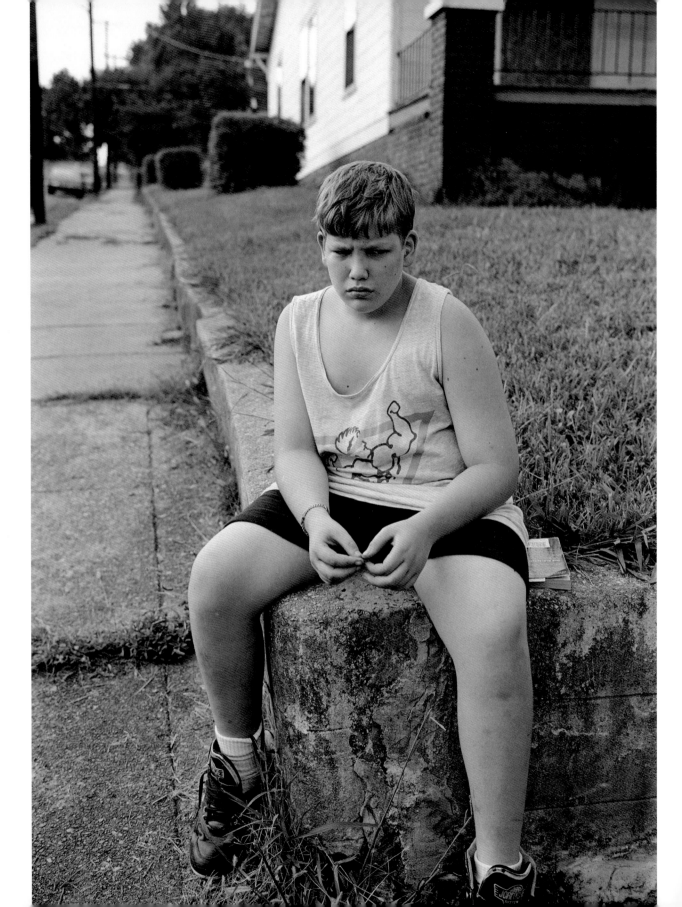

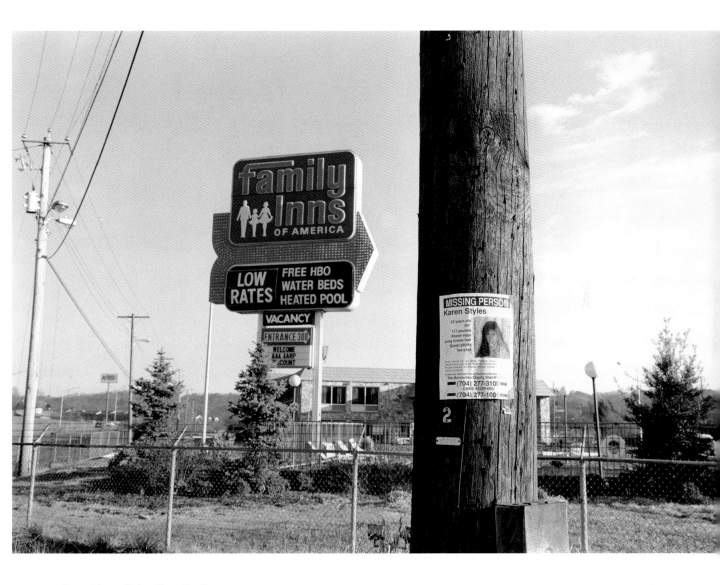

Above: Karen Styles, Knoxville, Tennessee, 1994

Left: Knoxville, Tennessee, 1992

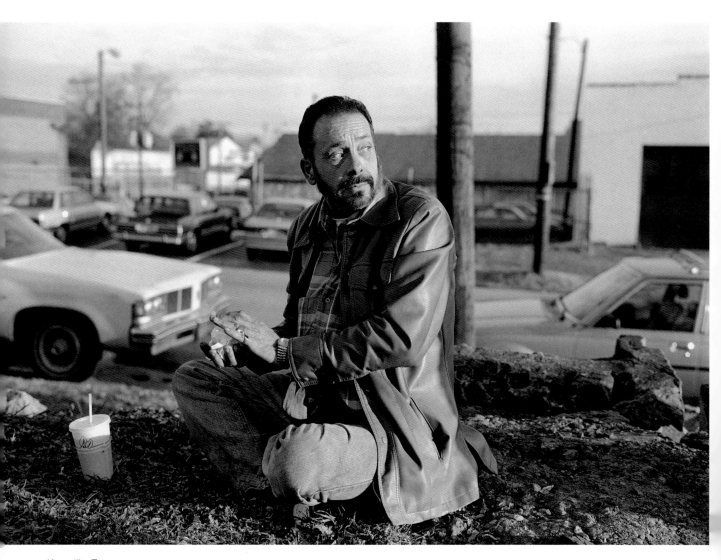

Knoxville, Tennessee, 1992

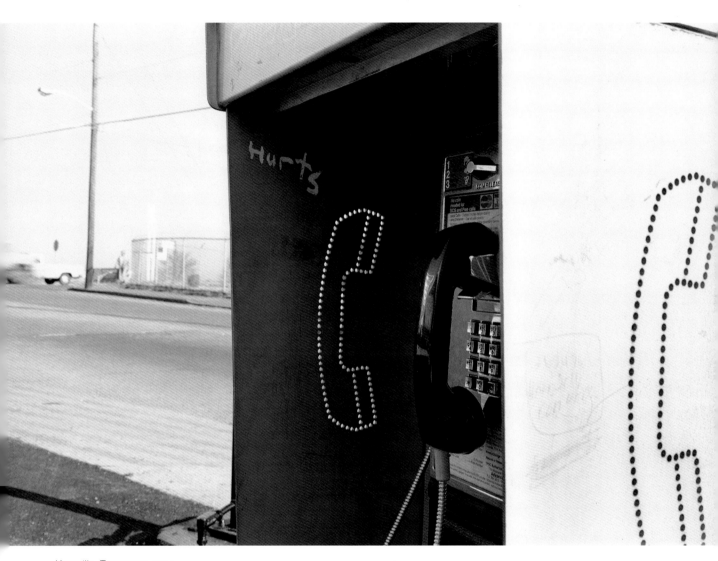

Knoxville, Tennessee, 1994

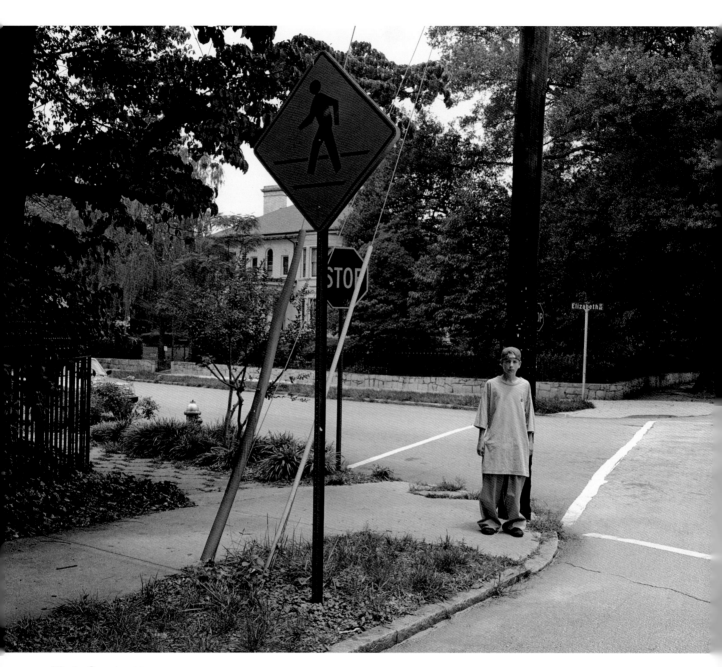

Atlanta, Georgia, 1994

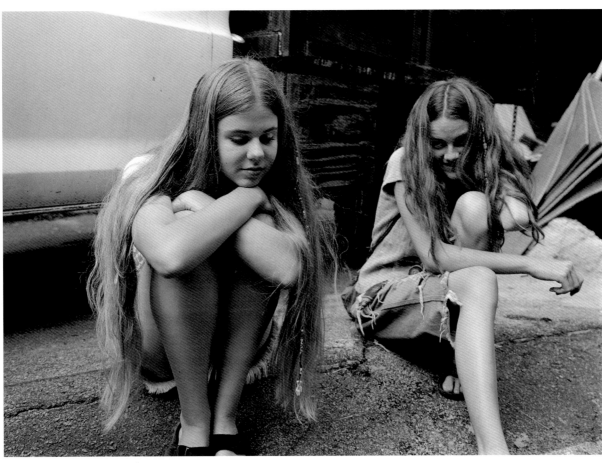

Atlanta, Georgia, 1994

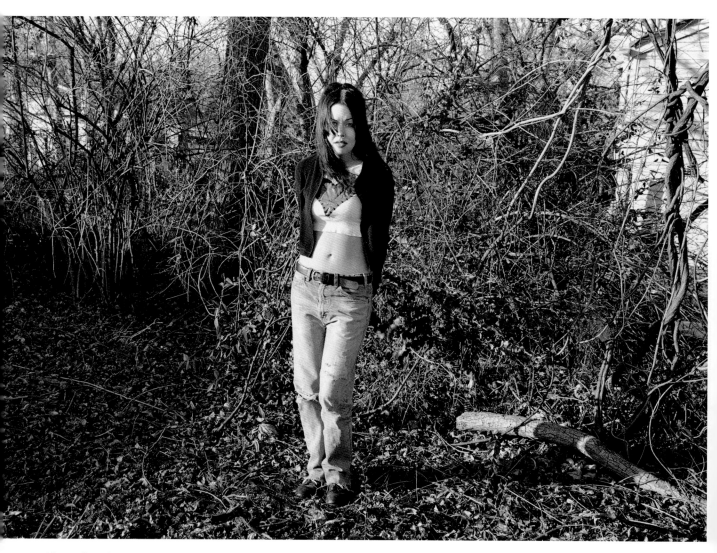

Athens, Georgia, 1995

Knoxville, Tennessee, 1991

Knoxville, Tennessee, 1992

Atlanta, Georgia, 1994

Knoxville, Tennessee, 1992

A Woman's Place

Marita Golden

Rasheed

She reminds me of my first wife, Lena. Even looks like her and carries herself
with that same kind of delicate style. But I wanted Lena because she was a
woman; I desire Aisha because she's a child. A child who can neither entrap nor
fool me. Who does not know how complex and unreliable love can be. Like
Aisha, Lena inspired an openness in me that is not my true nature. I told Lena
things I didn't even know I felt. She was five years older. Had been married once
before. And I planned to give her everything. So I worked two jobs to earn the
money to set up my hardware stores. She made me a father twice, and I was
proud, but I only associated the children with christenings and birthdays.
I spent so much time working that the passing of their days into years I only
witnessed now and then, helping them with homework sometimes and looking
in on them when I came home at 2 A.M., or falling asleep as I read them a bed-
time story.

 And when I had made the money, opened the first store, I look around and I
had lost them. I was unsure around the children. They were uncomfortable with
me, didn't know how to accept my affection. Challenged my authority while
accepting Lena's because she'd always been there. And she had friends, inter-
ests, a promotion on her job, that I knew nothing about. I had been too tired to
ask, too obsessed with my business to care. I tried to find an explanation for the
emptiness that had sprung up where feelings used to be. But I saw no crime,
only her unhappiness.

One of the men I'd known when I worked at the Post Office had become a Muslim. I was always skeptical about most religions. But one day, out of curiosity, I attended a service with Guy and met his wife and children. The reverence of his wife around him, the obedience of the children impressed me. The order I saw in his family made the chaos of my own seem all the greater. I thought Islam would give me back the family I'd lost. But Lena resisted. Even refused to allow me to take the children to the mosque. I joined the faith anyway, and soon it was over between us.

After we separated, more than once I stopped by her apartment to visit the children and ended up staying the night. Lying in her arms, I told her new secrets, more revealing than the old ones. Then one day I came to the apartment and the landlord told me she'd moved. What did all those words earn me? All the pleas, the confessions? And since then loneliness has lived with me. Took over this house, staring at me as I ate dinner alone in the kitchen. Mocked me when I left in the morning or pulled into the driveway at night.

I've heard this house laugh at me as it watched me eat too much, then felt depression sink into my spirit and steal my appetite for anything other than grief. And the house has seen me, tongue-tied with the children I no longer knew, when they still used to visit on the weekends before Lena married again. And so I promised myself there would be few words next time. There would be possession and there would be control. I want this house to be filled with all the things I lost. And this time I'll protect them. I won't let them get away.

Aisha

In the beginning we used to talk a lot. He asked me to tell him things about myself. But we don't do that so much anymore. It's like he has learned already all he needs to know. I know there won't be any denying him. And he is now as confident of me as he seems of himself. After Jummah he comes to the back of the mosque and gives me a look that asks me to come and stand with him. He squeezes my hand and then just wants me to be near him. Like us standing together completes a picture he has of himself. We don't talk so much like before, but there's a bond between us that maybe makes words unnecessary. The things we do are ordinary, simple things. We signed up with some people in the mosque to take an Arabic class at the Y. We study the Hadith together, at my house. And on Wednesday nights at his house there's a Qur'anic study group. I come early and help him make refreshments. He's assuming something very important about us. So am I. But neither one of us knows how to say what it is.

Rasheed

I told Sister Khadija I've been seeing her. And I hinted at how deeply I feel for the girl. Khadija is one of the few women I really respect. She carries herself with dignity, and that's rare these days, even among the women in Islam. I've taken her boys out to the park, the movies, or on errands with me, just so they could be around a man. I've spent evenings at her house discussing the Qur'an, people in the mosque, and anything under the sun. I thought we were friends. So I was surprised when she let me know she had doubts about my wanting Aisha.

I was sitting in her kitchen watching her wash her daughter's hair in the sink. When I told her, she didn't even look at me, just said, "I knew something was up. Everybody in the mosque does."

"Well, what do you think?"

"Why should it matter, what I think?"

"You're right. It shouldn't. But it does." She was drying Amina's hair and trying, I could tell, not to look at me.

"You know me, I do what I want," I said. "But I was just curious. It's not like what you think will change my mind."

"I wish it could," she said, wrapping the towel around Amina's head and telling her to go into her bedroom. "I just have a fearful feeling, that's all."

"Fearful? You act like I'm some madman, somebody with nothing to offer her."

"Calm down . . . Rasheed, calm down." She poured a cup of tea and sat down across from me at the table. One of the things I like about Khadija is, she won't shrink before you. Right or wrong, she stands up for what she believes. But I could tell what was coming, and for the first time since I'd known her, I wished I could sway her.

"You've had so much more experience." She was finally looking at me. "I wonder if you might not ask her for too much. More than she can give."

"What am I asking for but a wife, a family. Not to be alone."

"I know that sounds very simple to you. But depending on how you want her to fulfill all that, it could be harder than it seems."

I got up and looked out the window, just to avoid her stare.

"A man like you, I never understood why none of the other women in the mosque ever attracted you. You been living like a monk, from what I can see."

"Can you believe I was scared? Scared of choosing with my heart instead of my head. I did that the first time around, and I'm still paying for it. I never let a woman get too close because I hadn't met anybody I could have on my terms."

"And you think you can have Aisha, as you say, on your terms?"

"I do. And if I didn't know better, I'd almost say you don't want me to be happy."

"Sure I do. It's just that I want Aisha to be happy, too."

"And so I can't . . ."

"I'm not saying that. I'm saying you've decided already what she's got to be, who she's got to become to please you. What'll you do if she can't do it? If she wants to be someone else? She's yet to be tested. How do you know she can make a commitment to the kind of marriage the faith requires?"

"She's got more conviction than lots of people who *live* in the mosque."

"I don't doubt her belief. I just know she's got some growing still to do that's got nothing to do with Allah."

"Everything has to do with Allah."

"You sound like a man who's made up his mind not to listen."

"I sound like a man who's decided what he wants."

"Maybe you're right. Maybe she'll stay the way she is now. But I wouldn't wish that on her or you."

"Anyway, I haven't even asked her yet to be my wife."

"What do you think she'll say?"

"It's been enough just trying to live with the question. I don't yet have the nerve to imagine the answer."

Aisha

His house is large. Too big for one person. And in it there are the ghosts of the people who once lived there with him. It's a house that's been lived in too much and too little. All at the same time. Last night after everybody had left to go home after the study group, we were sitting in the kitchen drinking tea. I looked around and thought about the three bedrooms and the study upstairs and the large front and back yards. I thought about all the space in the house, and it struck me as maybe not as much of a blessing as it seemed.

So I asked him, "What's it like, to live alone in a big house like this?"

"There are days and nights when it's a pleasure and times when it almost drives me crazy."

"Does it make a difference that you built it?"

"That's why I've stayed in it so long. It's like a second skin."

"I never lived in a house," I told him. "Only apartments. Houses I saw in mag-

azines or on television. My grandmother has a house in the country in Maryland, but it's not anything special."

"I've thought of moving out. But I put too much into it," he said. "It meant too much to me, building it with my own hands. This isn't just a house, it's everything I believe in. Everything I am."

"Would you ever sell it?"

"No. Never. I'd rent it out, but it'll always belong to me. Could you live in a house like this?" he asked me.

"Alone or with somebody?"

"Could you live in this house with me?"

"I don't think at this point there's any other place I'd rather live." I reached out to touch his hand, but he stood up real quick and went over to the refrigerator and leaned against it with his hands folded across his chest. He was talking to me but looking at his shoes. And he asked me to marry him like he was asking me to do a favor he was afraid might inconvenience me. "I want a wife and a family I can be sure I won't lose. But I've been alone too long for it to be easy to live with me. You're so young. Just looking at you makes me think about starting all over. Fresh. With no mistakes this time." Finally he looked at me and said, "Maybe that's why I'm scared, too, of my own desire. And whether or not it'll give me a second chance."

Aisha

He didn't say anything about love. When I told Mama, she said love wasn't the most important thing in a marriage, that it wasn't even always necessary. She said respect was the thing that mattered most. And anyway, "Just because he didn't say it don't mean he don't feel it," she told me. Then she said, "I don't know nothing about you-all's religion and all that. But he strikes me as a decent man." That's about what I'd expect Mama to say. There wasn't too much for me to think about, really; it had already been decided. Because I like what he's done with his life. And I want to see what he'll do with mine.

Last night he gave me my dowry. I had asked him for a ring, a prayer rug, and a copy of the Qur'an. He brought everything all wrapped up in a box and gave it to me, with Mama standing right there watching us. Then he brought out another box from his pocket and opened it. Inside were three gold bracelets. He put

them on my wrist and told me I was more beautiful than any jewelry and more precious than any stone, because I was a woman who had submitted herself to the will of Allah. I could feel his hands warm, and though we weren't that close to each other, his body wanting me. The urge just came down on him like a fever, but before that feeling could possess us, he dropped my hand and just said real softly, "I took you as my wife the first day I saw you."

Almost everybody in the mosque came to our wedding. Mama made me a long beautiful dress of lace and silk. And Crystal and Serena came, looking like they didn't quite believe what I was doing, but happy for me anyway. After the Imam talked about the meaning and importance of marriage, he joined my and Rasheed's hands and placed a white handkerchief over them. Then I knew I was Rasheed's wife. Then I knew Allah had answered my prayers.

He tells me, when we make love, that my hands feel like dove feathers against his skin. But it took me a long time to learn how to please him. And I'm still learning. The first few weeks after we got married, I was nervous and shy. He'd have to pull me close to him and guide my hands over his neck, chest, along his thighs, and between his legs. After a while I relaxed and could do it naturally.

I like it when we do the same things to each other together. And he has a strange, funny taste. I never did that with anybody before. His skin is warm and salty on my lips, and his penis brushes against my teeth, resting on my tongue. And then sometimes he smells a little like antiseptic, and the scent fills my nostrils. His hairs get inside my nose while he's pushing harder and harder against the walls of my mouth. When he's real excited his fingertips knead my scalp and hold on to my curls. He starts whimpering, and it sounds like a baby getting ready to cry. I want to tell him it hurts, and just then he pulls himself out and comes inside me. He lays on me for a while, his breath hot and raspy in my ears, his fingers playing with my hair. Then he rolls onto his side of the bed and pulls me close. This time just to hold me. Almost all the time I fall asleep in his arms.

One night I told him about Jessica. We were laying on our backs, just staring at the ceiling. The dark and the things we had just done made me tell him. And when I did, I said, "I didn't expect to grieve. I didn't think it would hurt so much. I missed that baby just like it was a friend instead of a promise." He squeezed my hand and said, "We'll have babies of our own. Babies for you to love and to ensure I'll never die."

Rasheed

I never get tired of looking at her when she's pregnant. Her skin starts to glow around the fifth month, and for the whole time her eyes sparkle. When she is carrying my child and I make love to her, her body's filled with surprises. It becomes the body of the woman she's going to be one day.

I'm a father now, really for the first time. With Tameka and Tariq, we'd get up at night to feed them. Aisha from her breast. Me with a bottle of her milk. At first I was so amazed we had twins, I didn't know what to do, where to begin, which child to look at or hold. The first month I let Randolph run the stores for me, and I stayed home with Aisha. I'd waited so long to have children in this house again I didn't even mind that for weeks seemed like all I smelled was dirty diapers and sour milk, or that me and Carrie kept up the house while Aisha dealt with the babies. None of that bothered me at all. Because I'd missed even this with my other kids. I got so good I could change diapers in a flash, and even feed them without being scared they'd choke. When they started crawling and getting into things, Aisha was always telling them no, taking things out of their hands. But I told her to leave them alone, let them have the run of the house as long as they didn't touch nothing that could hurt them. I'd just sit and watch them. They'd be pulling down magazines from the bottom shelves of the bookcases and knocking over trashcans and squealing every time they found out a new thing to do. I could see my children growing right before my eyes.

I don't much care whether this child is a girl or a boy. Everybody says from the way Aisha's carrying it, that it's a girl. If it is, one of her names will be Rose, that of my mother, to ensure that she's got the same kind of strength she had. We didn't have much, not sharecropping in Macon, Georgia. And it was the kind of life guaranteed you'd never have nothing either. But my mother'd bring home old magazines from the house of the people she worked for. The *Saturday Evening Post* especially. Almost every night we'd look through the magazine after dinner, and looking at those pictures was better than any fairy tale. Mama'd always tell us, "Just 'cause you don't see your face here, don't mean your name ain't on these cars and houses and clothes. There's good things waiting for you to come and claim 'em. Got your name on 'em right now. Always look farther," she told us, "than you can see." And the older I get the more important I think names are. That's why I told Aisha we'll give each of the children one name that comes out of our faith and another name of someone in the family. Those are the two most important things, and without one or the other you don't have very much, in this life or the next.

Aisha

The houses on our street are well tended and sturdy. The lawns are neat and most of the driveways have two cars, some even three. Christmastime everybody's house but ours is dressed up in lights, wreaths, and holly. It's as if the people inside were surprised that they had gotten through another year and wanted everybody to know they could afford the year to come. Everybody knows Rasheed, he's lived in the neighborhood so long. When we first got married, the other women on the block were kind of distant. They'd stare at me, not even trying to hide their curiosity. I think they were trying to figure out how young I really am. Then when I had the twins, they became friendlier, stopping to talk when they passed me on the street or saw me at the shopping center with the babies in the double stroller. Seems like a child can win over anybody.

Some of our neighbors are from the islands—Trinidad, Jamaica, Haiti. I've seen pictures of those places, and I can't imagine ever wanting to leave them. But Rasheed told me that the islands, despite their beauty, had betrayed the people, given them lives that were meager and secondhand. We were in his study, and he pointed to the Caribbean on his globe. He told me about the history of that part of the world, about slavery and sugar cane and the British and the French revolutions. And why all the people think about America when they want to flee.

In the afternoons I put the twins in bed for a nap, and after they've gone to sleep, I tiptoe back into the room and just look at them sleeping. I study them best when they're asleep, see things about them that I can't when they're laughing or crying. In sleep they don't resist me. And I never look at them long or hard enough to see everything they are.

Today Serena came over to tell me she's going to Africa next month, and that she might stay for a while. She said that she envied me because, as she put it, I had "defined my borders narrowly but found in them a whole world." She sounded excited and a little scared. Her voice had an urgent sound, and she was talking real fast, the way she always does when she's got a plan or has made up her mind to do something. She told me about the closing of the center where she'd been working and said that even if it hadn't run out of funds, she'd probably have left.

"I'd done what I came there to do," she said. "I helped some women who needed training and jobs find both, gave them support and encouragement, and met some people I'll never forget. But it wasn't enough. I wanted to do something

more. I wonder if I'll ever find a job or an endeavor big enough for me." She talked about wanting to learn French and maybe Swahili while she's in Africa and maybe work with some UN project and go to see Victoria Falls. Just listening to her talk made my heart beat a little faster, made me smile for no reason, made me think maybe I could do anything I wanted to.

It was nice outside, so we took the kids into the backyard and put them in the swings. Serena looked around the yard, at the two huge oak trees and the screened-in patio. The air smelled like October—crisp and cold and maybe even snow. "This is so perfect," she said.

"And it's too small for you," I told her.

"Some people have to leave everything they know to discover who they are," she said, giving Tariq a hard push in his swing.

"I don't think you ever leave everything you are," I told her. "Maybe you didn't pack it in your suitcases, but believe me it's right there with you." Serena looked at me like she didn't expect me to say something like that, and I told her, "There's nights when I still hear my mama giving me a lecture about why I have to go to college. And warning me to trust myself before any man. And sometimes I think about Jessica, especially when I see how healthy the twins are. You know, I've even thought about that boy who made me pregnant? Wondered what he was doing, where he is, and if he's found as much peace as I have. The past never lets you go, never sets you free," I told her. "One way or another you're going to bump into it, trip over it, or feel it like a shadow." I pushed Tameka and said, "Remember when I told you that time at Winthrop that I didn't like who I was, that's why I wanted to keep the baby. Now I can see I was so young then I thought that girl was who I'd always be."

We pushed the kids in the swings a few more minutes and then went inside. We drank hot cider, and even though all Serena was talking about was leaving, I didn't feel sad, or like I'd miss her. She left around four o'clock, and I couldn't figure out why I felt so happy, so excited the next couple of days. I felt so good, even when I thought about not seeing her for a long time. Then I realized that it was because she'd left behind a little spark of her imagination, a little bit of her courage for me to live on while she's gone.

We named the baby Malika Rose. She was born right in this house, in the same bed where she was conceived. Sister Khadija is a midwife, and during the pregnancy she had me drinking special teas for anything that ailed me. We didn't use any medicines or drugs at all. This time I didn't feel like I was giving myself over to people who didn't really care about me, like when I had the twins in the

hospital. This time my baby was born where she's going to live. Rasheed took Tameka and Tariq over to stay with Mama during my labor. And when he came back he sat in the bedroom to see his child being born. There were times with this baby I wanted to give up, my labor was so long. And it hurt real bad because we weren't using any drugs.

I kept thinking on the things Sister Khadija had told me to and praying to Allah. I could even see how beautiful my baby's face would be when I finally saw it. But it hurt. It didn't feel like there was much difference in the pains when they came. They were all sharp and long. Hard pains that dug into me and didn't want to let go, that made all the breathing exercises useless. And I didn't want to cry or scream because Rasheed was watching and I wanted him to be proud. And to think I'm strong. He was looking at me with no emotion on his face that I could see. Like he was trying as hard as me to control what he felt.

And then the pains stopped for a while and that was when I cried, because I was so tired and felt like my baby was holding me hostage to pain. The only thing I could see very well or hear was the clock, and I knew it had been fifteen hours since my baby started trying to move into this world. Rasheed wiped my forehead with a damp cloth, and because he was so close to me I got to see him clearly, and I saw that he'd been crying, too. I saw that even as he put a dry towel over the pillow beneath my head and tried to make me more comfortable, tears were streaming down his cheeks. I knew not to say anything. I couldn't even think of what to say if I'd had the strength right then. Maybe I'd have just said thank you. And when Sister Khadija came back into the room, my own tears had dried. And I was ready to bring my baby into the world. And two hours later I did.

Malika Rose is a good baby. She sleeps straight through the night and has an even, friendly disposition. Rasheed has shown me pictures of his mother, and Malika has her eyes. She's not like some babies who stare and stare and you can't tell if they really see or understand what they're looking at. When Malika Rose looks at you, you know she sees you. And her gaze kind of warms you up. She was chubby and very round when she was first born. Even had a double chin. But now she's slimming down and we can see she's going to be tall. Malika Rose has the eyes of a seer. Maybe that's what she will be.

I like children best when they're babies. I look at them then and think everything is possible. But as they get older, I fear for them and am filled with regrets for all the things they will want and never have, the things they will yearn for and lose before they are in their grasp. Then, too, I'm more confident of myself as

mother to a baby than an older child. A baby's needs are so basic. The twins will be four next year. They're moving into a childhood that is a never-ending change. And they are so many different children all at once—just when I feel like I know them, they become strangers quite suddenly again.

Rasheed

I asked her to dye my hair the other night. Every time I look in the mirror these days, all I see is gray—in my beard, my mustache, my hair. She asked me why I wanted to dye it. Said she thought it was beautiful. "When I was your age I thought gray hair was pretty, too," I told her. "But that's 'cause it was on somebody else's head."

She laughed and looked at my hair like it was something she couldn't resist, saying, "Those silver strands make me imagine all the things you've done and seen."

"All I see in the mirror is endings and things I may never get a chance to do," I told her.

"I wanted you *because* you're older than me," she said, all serious and agitated. "Because I thought you'd teach me everything I figured you must know."

Her eyes were pleading in a quiet way. But they didn't stop me from telling her, "I know what I'm doing."

"You want to dye your hair because it makes you think about death."

"That's not true," I said, uncomfortable because she read me so well. "Mostly it makes me think about being helpless and needy and pitied the way my father was when he got old. It makes me feel angry, like the day I was in the park with the kids and this woman sits beside me and starts talking about how cute Tariq and Tameka are, and then says, 'I've got grandchildren, too.' If I dyed my hair maybe I wouldn't feel like every birthday just meant you becoming more of a woman and me becoming less of a man.'"

"But how will it change anything?"

"I'll feel like maybe I could live long enough to see my children grow up. Like I could live long enough to give you what you desire *and* what you need. Long enough for us to have a life, not just an interlude."

I don't know if she understood everything I said. I mean *really* understood. Understood as deeply as I felt everything I told her. But she must have because she stood up and draped the towel over my shoulders and started rubbing the dye in. I was surprised even to hear myself saying all those things. I'd told her what I'd sworn

never to tell anybody. But because she's my wife, she'd know what I felt even if I never said a word.

I showed her the drawings I've done for the next house. It's gonna be another year or two before I start on it, but I'm thinking about it now. We're running out of rooms in this house already. And what with us wanting to have another child, we're going to need more space. I've been working on the drawings for the last couple of months, almost every night. I'll be sitting right here in my study and Aisha's over there in the corner feeding Malika Rose or maybe crocheting. She was rocking Malika Rose to sleep on her back when I asked her to look at what I'd done. I explained where everything would be. We talked about how many bedrooms we'd need and then about where I'd build it. We sat up a couple of hours talking about all that. Then I rolled up the drawings and told her I was going to build a house where we could be happy. "I just want a house," she said, "that's big enough for all of us to grow in. Build us a house where our children can become the people we want them to be," she said. "Build us a house where you can be their father and their friend. Where I can be their mother, your wife, and anything else I need to be."

Then she said she was tired and was going to bed. It was past midnight. I told her I'd be upstairs soon. But after she left the room I just sat there afraid to go to bed, terrified of going to sleep because lately I've been having dreams about suddenly dying, or having a heart attack, getting real sick right in the midst of everything I wanted, losing it all before I could really call it mine.

Clarissa Sligh

from the series Suburban Atlanta, 1994

Black chairs

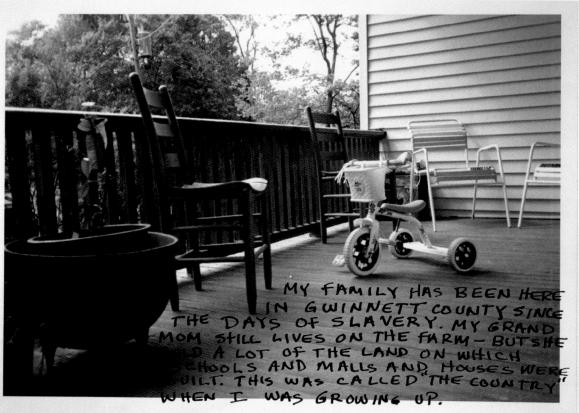

MY FAMILY HAS BEEN HERE IN GWINNETT COUNTY SINCE THE DAYS OF SLAVERY. MY GRAND MOM STILL LIVES ON THE FARM — BUT SHE [SO]LD A LOT OF THE LAND ON WHICH [S]CHOOLS AND MALLS AND HOUSES WERE [B]UILT. THIS WAS CALLED "THE COUNTRY" WHEN I WAS GROWING UP.

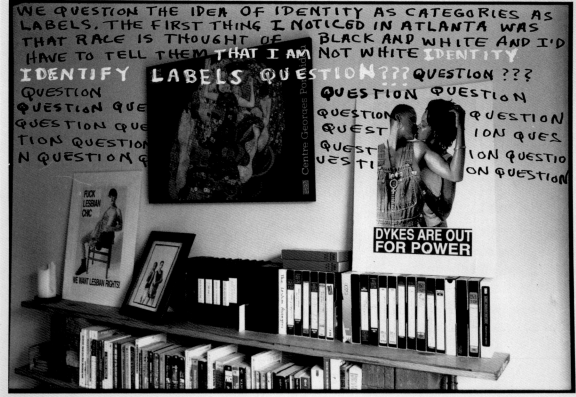

WE QUESTION THE IDEA OF IDENTITY AS CATEGORIES AS LABELS. THE FIRST THING I NOTICED IN ATLANTA WAS THAT RACE IS THOUGHT OF BLACK AND WHITE AND I'D HAVE TO TELL THEM THAT I AM NOT WHITE IDENTITY
IDENTIFY LABELS QUESTION??? QUESTION ???
QUESTION
QUESTION QUE[STION] QUESTION QUESTION
QUESTION QUE[STION] QUESTION QUESTION
TION QUESTION[N] QUEST ION QUES
N QUESTION Q[UESTION] QUEST ION QUESTIO
[Q]UESTI ON QUESTION

FUCK
LESBIAN
CHIC

WE WANT LESBIAN RIGHTS!

Centre Georges Pompidou

DYKES ARE OUT
FOR POWER

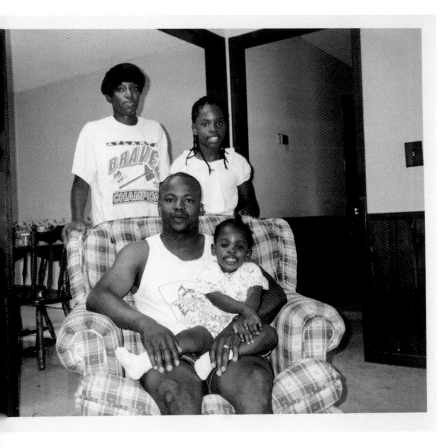

Eddie Curinton's family

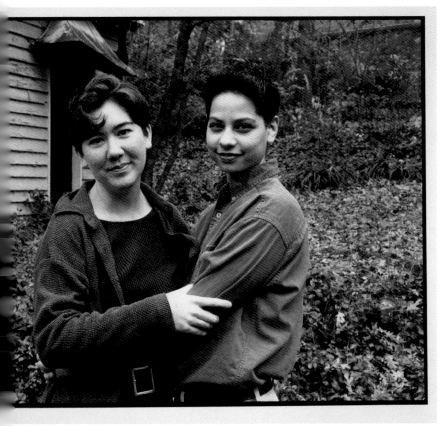

Patti and Ami

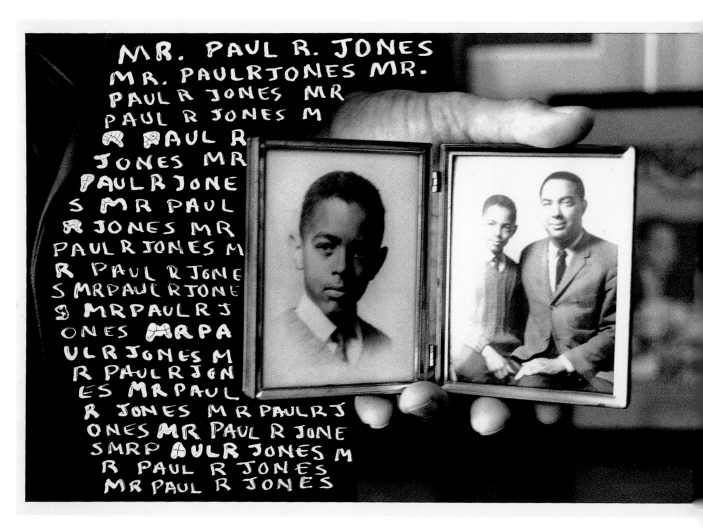

The Collector

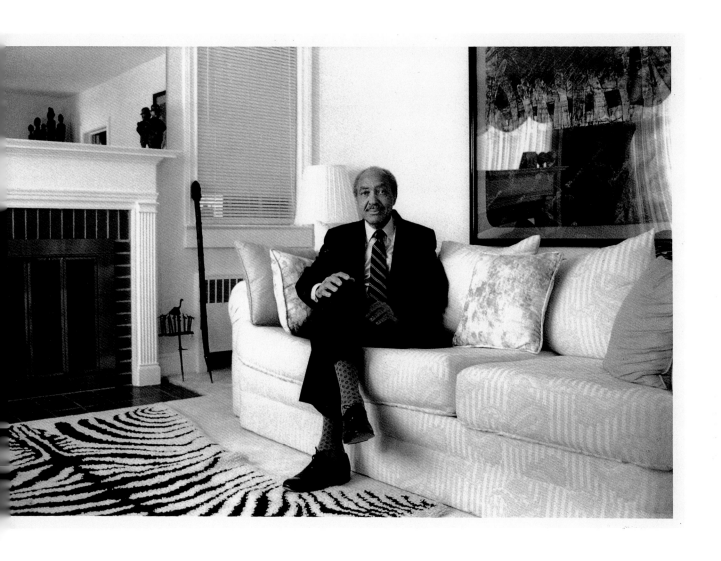

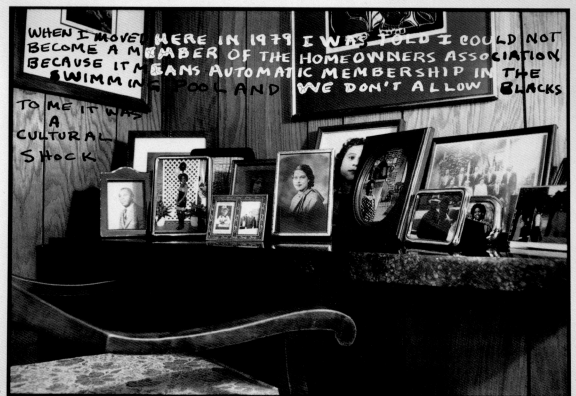

WHEN I MOVED HERE IN 1979 I WAS TOLD I COULD NOT BECOME A MEMBER OF THE HOMEOWNERS ASSOCIATION BECAUSE IT MEANS AUTOMATIC MEMBERSHIP IN THE SWIMMING POOL AND WE DON'T ALLOW BLACKS

TO ME IT WAS A CULTURAL SHOCK

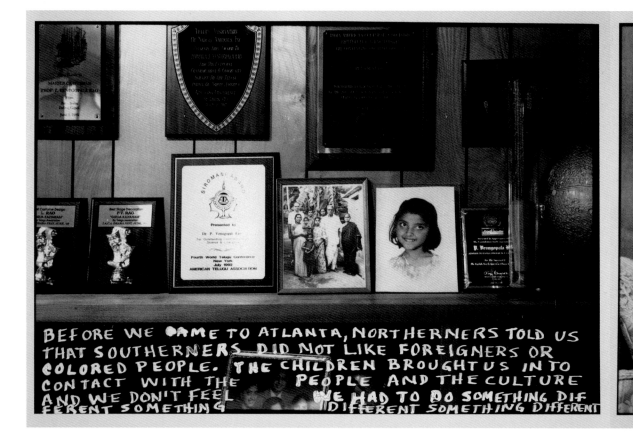

BEFORE WE CAME TO ATLANTA, NORTHERNERS TOLD US THAT SOUTHERNERS DID NOT LIKE FOREIGNERS OR COLORED PEOPLE. THE CHILDREN BROUGHT US INTO CONTACT WITH THE PEOPLE AND THE CULTURE AND WE DON'T FEEL WE HAD TO DO SOMETHING DIF FERENT SOMETHING DIFFERENT SOMETHING DIFFERENT

Ann River Davis

Lakshmi Rao

Akko Nishumora

I GREW UP THE ONLY ASIAN CHILD IN AN
UPPER MIDDLE CLASS WHITE NEIGHBORHOOD
NOT UNDERSTANDING WHY THEY CALLED
SOME PEOPLE "NIGGERS"... ONLY ASIAN CHILD
ONLY ASIAN CHILD ONLYASIANCHILD ONLYASIANCHILD ONLYASIANCHI

The Trip Back

Robert Olen Butler

I am just a businessman, not a poet. It is the poet who is supposed to see things so clearly and to remember. Perhaps it is only the poets who can die well. Not the rest of us. I drove from my home in Lake Charles, Louisiana, to the airport in Houston, Texas, to pick up my wife's grandfather. And what is it that I experienced on that trip? What is it that struck me as I got off the interstate highway in Beaumont, knowing the quick route to the airport as I do? I was driving through real towns in Texas. One was named China, another Nome. One was Liberty. If I was a man who believed in symbols and omens, I would have smiled at this. I was passing through Liberty to pick up my wife's grandfather, whose own liberty my wife and I and the man's nephew in San Francisco had finally won, after many years of trying. He was arriving this very day from the West Coast after living thirteen years under communist rule in our home country of Vietnam. Perhaps a poet would think of those things—about Liberty, Texas, and my wife's grandfather—and write a memorable poem. Though maybe not. I am ignorant of these matters. Maybe it is only the bird taking flight or the frog jumping into the pond that the poet is interested in.

All I know is that for me I drove the two-lane highway across Texas and I just noticed the businesses. The little ones that seemed so Vietnamese to me in how the people always looked for some new angle, some empty corner in the marketplace. I noticed the signs for stump grinding and for house leveling and for mud pumping. The different stands along the way—fireworks, fruit and vegetables, hub caps and antiques. The Paradise Club had a miniskirt contest and The Bait Barn had a nightcrawler special and Texas Winners had a baseball trophy sale. There

was a Donut Delight and a Future Star Twirling Academy and a handpainted sign on a post saying that the finest porch swings were a mile down this dusty road. The Mattress Man said on his sign, right underneath his business name, JESUS IS LORD.

I am a Catholic and I must say that this made me smile. The Lord of the universe, the Man of Sorrows, turned into the Lord of the Mattress, the Mattress Man. But even so, I understood what this owner was trying to do, appealing specially to those of his own kind. This is good business practice, when you know your sales area. I have done very well for myself in Lake Charles in the laundry and dry-cleaning business. It is very simple. People sweat a lot in the climate of southern Louisiana, and there was a place for a very good laundry and dry cleaner. I have two locations in Lake Charles and I will soon open one in Sulphur. So it was this that interested me as I drove through Texas, as it always does. I am a businessman. It is my way.

And if I was a man who believed in symbols and omens, I would have been very interested toward the end of my journey when I came to a low highway bridge that took me across the wide converging of two rivers, for as I entered the bridge, the sign said, LOST AND OLD RIVERS. These two rivers were full of little islands and submerged trees and it was hard to see how the two ran together, for they looked more like one sprawling thing, like perhaps a large lake, something that was bound in and not moving, not flowing. Lost and old.

I had not given much serious thought to Mr. Chinh, my wife's grandfather. I knew this: My wife loved him very much. We are all like that in Vietnam. We honor our families. My four children honor me very much and I honor them. My wife is devoted to me and I am devoted to her. I love her. We were very lucky in that our parents allowed us to marry for love. That is to say, my mother and father and my wife's mother allowed it. Her father was dead. We still have a little shrine in our house and pray for him, which is the way of all Vietnamese, even if they are Catholic. As Catholics we understand this as the communion of saints. But my wife has no clear memory of her father. He died when she was very young. He drowned swimming in the South China Sea. And after that, Mr. Chinh became like a father for my wife.

She wept the night before my trip to the airport. She was very happy to have her grandfather again and very sorry that she'd missed all those years with him. I heard her muffling the sound of her crying in the pillow and I touched her on the shoulder and felt her shaking, and then I switched on the light by the bed. She turned her face sharply away from me, as if I would reproach her for her tears, as if there was some shame in it. I said to her, "Mai, it is all right. I understand your feeling."

"I know," she said, but she did not turn back to me. So I switched the light off once more and in the dark she came to me and I held her.

You must wait to understand why it is important, but at this point I must confess one thing. My wife came to me in the dark and I held her and her crying slowed and stopped and of course I was happy for that. I was happy to hold my wife in the dark in this moment of strong feeling for her and to be of help, but as I lay there, my mind could not focus on this woman that I love. My mind understood that she was feeling these things for a man of her own blood who had been very important to her and who then disappeared from her life for more than a decade and now was coming back into it. But these are merely bloodless words, saying it this way, things of the mind. And that was all they were to me, even lying there in the dark. I made those words run in my head, but what was preoccupying me at that moment was an itching on my heel that I could not scratch and the prices of two different types of paint for the outer shop of the new drycleaning store. My wife was a certain pressure, a warmth against me, but there was also a buzz in the electric alarm clock that I was just as conscious of.

Do not misjudge me. I am not a cold man. I drew my wife closer as she grew quieter, but it was a conscious decision, and even saying that, I have to work hard to remember the moment, and the memory that I have is more like a thought than a memory of my senses. And it's not as if the itching on my heel, the buzz of the clock, are any more vivid. I have to work extremely hard to reconstruct this very recent night so that I can even tell you with assurance that there was a clock in the room or that there was a foot at the end of my leg.

But you will see that it is Mr. Chinh who has put me in this present state of agitation. After a time, as I held her in the bed, my wife said, "My tears are mostly happy. Don't worry for me, Khánh. I only wish I was small enough and his back was strong enough that I could ride upon it again."

At the airport gate I looked at the people filing through the door from the jetway. The faces were all white or Spanish and they filed briskly through the door and rushed away and then there were a long few moments when no one appeared. I began to think that Mr. Chinh had missed the plane. I thought of the meal that my wife was preparing at home. She and my children and our best friends in Lake Charles had been working since dawn on the house and on the food for this wonderful reuniting, and when the door to the jetway gaped there with no one coming through, that is the only thought I had, that the food would be ruined. I did not worry about Mr. Chinh or wonder what the matter could really be.

I looked over to the airline agents working behind their computers, checking in the passengers for the next flight. I was ready to seek their help when I

glanced back to the door, and there was Mr. Chinh. He was dressed in a red-and-black-plaid sport shirt and chino pants and he was hunched a little bit over a cane, but what surprised me was that he was not alone. A Vietnamese man about my age was holding him up on the side without the cane and bending close and talking into his ear. Then the younger man looked up and saw me and I recognized a cousin of my wife, the son of Mr. Chinh's nephew. He smiled at me and nodded a hello and he jiggled the old man into looking at me as well. Mr. Chinh raised his head and an overhead light flashed in his glasses, making his eyes disappear. He, too, smiled, so I felt that it was all right.

They approached me and I shook Mr. Chinh's hand first. "I am so happy you have come to visit us," I said.

I would have said more—I had a little speech in my head about my wife's love for him and how she is so sorry she is not at the airport and how much his great-grandchildren want to see him—but my wife's cousin cut in before I had a chance. "This is Mr. Khánh," he said to the old man. "The one I told you about who would meet you."

Mr. Chinh nodded and looked at me and repeated my name. He spoke no more and I looked to the cousin, who said, "I'm Hu'o'ng," and he bowed to me very formally.

"I remember you," I said and I offered my hand. He took it readily, but I knew from his formality that there could be things I did not know about Mr. Chinh. It is the custom of Vietnamese, especially of the old school of manners, not to tell you things that are unpleasant to hear. The world need not be made worse than it is by embracing the difficult things. It is assumed that you wish to hear that all is well, and many people will tell you this no matter what the situation really is. Hu'o'ng struck me as being of this tradition—as surely his father must, too, for this is how an otherwise practical people learns an attitude such as this.

But I am a blunt man. Business has made me that way, particularly business in America. So I said to Mr. Hu'o'ng, "Is there something wrong with Mr. Chinh?"

He smiled at me as if I was a child asking about the thunder. "I came with our dear uncle to make sure he traveled safely. He is very old."

I suddenly felt a little uncomfortable talking about the man as if he wasn't there, so I looked at him. He was leaning contentedly on his cane, gazing around the circle of gates. I bent nearer to him and said, "Mr. Chinh, do you like the airport?"

He turned to me at once and said, "This is a fine airport. The best I have seen."

The man's voice was strong, and this reassured me. I liked his appreciation of the airport, which I, too, admired, so I said to Mr. Hu'o'ng, "Is he a little frail, physically?"

"Yes," said Mr. Hu'o'ng, happy, I suppose, to have words put in his mouth sufficient to answer my blunt question. I did not like this cousin Hu'o'ng.

But I was compelled to ask, "Will you be coming to Lake Charles to join us?"

"No. I must decline your gracious invitation. I return by a flight later this day."

I was blunt again. "You came all this way never to leave the airport? Just to return at once?"

Mr. Hu'o'ng shrugged. "It is my pleasure to make sure our beloved uncle arrives safely. My father said that if you should wish to discuss Uncle Chinh's permanent home after perhaps a week or so, he will await your call."

I didn't know the details of all that, except that I was prepared for my wife's sake and the sake of our country's family tradition to make him part of our household. So I just nodded and took Mr. Chinh by the arm and said a brief good-bye to Mr. Hu'o'ng, and the old man and I started off for the baggage check.

Mr. Chinh was enchanted with the airport, gawking about as we moved, and his interest was so intent and his pleasure so evident from the little clucks and nods he made that I did not try to speak with him. Twice he asked me a question, once about where they would take the luggage, answered by our arrival at the carousel, which caused him to laugh loud when the bell rang and the silver metal track began to run. Mr. Chinh stood at the opening and he watched each bag emerging through the plastic flaps as closely as a customs inspector. The second question was if I had a car. And when I said yes, he seemed very pleased, lifting his cane before him and tapping it down hard. "Good," he said. "Don't tell me what kind. I will see for myself."

But in the parking garage, he was baffled. He circled the car and touched it gently with the rubber tip of his cane, touched it several places, on a taillight, a hubcap, the front bumper, the name on the grill. "I don't know this car," he said. "I don't know it at all."

"It's an Acura," I said.

He shook the name off as if a mosquito had just buzzed his head. "I thought you would own a French car. A Citroën, I had predicted. A 15CV saloon."

"No, Mr. Chinh. It's an Acura. It's a very good car," and I stopped myself from telling him it was from Japan.

Mr. Chinh lifted his shoulders and let them drop heavily, as if he was greatly disappointed and perhaps even a little scornful. I put his bags in the trunk and opened the door for him and we made it out of the airport and back onto the two-lane highway before any more words were spoken. I was holding my eyes on the road, trying to think of small talk, something I'm not very good at, when Mr. Chinh finally said, "The inside is very nice."

I didn't understand. I glanced over at him and he was running his hand along the dashboard and I realized that he'd been thinking about the car all this time. "Good," I said. "I'm glad you like it."

"Not as nice as many others," he said. "But nice."

There's no car interior short of a Rolls that is nicer than my Acura, but I nodded at the old man and I told myself that there was no need to debate with him or entertain him but just to be cordial with him. Let him carry the conversation, if he wished one. But the trip looked very long ahead of me. We hadn't even gotten out into the country of stump grinders and fruit stands. It was still franchised fast food and clusters of gas stations and mini-malls and car dealerships. There were many miles to go.

Then up ahead I saw the work of a clever man, a car dealer who had dangled a big luxury car from the top of what looked like a seventy-foot crane. I said to Mr. Chinh, "There's something the Citroëns don't do," and I motioned the man's attention to the car in the sky. He bent down and angled his head up to look and his mouth gaped open. He said nothing but quickly shifted to the side window as we passed the car dealership and then he turned around to watch out the back window until the car on the crane was out of sight.

I expected Mr. Chinh to remark on this. Perhaps how no one would ever do such a thing to a French car. There would be no need. Something like that. But he said nothing, and after a time, I decided to appreciate the silence. I just concentrated on covering these miles before the old man would be reunited with the granddaughter he loved. I found that I myself was no longer comfortable with the old ways. Like the extended family. Like other things, too. The Vietnamese indirectness, for instance. The superstition. I was a good American now, and though I wished I could do more for this old man next to me, at least for my wife's sake, it was not an unpleasant thought that I had finally left Vietnam behind.

And I'd left behind more than the customs. I don't suppose that struck me as I was driving home from the airport. But it is clear to me now. I grew up, as did my wife, in Vũng Tàu. Both our families were pretty well off and we lived the year around in this seaside resort on the South China Sea. The French had called it Cap St. Jacques. The sand was white and the sea was the color of jade. But I say these things not from any vivid recollection, but from a thought in my head, as real only as lines from a travel brochure. I'd left behind me the city on the coast and the sea as well.

But you must understand that ultimately this doesn't have anything to do with being a refugee in the United States. When I got to the two rivers again, Old and

Lost, I could recognize the look of them, like a lake, but it was only my mind working.

Perhaps that is a bad example. What are those two rivers to me? I mention them now only to delay speaking of the rest of my ride with Mr. Chinh. When we crossed the rivers, I suppose I was reminded of him somehow. Probably because of the earlier thoughts of the rivers as an omen. But now I tried once more to think of small talk. I saw a large curl of rubber on the shoulder of the road and then another a little later on and I said to Mr. Chinh, "Those are retreads from trucks. In Vietnam some enterprising man would have already collected those to make some use of them. Here no one cares."

The old man did not speak, but after a few moments I sensed something beside me and I glanced and found him staring at me. "Do we have far to go?" he asked.

"Perhaps an hour and a half," I said.

"May I roll down the window?"

"Of course," I said. I turned off the air conditioning and as he made faint grabbing motions at the door, I pressed the power button and lowered his window. Mr. Chinh turned his face to me with eyes slightly widened in what looked to me like alarm. "They're power windows," I said. "No handle."

His face did not change. I thought to explain further, but before I could, he turned to the window and leaned slightly forward so that the wind rushed into his face, and his hair—still more black than gray—rose and danced and he was just a little bit scary to me for some reason. So I concentrated again on the road and I was happy to let him stay silent, watching the Texas highway, and this was a terrible mistake.

If I'd forced him into conversation earlier, I would've had more time to prepare for our arrival in Lake Charles. Not that I could have done much, though. As it was, we were only fifteen minutes or so from home. We'd already crossed the Sabine River into Louisiana and I'd pointed it out to Mr. Chinh, the first words spoken in the car for an hour. Even that didn't start the conversation. Some time later the wandering of his own mind finally made him speak. He said, "The air feels good here. It's good when you can feel it on your face as you drive."

I naturally thought he was talking to me, but when I said, "Yes, that's right," he snapped his head around as if he'd forgotten that I was there.

What could I have said to such a reaction? I should have spoken of it to him right away. But I treated it as I would treat Mai waking from a dream and not knowing where she is. I said, "We're less than twenty miles from Lake Charles, Mr. Chinh."

He did not reply, but his face softened, as if he was awake now.

I said, "Mai can't wait to see you. And our children are very excited."

He did not acknowledge this, which I thought was rude for the grandfather who was becoming the elder of our household. Instead, he looked out the window again, and he said, "My favorite car of all was a Hotchkiss. I had a 1934 Hotchkiss. An AM80 tourer. It was a wonderful car. I would drive it from Saigon to Hanoi. A fine car. Just like the car that won the Monte Carlo rally in 1932. I drove many cars to Hanoi over the years. Citroën, Peugeot, Ford, Desoto, Simca. But the Hotchkiss was the best. I would drive to Hanoi at the end of the year and spend ten days and return. It was eighteen hundred kilometers. I drove it in two days. I'd drive in the day and my driver would drive at night. At night it was very nice. We had the top down and the moon was shining and we drove along the beach. Then we'd stop and turn the lights on and rabbits would come out and we'd catch them. Very simple. I can see their eyes shining in the lights. Then we'd make a fire on the beach. The sparks would fly up and we'd sit and eat and listen to the sea. It was very nice, driving. Very nice."

Mr. Chinh stopped speaking. He kept his face to the wind and I was conscious of the hum of my Acura's engine and I felt very strange. This man beside me was rushing along the South China Sea. Right now. He had felt something so strong that he could summon it up and place himself within it and the moment would not fade, the eyes of the rabbits still shone and the sparks still climbed into the sky and he was a happy man.

Then we were passing the oil refineries west of the lake and we rose on the I-10 bridge and Lake Charles was before us and I said to Mr. Chinh, "We are almost home now."

And the old man turned to me and said, "Where is it that we are going?"

"Where?"

"You're the friend of my nephew?"

"I'm the husband of Mai, your granddaughter," I said, and I tried to tell myself he was still caught on some beach on the way to Hanoi.

"Granddaughter?" he said.

"Mai. The daughter of your daughter Chim." I was trying to hold off the feeling in my chest that moved like the old man's hair was moving in the wind.

Mr. Chinh slowly cocked his head and he narrowed his eyes and he thought for a long moment and said, "Chim lost her husband in the sea."

"Yes," I said, and I drew a breath in relief. But then the old man said, "She had no daughter."

"What do you mean? Of course she had a daughter."

"I think she was childless."

"She had a daughter and a son." I found that I was shouting. Perhaps I should have pulled off to the side of the road at that moment. I should have pulled off and tried to get through to Mr. Chinh. But it would have been futile, and then I would still have been forced to take him to my wife. I couldn't very well just walk him into the lake and drive away. As it was, I had five more minutes as I drove to our house, and I spent every second trying carefully to explain who Mai was. But Mr. Chinh could not remember. Worse than that. He was certain I was wrong.

I stopped at the final stop sign before our house and I tried once more. "Mai is the daughter of Nho and Chim. Nho died in the sea, just as you said. Then you were like a father to Mai . . . you carried her on your back."

"My daughter Chim had no children. She lived in Nha Trang."

"Not in Nha Trang. She never lived in Nha Trang."

Mr. Chinh shook his head no, refuting me with the gentleness of absolute conviction. "She lived on the beach of Nha Trang, a very beautiful beach. And she had no children. She was just a little girl herself. How could she have children?"

I felt weak now. I could barely speak the words, but I said, "She had a daughter. My wife. You love her."

The old man finally just turned his face away from me. He sat with his head in the window as if he was patiently waiting for the wind to start up again.

I felt very bad for my wife. But it wasn't that simple. I've become a blunt man. Not like a Vietnamese at all. It's the way I do business. So I will say this bluntly. I felt bad for Mai, but I was even more concerned for myself. The old man frightened me. And it wasn't in the way you might think, saying to myself, Oh, that could be me over there sitting with my head out the window and forgetting who my closest relatives are. It was different from that, I knew.

I drove the last two blocks to our house on the corner. The long house with the steep roof and the massively gnarled live oak in the front yard. My family heard my car as I turned onto the side street and then into our driveway. They came to the side door and poured out and I got out of the car quickly, intercepting the children. I told my oldest son to take the others into the house and wait, to give their mother some time alone with her grandfather, who she hadn't seen in so many years. I have good children, obedient children, and they disappeared again even as I heard my wife opening the car door for Mr. Chinh.

I turned and looked and the old man was standing beside the car. My wife embraced him and his head was perched on her shoulder and there was nothing on his face at all, no feeling except perhaps the faintest wrinkling of puzzlement. Perhaps I should have stayed at my wife's side as the old man went on to explain

to her that she didn't exist. But I could not. I wished to walk briskly away, far from this house, far from the old man and his granddaughter. I wished to walk as fast as I could, to run. But at least I fought that desire. I simply turned away and moved off, along the side of the house to the front yard.

I stopped near the live oak and looked about, trying to see things. Trying to see this tree, for instance. This tree as black as a charcoal cricket and with great lower limbs, as massive themselves as the main trunks of most other trees, shooting straight out and then sagging and rooting again in the ground. A monstrous tree. I leaned against it and as I looked away, the tree faded within me. It was gone and I envied the old man, I knew. I envied him driving his Hotchkiss along the beach half a century ago. Envied him his sparks flying into the air. But my very envy frightened me. Look at the man, I thought. He remembered his car, but he can't remember his granddaughter.

And I demanded of myself: Could I? Even as I stood there? Could I remember this woman who I loved? I'd seen her just moments ago. I'd lived with her for more than twenty years. And certainly if she was standing there beside me, if she spoke, she would have been intensely familiar. But separated from her, I could not picture her clearly. I could construct her face accurately in my mind. But the image did not burn there, did not rush upon me and fill me up with the feelings that I genuinely held for her. I could not put my face into the wind and see her eyes as clearly as Mr. Chinh saw the eyes of the rabbits in his headlights.

Not the eyes of my wife and not my country either. I'd lost a whole country and I didn't give it a thought. Vũng Tàu was a beautiful city, and if I put my face into the wind, I could see nothing of it clearly, not its shaded streets or its white-sand beaches, not the South China Sea lying there beside it. I can speak these words and perhaps you can see these things clearly because you are using your imagination. But I cannot imagine these things because I lived them, and to remember them with the vividness I know they should have is impossible. They are lost to me.

Except perhaps when I am as old as Mr. Chinh. Perhaps he, too, moved through his life as distracted as me. Perhaps only after he forgot his granddaughter did he remember his Hotchkiss. And perhaps that was necessary. Perhaps he had to forget the one to remember the other. Not that I think he'd made that conscious choice. Something deep inside him was sorting out his life as it was about to end. And that is what frightens me the most. I am afraid that deep down I am built on a much smaller scale than the surface of my mind aspires to. When something finally comes back to me with real force, perhaps it will be a luxury car hanging on a crane or the freshly painted wall of a new dry-cleaning

store or the faint buzz of the alarm clock beside my bed. Deep down, secretly, I may be prepared to betray all that I think I love the most.

This is what brought me to the slump of grief against the live oak in my front yard. I leaned there and the time passed and then my wife crept up beside me. I turned to her and she was crying quietly, her head bowed and her hand covering her eyes.

"I'm sorry," I said.

"I put him in the guest room," she said. "He thanked me as he would an innkeeper." She sobbed faintly and I wanted to touch her, but my arm was very heavy, as if I was standing at the bottom of the sea. It rose only a few inches from my side. Then she said, "I thought he might remember after he slept."

I could neither reassure her with a lie nor make her face the truth. But I had to do something. I had thought too much about this already. A good businessman knows when to stop thinking and to act instead. I drew close to my wife, but only briefly did my arm rise and hold her. That was the same as all the other forgotten gestures of my life. Suddenly I surprised myself and my wife, too. I stepped in front of her and crouched down and before either of us could think to feel foolish, I had taken Mai onto my back and straightened up and I began to move about the yard, walking at first, down the long drooping lower branch of the oak tree and then faster along the sidewalk and then up the other side of the house, and I was going faster and she only protested for a moment before she was laughing and holding on tighter, clinging with her legs about my waist and her arms around my neck, and I ran with her, ran as fast as I could so that she laughed harder and I felt her clinging against me, pressing against me, and I felt her breath on the side of my face as warm and moist as a breeze off the South China Sea.

Tet Festival food stand, 1995

Mitch Epstein

from the series Vietnam in Versailles

All images were made in Versailles, Louisiana.

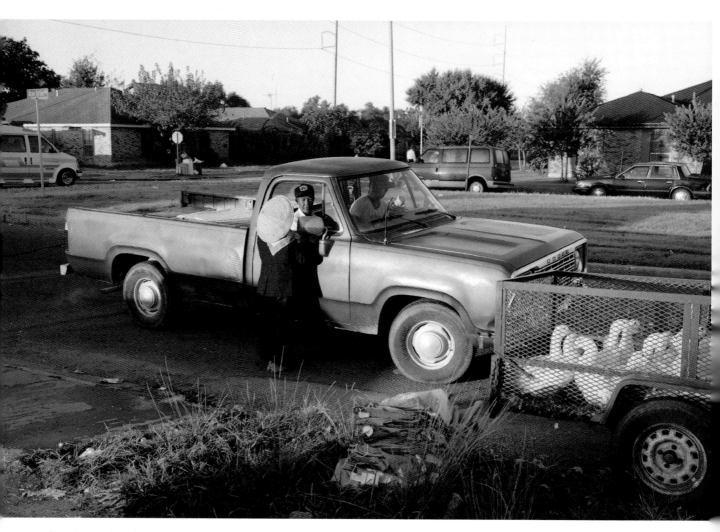

Saturday squat market, 1994

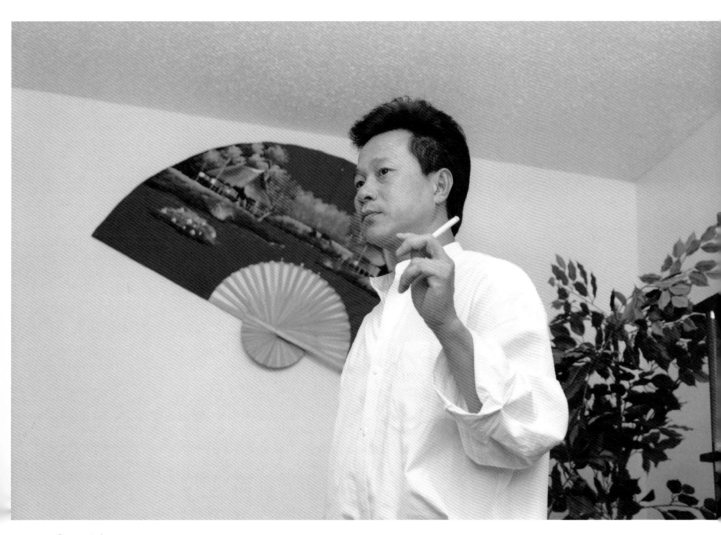

Souvenir fan, 1993

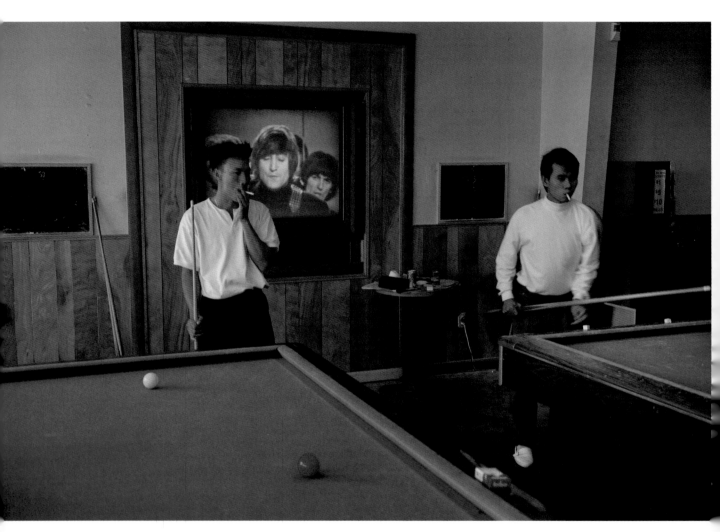

Billiards club, 1993

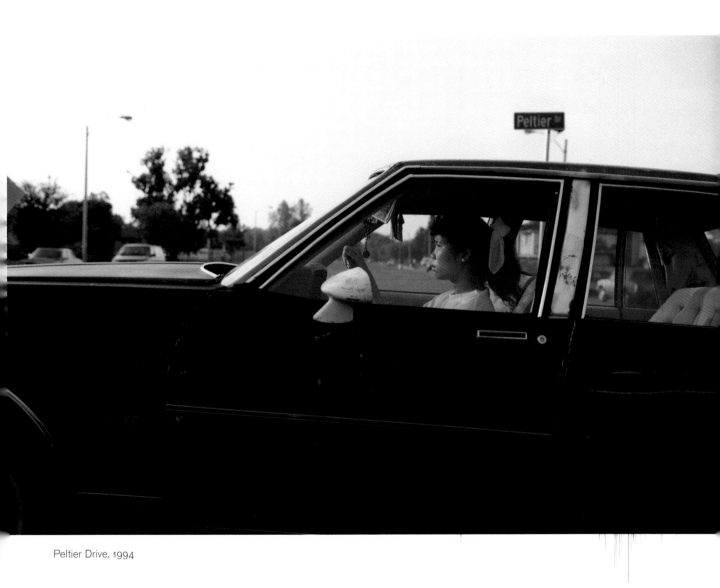

Peltier Drive, 1994

Vegetable gardener, 1993

Sidewalk graffitti, 1995

Scenic garage doors, 1995

After Tet, 1995

Saints game, 1993

Virgin Mary, 1994

Pulling Jane

Jonathan Bowen

His daughter is home after her first year at Towson State. Richard, an insurance adjuster, was assigned to storm duty in Louisiana the last two weeks of December, the period of her winter break Jane chose to spend at home. So the last time he saw her was a full nine months ago, and one of the intervening changes he finds difficult to bear is that his daughter has discontinued the practice of shaving her legs. When she hikes up her skirt to sit on a stool at the kitchen counter, Richard feels a heat slowly fan across his face. The three holes in her earlobe run through with steel studs, the bralessness showing her to have become more woman than he would've guessed, the black-framed Buddy Holly glasses despite her perfect vision—all are new, but none of them is what bothers Richard. What bothers him is something she said in her sleep the night she came home.

The two of them are finishing lunch while Richard's wife does crossword puzzles beneath a Cinzano umbrella on the patio beside the kidney-shaped swimming pool. Sara is a chemistry teacher and the head swimming coach at Bethesda High School. Last month she sprained both ankles in a fall from a diving platform, and during her confinement to a wheelchair, her interest in crosswords has grown to something like an addiction. From the kitchen, all Richard can see of his wife are her long, lean swimmer's legs booted with soft casts, and the pencil in her hand poised over the checkerboard puzzle.

Richard turns to his daughter without looking at her, pouring a tumbler of iced tea. "I guess they don't sell razors in Towson?"

"Oh, Father." This, too, is a recent invention. Before she left home Jane always called him Daddy, a name Richard silently disliked: it smacked too much of the

Waltons. But he's even more uneasy with this new name, one he has always associated with deity—*Our Father, who art in heaven*. Jane says, "Father, for centuries women abused their bodies for the purpose of making themselves more attractive to men. Plucking and painting, shaving and curling. It's over. The buck stops here." She slaps herself on the knees.

Richard gives her a look. It's the look of indictment he gives a client after inspecting a claim—a trailer home in ashes, an oak smashed through a car windshield—and concluding from telltale clues that the damage has been self-inflicted.

"Come on," he calls over his shoulder, turning with a glass of tea in each hand, "let's go outside and visit the cripple."

And he moves quickly through the doorway, not realizing until he's already outside that his daughter has stayed behind.

It is the end of May, the second month of his sobriety, the dogwood and forsythia have bloomed, and in the playground across the road children are playing TV tag. Richard remembers all the afternoons he spent on this patio feigning attention to insurance work while he watched Jane romp on the jungle gym in that same playground. He'd taken the scope off a BB rifle to track her without being noticed. Afraid she might break up her bones in a fall, his sense then was of how little he could protect her. His worry would send him off to the kitchen for a tall glass of Ancient Age over crushed ice. Later, as his vision of her became blurred, like something viewed through a prism, he worried that if she did get hurt, he might be too incapacitated to respond. This dread carried him, again, to the kitchen.

Each drink after the first imbued him with a sense of power and absolute control that multiplied in inverse proportion to the level of stuff remaining in the bottle. Richard had a singleness of mission that he imagined as available in the sober world only to Kamikaze pilots. One afternoon, without planning to, without knowing why, he walked over to where Jane was playing at the top of the sliding board, and, in the instant he approached, she stumbled into the air. Richard simply opened his arms and found her in them. He felt angelic.

Those afternoons on the playground make up most of the brief catalog of memories Richard has of his daughter in her younger days. Often he simply sits and tries to remember more. Across the screen of his closed eyelids he plays out scenes of father and daughter caught in a tender moment—a first lesson in shoelace tying, a shared snowcone at the zoo, a bearhug to soothe a skinned knee. But none of these moments is any he lived through. They're scenes from TV commercials. When he tries to haul up a particular recollection, all he gets is a

hazy, gray canvas. Pulling blanks is what they called it at the detox center, and the doctors also liked to say that your memory is the doorway to wholeness.

"What's a six-letter word for *frail?*" Sara asks.

"Come inside and talk to your daughter," Richard says, handing her the glass. "Flimsy."

"Good. A four-letter word for a slovenly woman."

Richard considers a smart-aleck response, thinks better of it. "Dowd."

In high school he made a New Year's resolution to read straight through *Webster's Encyclopedic Dictionary*, writing down all unfamiliar words on yellow legal pads to memorize, though his powers of word recollection now seem like a mockery. Lately he feels like nothing more than Sara's reference book, and, standing over her on the patio, he has the odd sensation of seeing his wife for the first time—a woman with much heart and spine, good-looking in a big-boned Meryl Streep way. Lately she has become inscrutable, like a medallion dropped overboard, receding into murky water, out of reach, out of sight. Sara makes no move except to tap her pencil idly on the armrest of her chair. "A four-letter word for a kind of tide."

"I don't know," Richard tells her. He puts his hands on the back of her Electroped. The stainless steel chair has whitewalled pneumatic tires, a levered throttle and rheostat, a joystick for steering—it handles sharp corners like a Porsche—the joke between Richard and Sara is that, considering its monthly rental cost, the thing should mow grass and give a killer hand-job.

Richard looks out over the swimming pool, and the glare makes him want to hide his eyes. Today everything is mirror and chrome, brightness and dazzle. "Let's go inside," he says.

"Five letters for a lateral step. Begins with *s.*"

"If I tell you, will you come inside?" Richard asks. She nods. "Sidle. And neap."

"What's neat?"

"*Neap.* A neap tide—from before."

"Oh, right. Good."

"Let's go in the house now."

Sara sings, "Hey, you, get off of my cloud."

"Gimme three steps," Richard sings, grins, and takes comfort from the familiarity of this old exchange, "won't you gimme three steps, gimme three steps toward the door."

"Walk this way, he told me to, walk this way," Sara sings, and slips the Electroped into gear. When Richard offers to guide the chair, she shoos him on

ahead. At the open door he pauses as Sara moves slowly, taking her time to cross the patio, having a little trouble one-handing the joystick as she scribbles the answers onto her crossword. In the kitchen Jane swings shut a cabinet. Richard waits, feigns a problem with his left shoe, takes it off, shakes it out, and slowly relaces it until Sara has come alongside, because he doesn't want to go in the house, where his daughter is, alone.

Jane is a sleepwalker. The first time it happened was during a family vacation to Cape Hatteras. They had rented a one-bedroom cottage right on the shore, with a kitchen flanked by an airy atrium and a sofabed for Jane in the den. The second night, Richard was wakened after midnight by a knock at the door. He opened it to a young man with a peachfuzz mustache and long hair parted down the middle, a mechanic or repairman, judging by the condition of his hands. He had an unlighted cigarette in his hand resting on top of Jane's head. He had found her, he said, trying to squeeze her barrette into the coin slot of the candy machine on the terrace of the hotel next door. Tiny and knock-kneed in her nightie, Jane was standing with both hands covering her eyes, rocking in her Miss Piggy slippers. The young man's T-shirt said I'M WITH STUPID and a massive finger pointed left, at Jane.

Richard tried to proof the house. He installed deadbolts in the doors and put iron grating on the windows of Jane's bedroom. This was when they lived in Orlando, and he made the rounds every night, checking for sharp utensils left on the kitchen counter, open doors she might bump into, rugs that might trip her. He stored toys, roller skates and her mini bowling set, anything that might cause a fall. He gathered shoes and magazines. It was easier when he put down his glass. He stapled the stereo wires out of reach, high on the wall. He put all the electric fans in the attic. He bought plastic insertion guards for the outlets, did everything thinkable to make the house a place in which no harm could visit his daughter wandering through it like a dream. In the end it turned out that Jane did most of her sleepwalking away from home—at camp or slumber parties, on vacations, visits with the Tennessee relatives. It seemed to be the confusion of a strange place that drew her out of bed and into the dark.

On the night Jane came home from her first year of college, last night, Richard woke suddenly. The digital clock said 3:18. He had been dreaming of alcohol. In his drinking days his dreams were about flying over lush wheat fields, and now he dreamt of abandoned houses with well-stocked bars. Sara was sound asleep. When he huddled against her, she sighed—lovingly, he liked to think—and pushed close. He lay, hoping for sleep. But after a time he felt a hollow rumble in his belly, so he slipped out of the sheets, careful not to jostle Sara's

casts resting like bookends at the foot of the bed, and made his way toward the kitchen.

Jane was there. Afterward, he would remember with the extraordinary clarity of a hallucination how the kitchen appeared in that instant. Moonlight came in through the window giving a glossy sheen to the Formica counter, cross-hatching the floor, everything drawn in the dramatic contrast of deep shadow and white light, and it would occur to Richard that this house, her home, had become strange to his daughter. She had turned on all four burners on the gas stove and stood facing it in an oversized Towson State T-shirt, her eyes wide open, one hand resting on the counter's edge, as if she were watching a pan of soup. The high flames made her face look blue, her eyes socketed in shadow. He started to speak, then stopped short, for fear of startling her into the fire. A soft whisper came from the high flames, or maybe it was the sound in his ears of his own blood rushing. He tried to move toward his daughter, and found that he couldn't.

"Help me," she said, "I'm dying."

And Richard saw her as dead.

In the afternoon Richard helps Sara bathe. He encloses her casts in plastic leaf bags and seals them with rubber bands. He helps her out of her clothes, thinking of all the times she helped him do the same, nights when he came home too drunk to operate a zipper. When Sara is undressed, Richard lifts her sideways into the tub, so that her legs from the knees down hang outside. As she's lowered into the water she holds her crossword magazine overhead, like a soldier would hold his rifle while crossing a creek.

"Four letters for *desire*," Sara says. "Last letter's *e*."

Richard shampoos her hair, careful not to spill suds onto her magazine. "Do you believe in ghosts?"

"The living dead, you mean?"

"Yeah, the living dead, the dead living, both kinds."

"There's more than one kind?"

"I don't know, just—do you believe in it?"

"No. Six-letter word for *cancel*."

"Is Jane still covered by our insurance plan?" Richard asks. And then, "Negate. And urge, for desire."

"Good, good." Sara prints the letters inside the tiny boxes. "She got new insurance this fall at Towson."

Richard steps into the tub and submerges his wife in the manner of a baptism, to rinse her hair. She surfaces and demands to know why Richard is so distracted.

He says nothing. He cannot disclose the source of his distraction: his daughter's spirit spoke to him and placed in his pocket the sole responsibility for warding off her death. When he saw Jane standing dead before the oven, he failed to press for more information—a nailed-down date, the exact hour of her demise— he feels ill-equipped for the task of protecting her. If he knew the means of her coming death, then he could act to block it. Had she spoken of a fiery highway crash, Richard would simply forbid her to drive. Had she told of falling prey to some killing disease, he would discreetly slip antibiotics and vitamins into her food. The trick is that he must go undetected in his surveillance of her, because this new Jane who has arrived home from college with unshaven legs and a fancy name for him seems to have acquired an independence which might lead her to bolt at the first suggestion that he is lording over her. It will take all his smarts and cunning, all his courage and backhandedness to do this thing his daughter's spirit has asked him from beyond death to accomplish.

There's another possibility. It could be that Jane's words were simply the mumblings of a sleepwalker, a snippet of dialogue from a dream. But if Richard takes that angle, and she dies, how will he live?

Sara insists on washing her own body, and orders Richard out of the bathroom. As he waits in the hallway with a fresh towel for his wife to call him, Jane returns from the swimming pool. She comes down the hall in a terry-cloth shift over her swimsuit, goggles around her neck, carrying wet towels and a Walkman. Richard presses his back against the wall, allowing her room to pass. He can't believe he let her swim alone, unwatched. He catches a whiff of her tanning lotion, like a piña colada. He longs for alcohol.

That evening, Richard drives Sara to the botanical garden across town. One of her college roommates is getting married there, but when they arrive it turns out that Sara has misread the time on her invitation. The ceremony is already over. The reception is in full swing. Richard walks behind Sara with his hands on her shoulders as she coolly navigates her Electroped through the shifting maze of young women, all done up in salmon dresses and pearls, men in tuxedos. Richard tried to talk Jane into sneaking along, but she begged off. Later that night, she's going to a party at the home of a high school friend.

Sara finds her roommate, and while they chat, Richard makes his way to the buffet table. He loads a plate with steamed mussels and pistolets. The next table is the bar. The young woman behind it looks about seventeen. She has on a strapless taffeta gown the color of green in traffic lights, and her hair is pulled back in a French braid so tight that it seems to make her eyes bug out. All the bottles are

uncapped, and Richard imagines each liquor. The astringent gin, medicinal scotch, the hot bite of tequila. Imperious bourbon—Ancient Age, Richard's brand.

"Seltzer," he says. "Please."

"You look like Alex Trebek," she says. "The hair."

"I get that a lot."

Richard takes the glass, removes the lemon wedge, squeezes it into the water. The woman pours a shot of vodka into a cup and downs it, head tossed sharply back, eyes tipped up. She's drunk to the point of dizziness, Richard sees now.

"You're too young to drink like that," Richard says. "You're younger than my daughter."

"Listen, Alex, I can drink a ton, and so can your daughter."

"My daughter doesn't drink."

"Right, Alex, whatever you say."

"You don't know her."

She hooks down another shot, then offers one to Richard, and he looks at it. "Alex, have a drink! It's 8 P.M., do you know where your daughter is?"

"Yes, I do. She's at home."

"Sure, Alex. Whatever."

Richard has to put a hand on the table to steady himself. This dazing fadeout produces an almost unbearable desire to reach for the bottle of bourbon. He turns his back and searches the crowd for Sara. Across the hall, she's demonstrating the finer points of the breaststroke, fanning her arms in the air, head bobbing. A sizeable queue has formed to put graffiti on her casts. Sara smiles, luxuriating in the attention of her friends, and Richard feels a stab of pity for his wife. It goes through his mind how destroyed she will be, how she will blame him, should he allow their daughter to slip into death without Sara having had the chance to say good-bye. He considers telling her about his vision of Jane dead, but he understands that his daughter's message was intended for him alone. She has spoken backward to the living from beyond her future final breath, a double-joint in time, and Richard is certain that the great effort required to communicate in this manner would lead Jane to carefully consider her choice of confidant. If anything, his daughter is cautious. She knew she might have only one chance, and since her father was the one most indebted to her—a debt accrued over the first seventeen years of her life, which he spent drunk, as dead to her as she will be to him should he fail—he would therefore feel the strongest tow of obligation to compensate for his damage. As an insurance adjuster, Richard understands her reasoning. She has called upon him in this,

the second, aching month of his sobriety, and for Richard to make others privy to the confidence established in him by Jane would be a betrayal. It might even hurry her death.

Richard glances over his shoulder at the girl behind the bar. She's pointing an imaginary pistol at the heads around her and making gunfire noises out of the side of her mouth. He cuts through the crowd toward his wife, puts a hand on her shoulder. "Let's go home."

She looks up at him from the piano bench with an expression of surprise, then pain, and Richard realizes that he has shouted and is gripping her shoulder, digging his fingertips into the hollow space below her collarbone. He takes his hand away, folds his arms, then unfolds them, and hides his hands in his pockets. The women around Sara step backward, hands going up to cover their mouths.

"Gimme me three steps, gimme three steps toward the door," he sings. Sara is having none of it. He tells her once more that he wants to leave, and walks outside.

The lawn is lush and clipped low as a putting green. Moisture soaks through his deck shoes, sends a chill into the bones of his feet. There is no moon, and Richard looks up at the bright stars, craning his neck back. The stars are like holes leading to another world, a world with light sufficiently immense to fuel its inhabitants with powers of self-discipline. He names the constellations. Hercules. Corona Borealis. He breathes out the ancient words. He hears Sara making her way toward him. He doesn't want to do it again, to hurt the people he loves out of his need for alcohol. He feels panic like what he felt the first few days of his residence in the detox hospital. His body seizes up, his hands shake, he can't speak or think, like the inability to scream in nightmares.

At home, Richard steps through the front door just as Jane is coming out of the basement stairwell opposite the foyer. She has on bell-bottoms with patched knees, a ratty mohair jacket, and unlaced construction boots. Her eyebrows look bleached above blue eyeshadow. Richard remembers the color of her face in the glow of flames from the stove, a blue like the skin of the suffocated.

Sara drives around, the tires of her Electroped whirring over the polished hardwood floor, and heads straight for the kitchen. "Lovely," she says, passing Jane with a sidelong glance. "My daughter, the vagrant."

When he can finally manage to speak, Richard says, "You're not wearing those clothes out anywhere."

"It's okay, Father. It's called grunge. It's fashionable. It's in *Vogue*."

"I don't care where it is. You are not leaving this house in that get-up."

"It's not a get-up. It's what I'm wearing to the party."

They are alone in the foyer now, waiting at arm's length for what will happen next. From the kitchen come the tinkle and clang of Sara putting away dishes. The only sound between Richard and his daughter is the whisper of their breathing. It's like the final standoff in the dusty street of some bad TV Western, two wary gunslingers staring one another down, waiting to see who will back off, who will draw.

Finally Jane pushes past him down the hall toward her bedroom. She closes herself inside, and Richard hears her moving around in there, gathering her purse and keys. He can't imagine where she got those kind of clothes, that uniform of dissent. He stomps down the stairwell to the laundry room with his heart beating in his throat. He has the idea that he will shred and burn whatever he finds. He opens the dryer door and pulls out a white cotton blouse with a lace-work collar, holds it up by the shoulders. It's the blouse Jane was wearing the day he went into the hospital. He recalls how she waited with him in the lobby as he filled out the admission paperwork, her hands playing about the lace of her blouse. In the hot, airless basement, Richard hugs the blouse to his chest, breathes. He feels oddly elated, giddy, the way he used to feel watching the bartender pour his first drink.

He has a memory of Jane working at the assembly of a model airplane, head bent over her desk, tongue curling out the side of her mouth. Fanned across the bridge of her nose and in the hollow below her collarbone are chicken pox scars, so it must be the summer she turned twelve. She would hang the finished models with twine from her bedroom ceiling, and when the windows were open to the breezes of thunderstorms, the planes flew. Richard smiles, remembers their first airplane ride together. Jane was only four, and her waist so tiny that the steward had to stuff a pillow behind her to take up the slack in the seatbelt.

Richard looks at the blouse in his hands. The naked light bulb overhead gives it a sheen. He folds the sleeves behind and doubles the blouse over, pats it down. With the flat of his hand he irons out every wrinkle, and remembers. It was an afternoon, he stood beside a rope clothesline folding cloth diapers, Sara nursed Jane in a wicker rocker, under the shade of elms. The smell of cotton dried by summer sun, the softness against his calloused hands. Was that yard in Orlando or Baltimore? He pulls another blouse from the dryer and gets on with the folding. In time, he will sort it all out. He'll remember everything.

Eric Breitenbach

from the series Photographs from Florida, 1989–94

Home, Key West

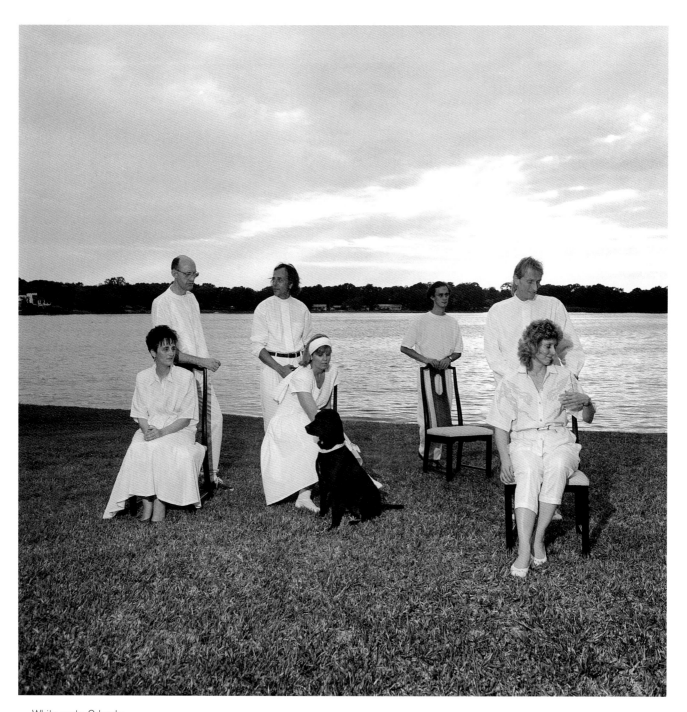

White party, Orlando

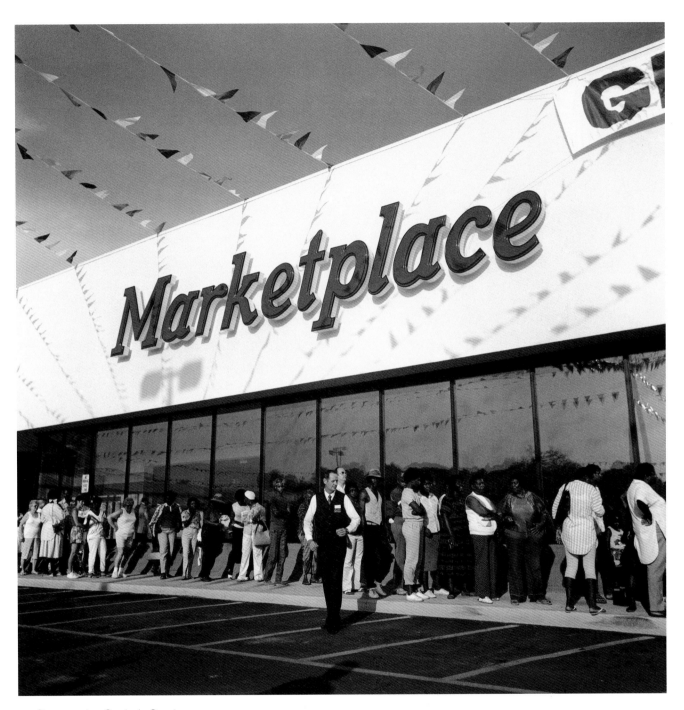

Store opening, Seminole County

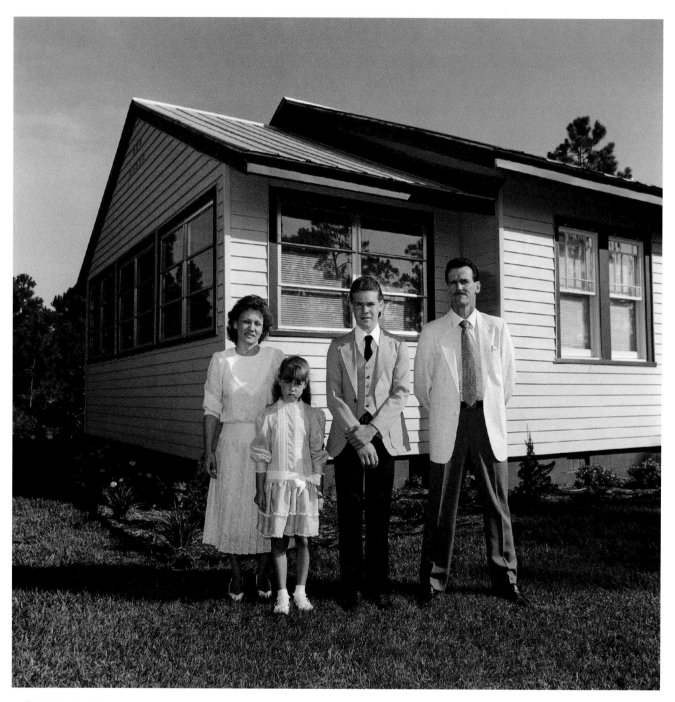

Family, Barberville

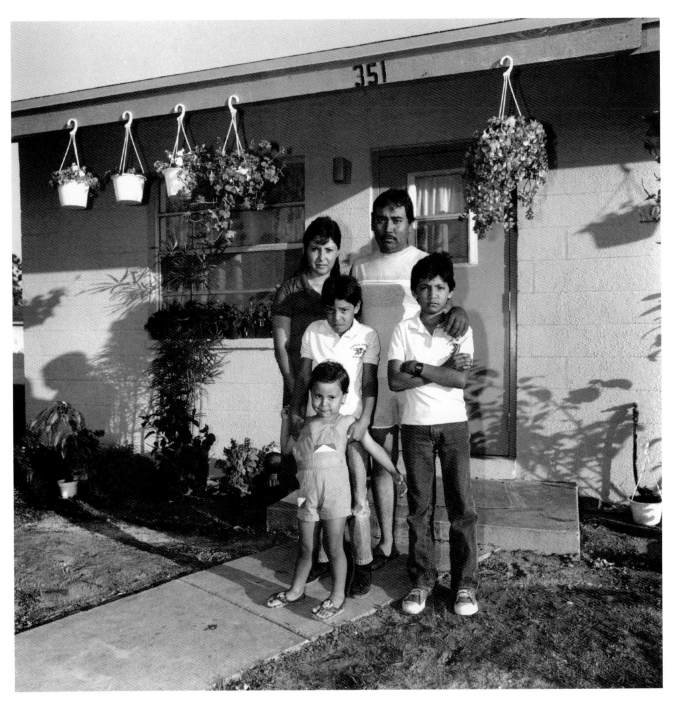

Family, Immokalee

Parade, Holly Hill

Public officials at a bridge dedication, Sanford

Above: Members of a high school swim team, Orlando

Right: Tennis complex, Key Biscayne

U.S. 27, south of Venus

Triathlete, Lake Mary

Pretty Please

Nanci Kincaid

I looked for proof all my life and found enough evidence to mount a fairly decent defense, you know, in case I was ever taken to court and made to prove anything to the world. But I wanted better than fairly decent. I wanted to know for certain that if Daddy was called down to the police station he could pick me out of a lineup of daughters. "That one," he would point at me, "is my daughter, Lee." After which I would break down and confess everything.

He read to me when I was young, the little engine that said, *IthinkIcan*, *IthinkIcan*, *IthinkIcan*, and all about princesses who were awakened by kisses and swept away into the *happyeverafter* by handsome princes. Even about the beautiful girl, no older than I was, who could kiss frogs and turn them into perfectly decent men.

He drove me to Sunday School, too. Rose had to be at church unnaturally early, and Daddy was left with the task of constructing my ponytail out of the thin wisps of my uncooperative hair. He went at it like he was building a bookcase. He tied my sashes into limp, heartbreaking bows that I was glad I couldn't see. He paid for me to go to Baptist church camp every summer without complaining and always gave me five dollars to waste while I was there. He never spanked me or yelled at me or punished me for anything. He said *I love you, too* when I confessed my love for him—but it always felt like I was saying *thank you* and he was using the same words to say *you're welcome*.

Most nights we ate suppers where Rose and I chatted and laughed and tried to haul Daddy into the conversational boat we struggled to keep afloat. But he always sat in his chair like a big fish at the end of our witty and enticing lines

and no matter how we tugged he never budged. I think now that if we had ever managed to pull him into the boat—which was the family, our tiny two-woman family—he would have sunk it altogether by just the pure weight of his unhappiness. Even now sometimes I think of my father as the fish that got away. A whale of a fish. I think of myself and Rose as wasted bait he wouldn't take, like we were a couple of frantic pink worms twisting ourselves into voluntary knots around the heart-shaped hook we hoped he'd swallow. But we never even seemed to tempt him.

The less sure I was that Daddy loved me, the more desperate I was to love him well, so well, that maybe he could not help reciprocating, even against his will. So I set out to do my part and his part, too. The more he withheld, the more I gave. I was determined not only to put in my half of the love, but also to put in his half for him since he was so ill-equipped to do it himself. I guess this was when I began my career as would-be savior. If I couldn't be Daddy's Jesus, then I would be his Virgin Mary.

I thanked God regularly that I was pretty enough. It was the thing I believed Daddy valued most about me. He rarely told me I was pretty but he looked at me sometimes in a way that let me think he thought so. I recognized the look because it was the same one I had seen him aim at women who walked past him on the street, after which he mumbled to me, "She was attractive."

Also, whenever I invited girlfriends to our house and introduced them to Daddy, his only comment would come later, after they had gone home, when he remarked on whether or not they were pretty—or just exactly how pretty they were. He might say, "Frances Delmar is a pretty girl." This meant he liked Frances Delmar. Or "I'm sure Margaret is a nice girl, but she's not a bit pretty." This meant he did not like Margaret. It was a code between us that I understood perfectly. He was never rude to any friend I invited home. He was always a perfect gentleman.

When we were in high school and Frances Delmar started wearing tight skirts, Daddy said, "Frances Delmar isn't as pretty as she used to be." This meant Frances Delmar was getting trashy. I lived in terror of the day Daddy might decide I was no longer pretty. To ward it off I spent a great amount of time learning to *fix up*. Late afternoons Rose said to me, "Lee, honey, you might want to fix up a little. Your daddy will be home soon." Rose herself was in a constant fixed-up state, which loomed before me like a living example.

I tried not to let Daddy see me with curlers in my hair or unshaved legs or blemished skin. It felt too much like failing a test—like letting him down when he was depending on me. The happiest moments of my life were when Daddy,

after surveying the girls in my Sunday School class, or at a spend-the-night party, or dressed for a dance, would lean over and whisper, "You're as pretty as any girl here." It never mattered that it wasn't true.

Even Lilly, our maid, was not immune. When I rode with Daddy to take her home in the afternoon, he always over-watched her walk up to the porch and fumble to unlock her door. He watched the way her hips shifted as she put one foot in front of the other, the way she braced the screened door with her elbow while she rummaged through her purse searching for her house key. "Lilly is a fine-looking woman, isn't she?" he said. "I don't care if she is colored."

I hoped Daddy didn't go around saying this to just anybody, especially not Lilly, who I knew for a fact didn't allow white men to look her over. The nicest thing she had ever said about Daddy was that he wasn't "bad as some them white mens." And once she'd said, "Your daddy is right harmless." I wanted her to keep thinking so. She would not like him sitting out in a hot car with the motor running, paying her compliments behind her back. I didn't like it either.

Daddy worked leisurely hours as the manager of an insurance company that his father, my grandfather, had owned. Now it belonged to Daddy. He was not a salesman. He was an owner/manager. This was a relief to Rose and me since we could never imagine Daddy persuading anyone to buy anything and were glad our livelihood didn't depend on such a thing. Daddy's life was less about per-suading than about never being persuaded. From as early as I can remember, even though I loved Daddy desperately, I made a decision to choose a husband very different from him. One who would not be so much work. I wanted to marry a happy man. A man who just came happy—automatically, all by himself—so it wouldn't be my job to make him that way.

Maybe from the stories Daddy had read me I got the idea that I should be Daddy's princess and Rose should be his queen. I became fixed on making this happen. Rose and I did our parts. For one thing, we both pretended Daddy was the king of the house. We did this two ways, by pretending that he owned the house and everything in it, including us, but at the same time we treated him like a special guest just stopping in from time to time to eat a good meal and watch a little TV. We didn't disturb him if we could avoid it. We didn't upset him. We didn't make demands. We only, on occasion, made polite requests. He almost always obliged. If he was a king didn't that make Rose a queen? Didn't that make me a princess? But Daddy wouldn't pretend back. Not that part about us.

Balls were what Daddy loved most. He played golf every weekend year-round and lots of afternoons after work, too. This is the main thing I ever heard Daddy and Rose argue about—the hours he spent on the golf course—especially when

he missed church to do it. "Maybe the golf course is my church," he said once. "Maybe golf is my religion, Rose. Did that ever occur to you?"

She didn't mind the money he spent joining country clubs or the money he bet on golf games. I don't even think she minded the drinking and the way he slurred his words when he got home—but she did mind sitting alone in the pew on Sunday morning. She minded being asked where Bennett was when he ought to be in church and having to think up something believable to say to people who had no intention of believing her and were just asking to be hateful.

Daddy had season tickets to BU football games and followed high school football, too. He acted like this was his real job, he was getting paid to do it, and his salary was already up into the millions. It's the only thing I know for sure he was ever serious about. He put a basketball hoop in our driveway and on rare occasions he shot baskets with me until after dark—unless Jett was around. Jett was Lilly's son. Daddy hired him to do our yard work. He liked Jett because Jett was a real good football player at his black high school. "Put that rake down, son," Daddy would say. "Let's me and you shoot some hoops. A little one-on-one." He made me sit in the grass and watch the two of them go at it. "Run get us a cold drink, Lee," he'd say, staggering around the driveway after the ball, panting, sweating, gasping for breath, making me think of a firm inner tube going soft, a leak someplace inside him that nobody could find, nobody could patch.

Jett beat Daddy every time. As much as Daddy hated losing, I knew he fully expected to lose and that was why he liked to play with Jett—because Jett would see to it that Daddy lost. And Daddy wanted that proven to him over and over again, that it was his destiny to lose. But it was clear he loved Jett for winning. Daddy had natural admiration for winners. It was like he was born admiring men who were better with balls than he was—even if that man happened to be black and more a kid than a man. I guess maybe those were the only moments Daddy ever came close to questioning white supremacy—but I'm not really sure.

Daddy watched football and golf and basketball and anything else ballish he could find on TV, but not boxing or horse races or car races because there were no balls involved in those. He tried to identify with the guys holding the trophy, accepting the check, or putting on the green blazer at the eighteenth hole at the Master's. These were his people—he wished. Winners. Their lives should have been his life. But something had gone wrong. He longed for the winner's circle and loved without reservation the men who lived winning lives, who mumbled their humble thanks into microphones on our television set.

This put Rose and me at a terrible disadvantage. We felt we needed to win something, too, in order to become real in Daddy's eyes. In order to show up at all

on the TV screen where Daddy watched for almost anything worthwhile in this life to happen. Rose was trying to win God's love. But me—what could I win?

More than once I went to sleep secretly wishing I was a son. Imagining myself as some sort of home-run hitter or some speed demon who could dodge the on-slaught of defensive linemen whose job it was to destroy me. I could get my picture in the paper the way Jett did, and then Daddy could read about me and know that I was worthy.

But the truth was Daddy had little respect for female athletes because he rarely found them pretty. There were a couple of professional women golfers who were the exception. He would call Rose and me into the den and point them out to us on TV. "Look at this," he'd say, "she's pretty good-looking for a lady golfer." The women always had blond hair and suntans. I had blond hair and a suntan, too, but there was nothing in me that longed to hit a ball, or kick one, or catch one, or throw one, or do anything at all to one. I wasn't inclined toward balls. I was too much like Rose. This was the whole trouble. And in my heart I blamed Rose for this.

It would be wrong to say that I ever gave up on wanting Daddy to love and adore me, like I imagined surely all other fathers did their daughters, but I made a deal with God that I would forego being loved by Daddy in that essential way. I promised God that I didn't mind if Daddy didn't love me the way he should, as long as he would love Rose the way he should. I am dead serious when I say I would have much preferred that Daddy love her than me. If he loved Rose enough, then I thought I could live off the scraps of their love. It would be enough.

But I never saw him hug her or kiss her or laugh at anything funny she said. He was not mean though. He did what she said to do for the most part, pick up Lilly in the mornings, get the Christmas decorations out of the attic, change the lightbulb in the bathroom, hose down the driveway. He didn't argue with her much. It was just that he obeyed so silently that he became ghostly to us. In dramatic moments I think my childhood was haunted by his ghostliness. It was my constant longing to be good enough, pretty enough, to bring him to life, to puff a breath into him that would resuscitate him or to speak words that would jump-start his heart—to somehow prove to both of us that he was real and alive. Not to wake him up with a kiss exactly, like all those stories he read me, but just to wake him up somehow. I got the idea at a very young age that love was an earned thing and I must work very very hard to deserve it.

"Friday is March fifth," I said. "Don't forget." I was always the one to remind Daddy of Rose's birthday.

"Here." He'd hand me a Pizitz credit card to buy her a gift from him. "You've got a better idea what she likes than I do." This was sad but true.

I picked out extravagant gifts for Rose; perfume sets, lacy slips and panties, silky nightgowns, add-a-pearl necklaces, and once a black satin French push-up bra, trying to fool my mother into thinking my father loved her. I wrote sweet cards and signed them *Love, Bennett*. I wanted her to believe that Daddy had searched the world over to find just the right gift, something romantic that would say to her all the things I feared he never said himself. Early on I took it to be my job to trick them into loving each other.

I was in junior high when the rumors first made their way to me. Girlfriends who heard their parents talking, whose fathers played golf with my father, whose mothers mentioned other women's names in sentences with my father's name. They delivered those sentences to me at school the next day—my friends. These sentences were hand-delivered like ropes to hang myself with, but I refused. I accepted each length of rope like it was really a ribbon for my hair, like it was something lovely and I was glad to have it.

"Don't pay attention to them," Frances Delmar said. "Your daddy is handsome. Lots of women probably flirt with him. That's all. Boy, I'd love it if anybody ever flirted with my daddy." We laughed because Frances Delmar's daddy was totally bald and totally fat. But he also loved her perfectly average-looking mother like crazy and I thought he worshiped the ground Frances Delmar walked on.

One day after school, the Tri-Hi-Y went to visit the Alabama Home for the Incurables, an old folks' home, mostly, that also had some deformed and insane children in it, too, who had no place else to go. There was a picture of Jesus hanging above every bed. It was our job to write letters for the bedridden patients as a service project. The Home for the Incurables seemed sort of like a pleasant prison. The people were strapped to their beds because they were loved, not because they were being punished. The nurse told us that. The patients wanted us to write letters to their family members, whom I secretly believed would never write them back.

I accidentally wandered into the room of a girl my age. I wished immediately that I hadn't. She seemed so glad to see me that I felt instant guilt about having never been there before. It's like when you walk into a place for the first time in your life and you know at once that you should have come sooner and oftener, but you also know you will never come back for the rest of your life if you can help it—you know all this in an ugly instant. The girl had a soup-bowl haircut

and too many teeth to fit into her smile. She had a disease where her muscles have minds of their own—and maybe her mind has muscles of its own, too—but the two were not connected. She didn't get to be still for even one second of her life. Everything was always jerking, jerking, even when she slept, I think.

"Hi," I said, trying to act like she was a girl from school, like I had known her all my life. I was casual. I got out my stationery and fountain pen. "Would you like me to write a letter for you?"

She smiled, nodded, then began the task of saying the word yes. She made yes into the longest one syllable word in the history of the world. I thought I would grow old and die before she finished the word.

"Who do you want me to write to?" I sat in the metal folding chair beside the door with the stationery in my lap and my pen poised. I tried to smile at her but it was hard because I was beginning to hate myself, my luckiness, my ability to sit still, which I had never appreciated, and the fact that I knew better than anyone that I didn't deserve to be lucky and probably God knew it by now and wished he could do things over and make me the girl in the bed and the girl in the bed me.

"Annnnnnnnnnnnnnnnnnnnnnna."

"You want me to write to Anna?"

She shook her head in big negative circles and tapped her finger on her chest.

"You don't want me to write to Anna?"

She pounded her finger harder against her rib cage. "Meeeeee."

"You're Anna?" "Oh," I said, "your name is Anna." My God, I hadn't even asked her her name. Everybody has a name.

"I'm Lee."

She smiled at me and nodded yes.

"So who do you want me to write to?" I scooted my chair closer so I could hear her and touch the bed if I decided to. Touch her leg maybe.

"Cheeeeeeeeese sauccccccccccce."

"Cheese sauce?" This was not going to work. She wasn't making sense. It seemed like I wasn't making sense either. We didn't have any shared words to volley back and forth. It was like we were trying to play verbal tennis only she had a bowling ball and I had a baseball bat and the net between us was too high anyway. "What? You want some cheese sauce?"

She shook her head in hard circles, then pointed to the wall above her head.

"Oh," I said, "Jesus. You want to write to Jesus?"

She nodded.

"Okay," I said, "Jesus it is." I scrawled across the stationery, "Dear Sweet Jesus."

At five o'clock the members of the Tri-Hi-Y gathered in front of the Home for the Incurables to wait for the mothers who would carpool us home. "Look, Lee. There's your daddy." Frances Delmar pointed to my father's car as it passed in front of us. We waved but he didn't see us.

He drove his car like he lived his life—as if the thing he was doing was never really the thing he was doing because in his head he was always off someplace better doing something better. Like that. He looked handsome though. I was proud of the somber-faced man who drove by us, distracted, in his shiny black Buick.

That night at dinner I talked about Anna just enough to say she had written a letter to Jesus, which I had mailed for her care of Rose Carraway, my mother, at First Baptist Church.

"How lovely," Rose said. Rose was big on getting messages to and from Jesus. If I had written to Jesus it wouldn't have been the sort of love letter Anna wrote. My letter would have said, "Jesus, what in the world is going on here? Why hast thou forsaken me?" There would be so much venom in my heart I would die from it. But I didn't talk about any of that. I locked Anna in the storage room behind my heart and pretended to have lost the key.

I mostly recited bits of a letter an old man had written to his daughter who lived in Ohio. Lord only knows if she'd ever write him back. Rose listened and shook her head. "There's nothing like family," she said. "Family is everything."

Then, like a fool, I said, "We saw you this afternoon, Daddy, when you drove by the Alabama Home for the Incurables."

"Not me," Daddy said.

"But it was you," I insisted. "I saw you myself. We all saw you."

"Then you must be seeing things," Daddy said, his eyes steady and blue. "The Home for the Incurables is all the way across town and I didn't leave the office all day. Came straight home after work."

Right before my eyes he was transforming into the ghost that haunted our house. "It wasn't me," he said flatly.

So I accepted that. No questions asked. I erased the memory of having seen him with my own two eyes and replaced it with the notion that I had only seen someone in a car like his. "You must have an evil twin." I shrugged and let it go.

"Anybody want dessert?" Rose said. "I've got coconut cake."

If there was a conspiracy going on in our house it was because we had all agreed to it. We all wanted it that way. Although I would have sworn on a stack of Bibles if given the chance that I never wanted it that way. That I had desperately

wanted it some other way. Real, I would have said. Sometimes I was so mad at Rose, my own mother, who allowed herself to be unloved and did it so cheerfully.

This was when I first began to suspect that it was possible to be so Baptist that you rendered yourself totally unlovable. If she weren't a preacher's secretary, if she weren't always rushing off to church for a wedding or a funeral would that make her a more interesting woman? Was Daddy defeated before he got started because he believed Rose loved Jesus more than she loved him? Did he wish she'd just become the bride of Christ and left him out of her life completely? I blamed Rose for not being lovable more than I blamed Daddy for not loving her. I always perceived Daddy as the victim in our home—although I never exactly understood how Rose and I got to be the villains. I thought we must have done it by loving Daddy too much. I hoped someday he would forgive us.

Margaret Sartor *from the series* Stealing Home

Katherine in the playhouse, Monroe, Louisiana, 1989

My mother, Tommie Sue, Monroe, Louisiana, 1994

Little Ryan, Monroe, Louisiana, 1986

Emily, Monroe, Louisiana, 1988

High school graduation party, Monroe, Louisiana, 1994

Above: Father Bill, Monroe, Louisiana, 1993

Left: Big Ryan, wedding reception, Monroe, Louisiana, 1993

Front porch, Durham, North Carolina, 1994

Dixie Deb Softball League game, Monroe, Louisiana, 1987

Morgan, Monroe, Louisiana, 1993

Will with his children, Monroe, Louisiana, 1993

Wood blocks, Monroe, Louisiana, 1993

A New Life

Mary Ward Brown

They meet by chance in front of the bank. Elizabeth is a recent widow, pale and dry-eyed, unable to cry. Paul, an old friend, old boyfriend, starts smiling the moment he sees her. He looks so *happy*, she thinks. She's never seen him look so happy. Under one arm he carries a wide farm checkbook, a rubber band around it so things won't fall out.

"Well. This is providential." He grips her hand and holds on, beaming, ignoring the distance he's long kept between them. Everything about him seems animated. Even his hair, thick, dark, shot with early gray, stands up slightly from his head instead of lying down flat. In the sunlight the gray looks electric. "We've been thinking about you," he says, still beaming. "Should have been to see you."

"But you *did* come." Something about him is different, she thinks, something major, not just the weight he's put on.

"We came when everyone else was there and you didn't need us. We should have been back long ago. How are you?"

"Fine," she says, to end it. "Thank you."

He studies her face, frowns. "You don't look fine," he says. "You're still grieving, when John is with God now. He's well again. Happy! Don't you know that?"

So that's it, she thinks. She's heard that Paul and his wife, Louise, are in a new religious group in town, something that has sprung up outside the church. They call themselves Keepers of the Vineyard. Like a rock band, someone said.

Small-town traffic moves up and down the street, a variety of midsize cars and pickup trucks, plus an occasional big car or van. The newly remodeled bank up-

dates a street of old redbrick buildings, some now painted white, green, gray. Around the corner the beauty shop is pink with white trim.

This is the southern Bible Belt, where people talk about God the way they talk about the weather, about His will and His blessings, about why He lets things happen. The Vineyard people claim that God also talks to them. Their meeting place is a small house on Green Street, where they meet, the neighbors say, all the time. Night and day.

Their leader is the new young pastor of the Presbyterian church, called by his first name, Steve. Regular church members look on the group with suspicion. They're all crazy, they go too far, the church people say.

When told, Steve had simply shrugged. "Some thought Jesus was a little crazy, too," he'd said.

He is a spellbinding preacher and no one moves or dozes while he speaks, but his church is split in two. Some are for him and some against him, but none are neutral. He is defined by extremes.

Paul opens the door to the bank for Elizabeth. "What are you doing tonight?" he asks, over her shoulder.

She looks back, surprised, and he winks.

"Louise and I could come over after supper," he says. "How about it?"

She understands his winks and jokes. They're cover-up devices, she'd discovered years ago, for all he meant to hide. New hurts, old wounds, the real Paul Dudley. Only once had she seen him show pain, ever. When his favorite dog, always with him, had been hit by a truck, he'd covered his face with his hands when he told her. But the minute she'd touched him, ready to cry, too, he'd stiffened. "I'll have to get another one," he'd said. And right away, he had. Another lemon-spotted pointer.

"You're turning down a good way of life, though," her mother had said, a little sadly, when she didn't take the ring. It had been his mother's diamond. He'd also inherited a large tract of land and a home in the country.

She'd never confessed one of her reasons, for fear that it might sound trivial. He'd simply made her nervous. Wherever they'd gone, to concerts, plays, movies, he hadn't been able to sit still and listen, but had had to look around and whisper, start conversations, pick up dropped programs. Go for more popcorn. He had rummaged through his hair, fiddled with his tie, jiggled keys in his pocket until it had been all she could do not to say, "Stop that, or I'll scream!"

He hadn't seemed surprised when she told him. Subdued at first, he had rallied and joked as he went out the door. But he'd cut her out of his life from

then on, and ignored all her efforts to be friendly. Not until both were married, to other people, had he even stopped on the street to say hello.

Back home now in her clean, orderly kitchen, she has put away groceries and stored the empty bags. Without putting it off, she has subtracted the checks she'd just written downtown. Attention to detail has become compulsive with her. It is all that holds her together, she thinks.

Just before daylight-savings dark, Paul and Louise drive up in a white station wagon. Paul is wearing a fresh short-sleeved shirt, the top of its sleeves still pressed together like uncut pages in a book. In one hand he carries a Bible as worn as a wallet.

Louise, in her late forties like Elizabeth, is small and blond. Abandoned first by a father who had simply left home, then by a mother his leaving had destroyed, she'd been brought up by sad, tired grandparents. Her eyes are like those of an unspoiled pet, waiting for a sign to be friendly.

When Elizabeth asks if they'd like something to drink now or later, they laugh. It's a long-standing joke around Wakefield. "Mr. Paul don't drink nothing but sweetmilk," a worker on his place had said years ago.

"Now would be nice," he says, with his happy new smile.

Elizabeth leads the way to a table in her kitchen, a large light room with one end for dining. The table, of white wood with an airy glass top, overlooks her back lawn. While she fills glasses with tea and ice, Paul gazes out the window, humming to himself, drumming on the glass top. Louise admires the marigolds, snapdragons, and petunias in bloom. Her own flowers have been neglected this year, she says. Elizabeth brings out a pound cake still warm from the oven.

"Let's bless it," Paul says, when they're seated.

He holds out one hand to her and the other to Louise. His hand is trembling and so warm it feels feverish. Because of her?, Elizabeth thinks. No. Everyone knows he's been happy with his wife. Louise's hand is cool and steady.

He bows his head. "Lord, we thank you for this opportunity to witness in your name. We know that You alone can comfort our friend in her sorrow. Bring her, we pray, to the knowledge of your saving grace and give her your peace, which passes understanding. We ask it for your sake and in your name."

He smiles a benediction, and Elizabeth cuts the cake.

"The reason we're here, Elizabeth—" He pushes back the tea and cake before him, "—is that my heart went out to you this morning at the bank. You can't give John up, and it's tearing you apart."

What can she say? He's right. She can't give John up and she *is* torn apart, after more than a year.

"We have the cure for broken hearts," he says, as if stating a fact.

Louise takes a bite of cake, but when he doesn't she puts down her fork. On her left hand, guarded by the wedding band, is a ring that Elizabeth remembers.

"I have something to ask you, Elizabeth." Paul looks at her directly. "Are you saved?"

Elizabeth turns her tea glass slowly clockwise, wipes up the circle beneath it with her napkin. "I don't know how to answer that, Paul," she says, at last. "What happened to John did something to my faith. John didn't deserve all that suffering, or to die in his prime. I can't seem to accept it."

"Well, that's natural. Understandable. In my heart I was rebellious, too, at one time."

She frowns, trying to follow. He hadn't been religious at all when she'd known him. On the contrary, he'd worked on a tractor all day Sunday while everyone else went to church, had joked about people who were overly religious.

"But I had an encounter with Jesus Christ that changed my life," he says. "I kept praying, with all my heart, and He finally came to me. His presence was as real as yours is now!" His eyes fill up, remembering. "But you have to really want Him, first. Most people have to hit rock bottom, the way I did, before they do. You have to be down so low you say, 'Lord, I can't make it on my own. You'll have to help me. *You* take over!'"

Now he's lost her. Things had gone so well for him, she'd thought. He'd had everything he said he wanted out of life when they were dating—to have a big family and to live on his land. He'd been an only child whose parents had died young. Louise had been orphaned, too, in a way. So they'd had a child every year or two before they quit, a station wagon full of healthy, suntanned children. Some were driving themselves by now, she'd noticed.

As for her, rock bottom had been back in that hospital room with John, sitting in a chair by his bed. Six months maybe, a year at the most, they'd just told her out in the hall. She'd held his hand until the Demerol took effect and his hand had gone limp in hers. Then she'd leaned her head on the bed beside him and prayed, with all her heart. From hospital room to hospital room she had prayed, and at home in between.

"I've said that, too, Paul, many times," she says. "I prayed, and nothing happened. Why would He come to you and not me?"

"Because you were letting something stand in the way, my dear!" His smile is

back, full force. "For Him to come in, you have to get rid of self—first of all your self-*will!* 'Not my will but Thine be done,' He said on the cross."

He breaks off, takes a quick sip of tea. With the first bite of cake, he shuts his eyes tight. A blissful smile melts over his face.

"Umh, umh!" He winks at Louise. "How about this pound cake, Mama!"

Late the next afternoon, Elizabeth is watering flowers in her backyard. Before, she grew flowers to bring in the house, zinnias for pottery pitchers, bulbs for clear glass vases. Now she grows them for themselves, and seldom cuts them. She has a new irrational notion that scissors hurt the stems. After what she's seen of pain, she wants to hurt nothing that lives.

From where she stands with the hose, she sees a small red car turn into her driveway. In front of the house, two young girls in sundresses get out.

"Mrs. North?" the first girl says, when Elizabeth comes up to meet them. "You probably don't remember me, but I'm Beth Woodall and this is Cindy Lewis. We're from The Vineyard."

Beth is blond and pretty. A young Louise, Elizabeth thinks. But Cindy has a limp and something is wrong with one arm. Elizabeth doesn't look at it directly.

"What can I do for you girls?"

"Oh, we just came to see you," Beth smiles brightly. "Paul and Louise thought we might cheer you up."

In the living room, Beth is the speaker. "We all knew your husband from the paper, Mrs. North. He was wonderful! My dad read every line he ever wrote, and says this town is lost without him." She pushes back her hair, anchors it behind one ear. Her nails, overlong, pale as seashells, seem to lag behind her fingers. "We've all been praying for you."

Elizabeth rubs a wet spot the hose has made on her skirt. "Thank you," she says, not looking up.

"I know how you feel," Beth says. "My boyfriend, Billy Moseley, was killed in a wreck last year. He'd been my boyfriend since grammar school, and we'd have gotten married someday, if he'd lived." Her eyes fill with tears. "We were just always . . . together."

Elizabeth remembers Billy. Handsome, polite. A star athlete killed by a drunk driver. She feels a quick stir of sympathy but, like everything painful since John died, it freezes before it can surface. Now it all seems packed in her chest, as in the top of a refrigerator so full the door will hardly shut. She looks back at Beth with dry, guilty eyes.

"Well, I'm all right now," Beth says. "But I thought it would kill me for a while. I didn't want to live without Billy, until I met the people at The Vineyard. They made me see it was God's will for him to die and me to live and serve the Lord. Now I know he's in heaven waiting for me, and it's not as bad as it was." She shrugs. "I try to help Billy's mother, but she won't turn it over to the Lord."

The room is growing dark. Elizabeth gets up to turn on more lights, which cast a roseate glow on their faces, delicate hands, slender feet in sandals.

"Would you girls like a Coke?" she asks.

Beth blinks to dry her eyes. "Yes, ma'am," she says. "Thank you. A Coke would be nice."

They follow Elizabeth to the kitchen, where she pours Coca-Cola into glasses filled with ice cubes.

"You must get lonesome here by yourself," Cindy says, looking around. "Are your children away from home or something?"

Elizabeth hands her a glass and paper napkin. "I don't have children, Cindy," she says. "My husband and I wanted a family, but couldn't have one. All we had was each other."

"Ah!" Beth says quickly. "*We'll* be your children, then. Won't we, Cindy?"

It is seven o'clock in the morning and Elizabeth is drinking instant coffee from an old, stained mug, staring dejectedly out the kitchen window. During the night, she'd had a dream about John. He'd been alive, not dead.

John had been editor-publisher of the *Wakefield Sun*, the town's weekly paper, had written most of the copy himself. In the dream, they'd been in bed for the night.

John had liked to work in bed, and she had liked to read beside him, so they'd gone to bed early as a rule. Propped up on pillows, he had worked on editorials, for which he'd been known throughout the state. At times, though, he had put aside his clipboard and taken off his glasses. When he turned her way, his eyes—blue-gray and rugged like the tweed jacket he'd worn so many winters— would take on a look that made the book fall from her hand. Later, sometimes, on to the floor.

In the dream, as he looked at her, the phone by their bed had rung. He'd forgotten a meeting, he said, throwing off covers. He had to get down there. It had already started, a meeting he couldn't afford to miss. Putting on his jacket, he'd stopped at the bedroom door.

"I'll be right back," he promised.

But he wasn't back and never would be, she'd been reminded, wide awake. In the dark, she had checked the space beside her with her hand to be sure, and her

loss had seemed new again, more cruel than ever, made worse by time. If only she could cry, she'd thought, like other widows. Cry, everyone told her. Let the grief out! But she couldn't. It was frozen and locked up inside her, a mass that wouldn't move.

She had waked from the dream at two in the morning, and hasn't been back to sleep since. Now she's glad to be up with something to do, if it's only an appointment with her lawyer. She has sold John's business but kept the building, and the legalities are not yet over. She wants to be on time, is always on time. It is part of her fixation on detail, as if each thing attended to were somehow on a list that if ever completed would bring back meaning to her life.

In the fall she will go back to teaching school, but her heart is not in it as before. For twenty years she had been, first of all, John's wife—from deadline to deadline, through praise, blame, long stretches of indifference. He couldn't have done it without her, he'd said, with each award and honor he'd been given.

Now no other role seems right for her, which is her problem, she's thinking, when the front door bell rings.

Louise is there in a fresh summer dress, her clean hair shining in the sun. She smells of something lightly floral.

"May I come in?"

Still in a rumpled nightgown and robe, aware of the telltale look in her eyes, Elizabeth opens the door wider, steps back. "I have an appointment," she says, and smiles as best she can. "But come in. There's time for a cup of coffee."

At the white table, Louise takes the place she'd had before. "I won't stay long," she says.

Elizabeth puts on a pot of coffee, gets out cups and saucers, takes a seat across from Louise. Outside all is quiet. Stores and offices won't open until nine. So why is Louise in town at this hour?

"I was praying for you," she says, as if in answer. "But the Lord told me to come and see you instead."

Elizabeth stares at her. "God told you?"

Their eyes meet. Louise nods. "He wanted you to know that He loves you," she says. "He wanted to send you His love, by me." Her face turns a sudden bright pink that deepens and spreads.

Next door a car starts up and drives off. A dog barks. The coffee is ready and Elizabeth pours it. She's learned to drink hers black, but Louise adds milk and sugar.

"Come to The Vineyard with us next time, Elizabeth," Louise says suddenly. "Please."

This is what she came for, Elizabeth thinks, and it's more than an invitation. It's a plea, as from someone on the bank to a swimmer having trouble in the water.

"It could save your life!" Louise says.

The Vineyard is a narrow, shotgun-style house of the 1890s, last used as a dentist's office. It has one large front room, with two small rooms and a makeshift kitchen behind it. Having been welcomed and shown around, Elizabeth stands against the wall of the front room with Paul and Louise. The group is smaller than she'd expected and not all Presbyterian. Some are from other churches as well, all smiling and excited.

Everything revolves around Steve, a young man in jeans who looks like a slight, blond Jesus. When Elizabeth is introduced, he looks her deep in the eyes.

"Elizabeth!" he says, as if he knows her already. "We were hoping you'd come. Welcome to The Vineyard."

He says no more and moves on, but she has felt his power like the heat from a stove. She finds herself following him around the room with her eyes, wishing she could hear what he says to other people.

The night is hot and windows are open, but no breeze comes through. Rotary fans monotonously sweep away heat, in vain. Someone brings in a pitcher of Kool-Aid, which is passed around in paper cups.

"Okay, people." Steve holds up his cup and raises his voice for attention. "Let's have a song."

Everyone takes a seat on the floor, in a ring shaped by the long narrow room. A masculine girl with short dark hair stands up. She tests one key then another, low in her throat, and leads off. "We are one in the Spirit, we are one in the Lord...."

Most of the singers are young, in shorts or jeans, but some are middle-aged or older. Of the latter, the majority are single women and widows like Elizabeth. The young people sit with folded legs, leaning comfortably forward, and the men draw up one leg or the other. But the women, in pastel pant suits and sleeveless dresses, sit up straight, like paper dolls bent in the middle.

The song gains momentum for the chorus, which ends, "Yes, they'll know-oh we are Christians by our love!"

"All *right*," Steve says. "Time to come to our Lord in prayer."

Someone clambers up to turn off the light switch and someone else lights a candle on the Kool-Aid table. In the dim light Steve reaches out to his neighbor on each side, and a chain of hands is quickly formed.

Without a hand to hold in her new single life, Elizabeth is glad to link in. She smiles at the young woman on her left and Paul on her right. Paul's hand no longer trembles but feels as it had in high school—not thrilling but dependable, a hand she could count on.

The room is suddenly hushed. "For the benefit of our visitor," Steve says, "we begin with sentence prayers around the circle, opening our hearts and minds to God."

Elizabeth feels a quick rush of misgiving. *Oh, no!* she thinks. *I can't do this!* She's never prayed out loud in her life except in unison, much less ad-libbed before a group.

But Steve has already started. "We thank you, Heavenly Father, for the privilege of being here. Guide us, we pray, in all we say and do, that it may be for the extension of your kingdom. We thank you again for each other, but above all for your blessed son Jesus, who is with us tonight, here in this circle."

On Steve's right, a young man with shoulder-length hair takes up at once. "I thank you, Lord, for turning me around. Until I found You, all I cared about was that bottle. But You had living water to satisfy my thirst. . . ."

Eagerly, one after the other, they testify, confess, ask help in bringing others to Jesus as Lord and Savior. They speak of the devil as if he's someone in town, someone they meet every day.

In her turn, a checkout girl from the supermarket starts to cry and can't stop. From around the circle come murmurs of "God bless you" and "We love you" until her weeping begins to subside.

"My heart's too full tonight," she chokes out, at last. "I have to pass."

On each side, Elizabeth's hands are gripped tighter. The back of her blouse is wet with sweat. The room begins to feel crowded and close.

"Praise God!" a man cries out in the middle of someone's prayer.

"Help me, Lord," a woman whimpers.

A teenage boy starts to pray, his words eerily unintelligible. Tongues?, Elizabeth wonders, electrified. They do it here, she's heard. But something nasal in his voice gives the clue, and she has a wild impulse to laugh. He's not speaking in tongues but is tongue-tied, from a cleft palate.

Too soon, she hears Paul's voice beside her, charged with emotion. He's praying about the sin of pride in his life, but she can't pay attention because she will be next. Heavy galloping hoofbeats seem to have taken the place of her heart.

When Paul is through, she says nothing. *I pass* flashes through her mind, but she doesn't say it. She is unable to decide on, much less utter, a word. Her hands

are wet with cold perspiration. She tries to withdraw them, but Paul on one side and the young woman on the other hold on tight. Fans hum back and forth as her silence stretches out.

At last someone starts to pray out of turn, and the circle is mended. As the prayers move back toward Steve, she gives a sigh of relief and tries, without being obvious, to ease her position on the floor.

Steve gives a new directive. "We'll now lift up to God those with special needs tonight."

He allows them a moment to think, then leads off. "I lift up Ruth, in the medical center for diagnosis," he says. "Her tests begin in the morning."

They pray in silence for Ruth, for someone in the midst of divorce, for a man who's lost his job. An unnamed friend with an unidentified "problem" is lifted up.

Louise clears her throat for attention, then hesitates before speaking out. When she does, her voice is girlish and sweet as usual.

"I lift up Elizabeth," she says.

Elizabeth has avoided the telephone all day, though she's heard it ring many times. The weather is cloudy and cool, so she's spent the morning outside, weeding, hoeing, raking, and has come to one decision. She will not see the soul savers today.

Tomorrow, it may be, she can face them. Today, she will do anything not to. They were holding her up, she thinks, not for her sake but theirs. They refuse to look on the dark side of things, and they want her to blink it away, too. If she can smile in the face of loss, grief, and death, so can they. They're like children in a fairy tale, singing songs, holding hands. Never mind the dark wood, the wolves and witches. Or birds that eat up the bread crumbs.

During lunch she takes the phone off the hook, eats in a hurry, and goes back out with magazines and a book. For supper she will go to Breck's for a barbecue and visit with whoever's there. When she comes back, the day will be over. "One day at a time" is the new widow's motto.

She is drying off from a shower when the front door bell rings. She doesn't hurry, even when it rings again and someone's finger stays on the buzzer. The third time, she closes the bathroom door, little by little, so as not to be heard. Gingerly, as if it might shock her, she flips off the light switch.

Soon there is knocking on the back door, repeated several times. She can hear voices but not words. When she continues to keep quiet, hardly breathing for fear they will somehow know or divine that she's there, the knocking stops and the

voices, jarred by retreating footsteps, fade away. At last, through a sneaked-back window curtain, she sees the small red car moving off.

And suddenly, in her mind's eye, she can also see herself as from a distance, towel clutched like a fig leaf, hiding from a band of Christians out to save her soul!

For the first time in her widowhood, she laughs when she's alone. It happens before she knows it, like a hiccough or a sneeze. With refound pleasure, she laughs again, more.

Still smiling, she dresses in a hurry and is about to walk out the back door when the front door bell rings.

This time she goes at once to face them. Beth and Cindy, plus Steve and two policemen, stare back at her. The policemen are in uniform, dark blue pants and lighter blue shirts, with badges, insignia, and guns on their belts. Obviously, they've been deciding how to get in the house without a key.

For a moment no one speaks. Then Beth, wide-eyed, bursts out, "You scared us to death, Mrs. North! We thought you had passed out or something. We knew you were in there because of your car."

"I didn't feel like seeing anyone today." Elizabeth's voice is calm and level. What has come over her?, she thinks. Where did it come from, that unruffled voice? She should be mad or upset, and she's not.

"Sorry we bothered you, Mrs. North," the older policeman says. "Your friends here were worried."

Out of the blue, Elizabeth is suffused all at once with what seems pure benevolence. For a split-second, and for no reason, she is sure that everything is over-all right in the world, no matter what. And not just for her but for everyone, including the dead! The air seems rarefied, the light incandescent.

"It was no bother," she says, half-dazed. "I thank you."

Steve has said nothing. His eyes are as calm as ever, the eyes of a true believer blessed or cursed with certainty. His focus has been steadily on her, but now it breaks away.

"Let's go, people," he says lightly. "We're glad you're okay, Elizabeth. God bless you."

Elizabeth has slept all night, for once. As she sits down to coffee and cereal, she is sure of one thing. She has to start what everyone tells her must be "a whole new life" without John, and she has to do it now. Though frozen and numb inside still, she can laugh. And she has experienced, beyond doubt, a mystical moment of grace.

When a car door slams out front, not once but twice, she gets up without waiting for anyone to ring or knock. It is Paul and Louise, for the first time not smiling. Paul has on khaki work clothes. Louise has brushed her hair on top, but underneath sleep tangles show.

In the living room, they sit leaning forward on the sofa. Paul rocks one knee nervously from side to side, making his whole body shake from the tension locked inside him.

"They should have come to us instead of going to the police," he says at once. "They just weren't thinking."

"No, it was my fault," Elizabeth says. "I should have gone to the door."

"Why *didn't* you?" Louise asks.

"Well. . . ." She falls silent.

"Our meeting upset you?" Paul asks, in a moment.

Elizabeth's housecoat is old and too short. They catch her like this every time, she thinks. Why can't they call before they come, like everyone else? She begins to check snaps down her front.

"Level with us, honey," Paul says. "We're your friends. What upset you so much?"

Except for the faint click of a snap being snapped, the room is utterly quiet.

"We need to pray about this," Paul says. "Let's pray. . . ."

"No!" Elizabeth is on her feet without thinking. "No, Paul. I can't!" She's out of breath as from running. "This has got to stop! I can't be in your Vineyard. You'll have to find somebody else!"

He's silent for so long a countdown seems to start. Then he stands up slowly, Louise beside him as if joined. At the door, with his hand on the knob, he turns.

"Well, Elizabeth," he says. "I guess it's time to say good-bye."

Her heart slows down as if brakes had been applied. The beats become heavy, far apart. She can feel them in her ears, close to her brain.

"I'm sorry, Paul!" she says quickly. Before his accusing eyes, she says it again, like holding out a gift she knows to be inadequate. "I'm *sorry!*"

But this time he has no joke or smile. Without a word, he takes Louise by the arm and guides her through the doorway.

Elizabeth watches them walk to the car, side by side but not touching. Paul opens the door for Louise, quickly shuts her in, and gets behind the wheel himself. The station wagon moves out of sight down the driveway.

Elizabeth's cereal is soggy, her coffee cold. She pushes it all away, props her elbows on the table, and buries her face in her hands. Suddenly, as from a thaw

long overdue, she's crying. Sobs shake her shoulders. Tears seep through her fingers and run down her wrists. One drop falls on the glass top where, in morning sunlight, it sparkles like a jewel.

Connette Pearl McMahon *from the series* Family and Friends

Getting ready for school, Butner, North Carolina, 1994

At home, Granite Quarry, North Carolina, 1994

Above: Baby's first outing, Durham, North Carolina, 1995

Below: Durham, North Carolina, 1994

Grandparents' fiftieth anniversary party,
Salisbury, North Carolina, 1994

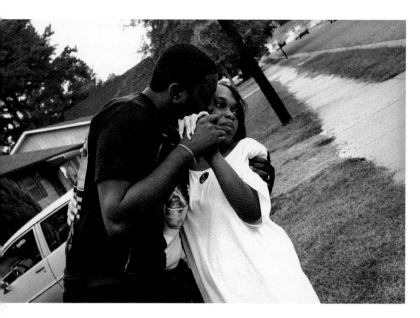

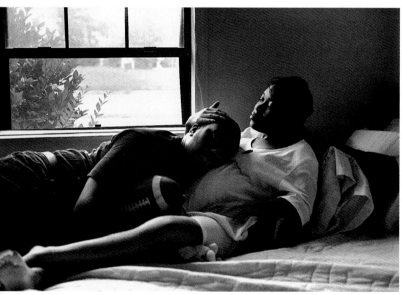

Above and below: Durham, North Carolina, 1994

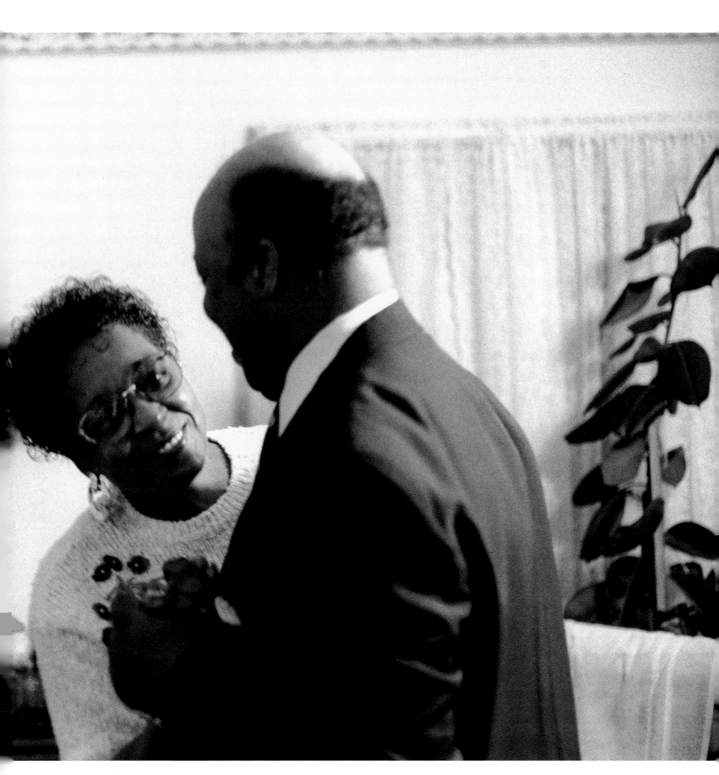

Salisbury, North Carolina, 1994

Dreamland

Alan Cheuse

On the day that Mike Quinn flew South for the first and last time he awoke in the grip of such a hunger that he thought that he might be sick. But it was pure emptiness in his belly, he decided, as he dressed for his quick trip to the office—he had just become a regional manager for a new software company out on Route 128—gobbling a jelly doughnut left over from a shopping trip he had taken over a week ago, and washing the remains down with day-old coffee. Ever since he had moved out of the apartment, he had eaten on the run. Darcy, his wife of three years, had been the cook in the family.

"Just like your mother, remember you telling me that?" she had said to him in one of the last rounds they had fought before splitting up this time. "Well, I'm not your mother, you know that, and goddamnit I'm not even *related* to you so you had better start treating me like a human being or else you're not getting invited back."

He wondered as he dialed her number on a whim just before going out the door—was this treating her like a human being?

"Yeah?" came a deep male voice.

He hung up the telephone.

It rang just as he was picking up his suitcase.

"Hello?"

"Don't do that, Mike," came Darcy's voice.

"Don't do what?" he said.

"Call like that and hang up."

"I didn't call you."

"Mike, you can't fool me. I know you."

"Who was that?" he said.

"A repairman."

"Sure."

"It was."

"Is he still there?"

"Yes."

"Let me talk to him."

"Mike, get out of here."

"I'm out," he said. "I'm going to Atlanta."

"You are?" There was a little of the old excitement in her voice this time. "You got the job?"

"Yep."

"Congratulations. Oh, Mike, that'll really help you get a new start."

"A new start?"

"With your new life. Like we talked about."

"I got to go now," he said, his heart sinking like a heavy object in mud. Was this where treating her like a human being got him? He pictured a big-necked, dark curly-haired repairman, his tools dangling from his belt, standing behind her, making nice with thick fingers on her arms and chest.

"Come on, Michael," she said. "What good's it talking if you don't follow through."

"I'm following, okay?" he said. "I'm following." He hung up the telephone again and followed out the door and into his car and drove to the office where a small mound of paperwork remained to be dealt with, and then he followed to the airport where he parked his car and went to catch his airplane. He did not have a lot of time before boarding—the row of telephone booths a few yards down the hall kept his attention. Would it be treating her like a human being to call her back and ask if they might try to see each other again when he returned from his trip? If he suggested that she might try to move South with him when it came time for his relocation? But things moved along and quite soon he found himself sighing ferociously over the noise of the airplane engines at the lost opportunity to call her and ask.

"Are you okay?" said a bony black woman in a navy blue suit who had been working in a lined notebook ever since they had taken off from Logan.

Quinn hadn't known many black people in his life, let alone black women who appeared to be employed by a company like his own. He began to speak, talking of business, and she spoke back, and soon they were going on about the coming

election, and it seemed that they could agree on a lot of issues. Lunch was served. Before Quinn knew it they were preparing for their descent into the Atlanta area, as the soothing flight attendant's voice informed them. And he had forgotten a lot of what had been on his mind.

The business in Atlanta kept him away from his troubles for the rest of the week. There was so much to do during the day, although Jack Henshaw, the big-handed, soft-voiced fellow who was his newly designated right-hand man, explained that in addition to everything else that he was doing for Quinn he was also in charge of what he called "attitude adjustment."

"Things run a little slower down here," Henshaw said. "Not any worse, don't y'all worry about that. It's going to be as good as Boston, just ..."—and here Henshaw smiled in a way that Quinn could have described as slyly. "See, Marty, it is Marty, isn't it? See, after your Yankee general Sherman left the city in ruins, we took us a while to look around and contemplate the mess. But we're re-building now. It's just a little more relaxed ... than up your way."

By Wednesday, Quinn knew he could use some of that. He decided that in-stead of calling it a night after one drink in the hotel bar as he had his first two nights he would suggest to Henshaw that they take a little look at the town.

"Now what'd you have in mind?" Henshaw appeared to be studying him as he might some new form of food or plant life. "I mean, topless? That what y'all thinking? Hell, I could do some of that. I haven't done it in a long time." He paused, as Quinn shook his head. "Well, then what else you got in mind?"

"Huh?" Quinn pursed his lips. "Nothing else. Well, maybe we could try a top-less bar. Aw...."

"You're the boss," said Henshaw. "I'll just go give the little woman a call and tell her to watch Johnny Carson without me tonight."

The little woman, Quinn was thinking, as he watched his new companion walk slowly toward the telephones in the palm-infested lobby. He had been daring himself to call Darcy again. Maybe after another drink or two he might try it, but not now, was what he decided.

"Well, hell in a ball court," Henshaw said, catching Quinn in that thoughtful pose, upon his return. "Look, I got to take a rain check on this carousing stuff tonight. Don't get started thinking that I'm pussy-whipped or anything like that, but seems like my older boy just got into a little fender bender out near the inter-state and I got to go and fetch him from the garage where they towed him."

"No, no, sure," Quinn said. "I understand that. You got to go. I'm just going to finish this drink and go up myself, anyway. I'll see you tomorrow."

"Early in the morning, bright-eyed and bushy-tailed, I'll be there," Henshaw said. Quinn watched him leave the bar in the direction of the entrance to the hotel. As soon as the man was gone, Quinn felt a sudden sadness overcome him, the common variety of sorrow that often descends on a traveler alone at night in a strange city. He wanted to get up and run after Henshaw and tell him that he would go with him to find his boy—he and Darcy had no children of their own and lately he found himself with a great curiosity about other peoples' kids—and then perhaps have a drink with him and his wife at home. Instead he sat and drank another drink, listening idly to the murmuring conversations in the bar around him.

At around eleven o'clock he suffered a few yawns, and got up to go to his room. A flashing light from a passing police car caught his eye as he walked through the lobby and he slowed down, then stopped. A large brick plaza lay outside the revolving doors. A taxi lingered there a moment, then pulled away. Quinn, as if drawn by a magnet, inserted himself into the doors and pushed and exited into the unexpected coolness of the evening air.

It's supposed to be warmer here than up there, he thought to himself as he walked across the hotel plaza to the near corner—Peachtree Street, Gone with the Wind, and all that. There actually was a breeze, but he assured himself that he shouldn't be surprised. He had done some reading about the territory. Atlanta was the highest American city east of Denver. Why not then such a breeze when the rest of the South lay sunk in the heart of Indian summer? He found himself walking south on Peachtree Street among high-rises and weedy lots with old wooden buildings falling in on themselves as if in despair at their own antiquity. At the far corner he saw a slender young thing in a miniskirt and skimpy blouse clinging to a lamppost as though it were a palm tree.

"Hi," the idler said, winking at the stroller.

It was a boy's voice, tuned unnaturally high. Quinn pondered this on the short walk back to the hotel alone. It was midnight when he reached his room. Was the message light winking on the telephone? Yes? No. He sat on the corner of the bed, studying the instrument, thinking, yes, I'll call her, no, I won't. He lay back to think about it and the next thing he knew it was three-thirty and he felt his exhaustion wrapped around him like a tangled blanket.

Henshaw picked him up at eight-thirty, all too alert and cheerful for Quinn's needs. He wasn't a stupid man and as soon as he saw what he was dealing with he shut up. Quinn was pleased. By noon, though, some of his old energy returned and he suggested that they walk out for lunch. He told Henshaw about his little stroll the night before, mentioned the transvestite.

"Hot-lanta," Henshaw said. "They come from all over the South to this place, doing their things. Though now the AIDS is killing them off."

Quinn reached for something in his mind out of his college days. "It's like the Black Plague," he said as they stopped before the restaurant of their choice.

Henshaw lay a hand on his shoulder and leaned confidentially toward his ear. "Oh, we had *that* for years."

Later in the afternoon Henshaw appeared at his desk, all smile.

"Hey, you know I felt real bad having to leave you by yourself at night...."

Quinn shrugged. "Look...."

"No, no," Henshaw said. "Listen. I just talked to a buddy of mine... and we have got a deal going for this weekend. Here it is. He, my pal Bobby, has got a little plane ... *and* some tickets for the game?"

"The game?"

"You're what?" Darcy said when he finally worked up the courage to call her. "A football game? I thought you hated football. Michael, maybe you're finding a new you down there. I'm happy for you."

"Oh, don't be happy for me," he said.

"Well, why shouldn't I?"

"Because it's condescending," he said, wondering where within himself he had found that word.

"You're the one who treated me like your mother—"

"Oh, shut up," he said.

"Don't tell me to shut up."

"My mother is dead."

"Don't go pulling that number on—"

He touched a heavy finger to the bar on the receiver and her voice went away. Lying in the dark room he felt the sadness rise, as if he were a little boy once more and his mother had just left him alone in the house while she hurried out to the corner store. It amazed Quinn just how far back in his life he could sink when pushed over into this feeling. Darcy—that woman! She treated him as though he were the one who had stepped out of the marriage. The pillow skidded out from under his head and he leaned down to retrieve it, feeling the sudden rush of blood to his brain. He got up and found an aspirin in his toilet kit. An hour later he was still fending off a headache, obsessed once again, in spite of himself, with the recollection of Darcy's infidelity, the look on her face when he surprised her with his question, the telephone calls that he answered that awful week from the caller who clicked off each time he said hello—and her tri-

umphant look, a stay against guilt he understood if he considered it carefully, when she finally admitted she had done it. So it was one of those nights again, he assured himself, when he could stand for hours here at this window, staring out across the city and feeling pleased because he knew that other men in those apartment buildings and ranch houses and hotels and shanty rentals were suffering as he had, and even now some of them were discovering for the first time their capacity for betrayal, or the power of their shame. It was around one o'clock or so—when Quinn turned from the window, went to the television, pondered the possibility of watching an R-rated movie on the closed-circuit channel, thought better of it, undressed, climbed in bed, played with himself, fell asleep.

They took off from a small field north of the city, three men, their bags, a case of whiskey.

"Hot damn," Henshaw said, leaning forward to slap his friend the pilot on the shoulder, "You run out of fuel, we got enough of this good drink to fly us to China."

As if in response, the small airplane dipped its wings to the south and went into the wide curve that would aim it toward their destination. Quinn's hope sank—he had never flown in a craft this small, and he found that his fingers were digging into his thighs as the noisy engine jerked them higher and higher through wispy clouds. For over an hour, Quinn's heart seemed tuned to the foul-dreaming engine, fading in and out, as the whine rose and fell, and when they finally went into their descent toward the small orange-brown field below he pressed back against his seat, feeling the sweat pour down his sides as if in release. He had not paid much attention to Henshaw, who now seemed well on the way toward complete incomprehensibility, jibbering odd sounds, only now and then saying words that had to do with football.

"Gol," said the man who had flown the airplane as they came to a stop on the runway. He slapped his hand to his head and let out a rush of air from between his thick lips. "I ain't been that scared since I ever first started flying." He reached under his flight jacket and came up with a flask that he passed to Quinn. "How'd *you* like it?" Quinn noticed the smoke pouring out of the little panel in front of the wheel.

So he had a few drinks himself on the way to the motel. It seemed in keeping with his retroactive fear for his life—and with the cars filled with fans of the Crimson Tide and of the Bulldogs, too, who flew pennants from their aerials, who waved pennants and pompoms and shot the bird to each other as they passed each other by. Out on the strip where they took their rooms the motel lobby was jammed

with revelers from Georgia in anticipation of the game. It was far far different from the way he had imagined such a scene, with some of the women and men dressed as if for a night at the theater and others in red hats and red shirts and red trousers, some even in red makeup. Here and there he saw a black face or two as well, and though he was sure it was an illusion he might have seen the same trim black woman who had been his seat mate on the plane flight south.

"Bobby had this room three months in advance, thank the Lord," Henshaw said, returning suddenly to clarity of speech as they entered the hallway behind the lobby. Two bottles gone—he flipped the next one into the wastebasket soon after they entered their room—and the game was still two hours away.

"Bobby?" Quinn leaned against the wall and stared out the window at a patch of sky nearly white.

"Remember that boy flew us here?"

"Bobby?"

"That's the dog, bubba," Henshaw said.

"Dog?"

"Hey, y'all ready for murder and mayhem? We going to whup their Alabama behinds!"

"Huh?" Quinn saw Henshaw standing in the bathroom door, his penis in hand, spraying urine across the rug. "Hey?"

"Haw! Haw!" Henshaw made a funny laugh, looked down at his mess and then went back into the bathroom.

"Dum-da-dum-dum!" A loud thudding at the door. "Hey y'all let us in!"

It was Bobby who stared at Quinn when he yanked open the door, a man a lot more red-faced than when he was last seen, with two blond women, one on either arm.

"Gol," he said, "what's that stink?"

Quinn looked down and saw that he was standing in a urine-soaked patch of carpet.

"Who's 'at?" Henshaw shouted from the bathroom.

"Santa Claus," said Bobby, motioning with his chin for Quinn to back up into the room so that he and the women could enter.

"It does stink," said one of the women, a short girl with orange-red hair and a sweater that said BULLdogs across her large chest. "Hi," she said, extending a hand toward Quinn, "I'm Tiffany."

"And I'm Brittany," said the other woman, who stood tall alongside her companion but not in comparison to the men. She was wearing a red dress that

seemed of a material much too fragile even for this slender-boned girl who wore it. It was cut way above the knee, and Quinn found himself staring at every available turn.

It was Tiffany or was it Brittany?—getting so drunk, he couldn't tell which girl was which—who pressed close to him in the rental car on the way to the stadium, and said, "Are you a doctor?"

"No," Quinn said, "do you need one?"

"Whoo-ee!" Henshaw kept on shouting out the window on the passenger's side of the wheel—Bobby was their pilot, their driver. "Whoo-eeee!"

"I was going with one," she said.

"Where's he?" Quinn said.

"Dead," she said.

"Sorry," he said.

"Oh, that's all right," she said. "I didn't know him real well."

"Oh," Quinn said, feeling her press harder against him, as though they were rounding a turn when they were still only pushing straight ahead along the roadway. "How'd he die?"

"His wife shot him," she said. "He was a real hero. She was trying to get me, I just know it, but he stepped in front."

"Dogs!" Henshaw shouted through the open window. "Dogs! you 'Bama slimebucket! Dogs!" He turned around in his seat and breathed fiery whiskey breath on Quinn and his companions. "Boston, you now an official Dog! You hear? You are an official Dog!"

"Arf," said Quinn. "Arf! Arf!" The two girls giggled. He liked that. He did his bark again.

Tiffany—or was it Brittany?—leaned up and gave him a big wet kiss on the cheek. It went like that all through the afternoon, the roaring smashing cheering game, the drinking, coughing, barking, shrieking Tiffany and Brittany, tens of thousands like them on both sides of the field, an enormously roaring blur of red and white and sky and green field, the ball soaring, clash of helmets and pads, the bottle in hand, empty, smashing the feel of her next to him, singing the songs he never knew.

The ride back grew louder, more drinking, loss made them thirsty, hungry. Tiffany—or was it Brittany?—lay her head in his lap, nibbling at his knee. Henshaw shouted at Bobby, foreign autos honked at them, Bobby honked in return. Next thing Quinn knew he was standing outside the motel waiting for the sun to go down. A car full of bearded men in camouflage pulled up alongside the

entrance, the motor ran a while, then it pulled away. The sun settled slowly down behind the restaurants and tire stores across the strip from the motel.

"Let's go, you dirty defeated Dog," said Henshaw from behind him. Bobby came up on the other side with the girls. They hustled him back into the automobile like Mafiosi gathering up a victim for their cruel undertakings of revenge.

"Follow them," Henshaw said, and Quinn discovered that a car was leading them along the strip.

"Can you believe it?" one of the girls said.

A sour tinge of vomit clung to Quinn's nose along with the odor of heavy sweet perfume worn by the women on either side of him.

"Sangwich," said one of them.

"White bread, baloney, white bread," said Tiffany or Brittany, whacking him with her hip.

"Want to call home," Quinn heard himself say.

They were streaming along beneath dark trees, real country all around. Quinn wanted to close his eyes but he had somehow forgotten how to do that. There was a little purring sound in his lap—one of the girls was snoring, breathing with her mouth open on his knee.

Next thing they were thrown forward as Bobby slammed on the brakes. Here they were—out in the woods somewhere, as far as Quinn could tell, with a stucco-brick shack with a sign in neon glowing on it—"Dreamland."

"Heard of this place?" Henshaw said.

"I told them," said one of the girls with a giggle.

"I did," said the other girl.

A few couples mingled outside the door. Inside it was all dim neon and the smell of the wood oven and the odor of the roasting meat and pungent sauce. It took what seemed like an hour before they got a table—and they drank beer all that while. When they finally sat down Quinn felt as though he were sinking into a bath of beer. All around them other revelers raised slabs of animal ribs to their jaws, or bottles of beer, or both. Most of the diners were white, and all of the people behind the counter, the huge man sitting at the roasting pit, the photographs on the wall—except for a pale-faced old man whom Quinn knew he should know but couldn't figure—all were black. Quinn felt the girl's hip—Tiffany's? Brittany's?—bumping against his as she chewed her meat. The sauce stuck to his fingers. His face almost stuck to the bones he gnawed on. More beer. And more beer. He had such a sensation in his mouth from eating the hot sauce, in his chest, in his limbs from all the drinking, that for a moment he looked around, beyond the tables to the counter, and had a fearful insight—that he was

biting into directly and chewing upon the old barbecued flesh of the black men behind the barrier.

"Do we know how to party here, sugar?" one of the girls said to him.

"Aw," said Henshaw, "y'all came to Hot-lanta, we'll show you—"

Quinn was feeling a little queasy. Seeing Bobby take a slice of white bread from the plate in the middle of the table and wipe his lips, he did the same. And then stood up. Something was calling him—and it was more than his kidneys and bladder, though God knew these organs were bleating out distress signals after the afternoon he had given them. The call took him toward the door.

Men and girls. More of them milling about outside the entrance. Cars roared up, cars departed. Quinn wandered off toward the woods, heeding the call in his lower parts before the other. He stood there, aiming his stream at the bushes for a long time. A little wind blew up, but not cold. Lights from a van caught him turning back toward the roadhouse. No one seemed to be left in front of it—or the lights blinded him to their presence.

"Hey!" came a yell from the van. "You one of the Thetas?"

Quinn was shaking his head when two young men appeared at either side of him and helped him toward the van.

"Tour is leaving," one of them said. There was an odor about the van, Quinn noticed, when he climbed in and sat on the little jump seat among a number of other travelers. Urine—barbecue sauce—perfume—beer. It was his own smell, the odor of others around him, these young boys and girls, swaying from side to side as the van drove along the narrow country roads.

"Well-fed, well-drunk," someone said at his ear.

"Now the rest," said another.

"Rest is the best," said another.

"Hey, y'all a poet and you don't even know it."

"Off to Moundsville," said a boy at his back. Except that Quinn finally understood that he said it like—"Mo-u-u-u-nds-veeel . . ."

Quinn dozed, awoke to the sound of the Theta boys singing, joking, dozed again. Was it twenty minutes it took them? More? Suddenly the van jolted across railroad tracks, made a sharp turn, then stopped abruptly. Someone got out and left the door open. Cool breeze filtered through the inside of the van. Moans. Groans. Suddenly the door slammed and they were moving again. And then stopped. And then moved again. Then stopped. And someone yanked open the rear door. Quinn piled out with the rest of them, these college boys and a few girls.

Tall mounds surrounded them in the moonlight all around, strange hills in this flat country that seemed, when he noticed it, arranged as if by the hands of some

giant's child across the grasslands of this park. Following the group, all of whom seemed to be holding bottles or glasses in their hands except him, he made a telephone call in his head, saying to her, You wouldn't believe it, Dar—and in that same exchange she cut him off with a snarling, You sneaking bastard, sneaking around with the co-eds, huh? Well—

It wasn't like that. No one paid any attention to him, even to the point of when he felt as though he were dying of thirst just sort of passing a bottle over to him without even looking him in the eye. It was as though he were a chaperone, an invisible one at that, or something like a ghost. The drink made him feel real, though—and he drank more and another, tasting the grease on his lips, the still lingering traces of the barbecue from Dreamland, where for the moment he had imagined they had been eating the flesh of negroes—and, thinking back to those girls, women, wiping his face with the white skin of young girls.

I'm an adult, a manager, I shouldn't be thinking this, he tried to convince himself as he trekked across the park.

"Talbot has the key," someone said up ahead of him.

"Talbot has the key," the group took up the chant.

"Hey," Quinn said, catching up with the last pair in the line ahead of him.

"Arf, arf," said the boy.

"Y'all coming?" the girl said.

It was a bright night full of moon. From the top of the mound—a broad grassy space large enough, it appeared, to capture that moon high above if it fell to earth right now at the size it appeared to be from their vantage point here—he could see some of the other strange hillocks in this park.

"Who made all these?" he said aloud.

"Arf, arf," said a boy next to him.

"Injins," came an answer in a young girl's voice.

Someone handed him a bottle.

"Black warriors," said another voice.

"Asshole! That's just a river," said another.

"No, no, hey, dey be de black warriors, wid de black faces. . . ."

"Talbot?"

Talbot? He had the key. Quinn took a sharp hot swallow from the bottle and followed the wavery line of students toward the low building on the far side of the mound. A blond-haired fellow—Talbot, he worked at the lock, and then suddenly swung open the door.

"*Museum . . .*" was all Quinn noticed about the sign in the dark as they passed in a noisy knot through the entrance. Inside, someone found a wall light, and the

entire place came up brightly, filled with cases along the wall showing pottery and maps and in one room a little exhibit filled with life-sized models of Indians at their fire.

"Talbot's Daddy's an anthomopolist," said a red-faced girl at his side. "He runs this place." The girl tugged at his shirt sleeve. "Come on and see."

They wandered away from the main room, the sounds of the other party-goers fading, echoing, fading in and out, faintly, bouncing off the walls. Quinn's bowels cried out to him suddenly with a burning and twisting that made him stop a moment, feel the girl alongside him, take a deep breath, then come along.

"I got to..."

"What's that?" the girl said.

"What's your name?"

"What's yours?"

"Tal...bot...," came a faint cry from far away.

"Tal..."

"...bot...."

"Can I have some?" the girl said, breathing close to his chest. Her hair smelled wonderful, some perfumed shampoo or other, but her breath was the foulest thing he had ever breathed. Her eyes lighted up, and then seemed to darken.

"Please," she said.

"Please what?" Quinn said, turning his head away.

"Whatever you brought," she said.

They heard footsteps. Lights in the other room blinked on and off, on and off. Someone was barking like a dog. Quinn backed up against a railing. The girl advanced.

"You got to get something," she said.

He twisted around, fearful that she might breathe again upon him. Her face— either Brittany's or Tiffany's—seemed to emanate a curious glow, as the sea does, or so he had once heard, when tens of hundreds of millions of microscopic animals float on the waves beneath the moon. His mouth hurt, as though by mistake he had bitten into something hard. He could taste blood, mixed with the sour traces of all the alcohol he had swallowed since the early morning. In his mind he found the telephone, picked it up, dialed Darcy's number, *mis*dialed, tried again, heard the ringing at the other end of the line.

A crash of glass distracted him.

"Down there," said the girl, Brittany, Tiffany, pushing him toward the railing.

"Where?"

"There," she said again, pointing into the pit that seemed to have just opened

up at their elbows, though it must have always been there. It was a burial pit, at the bottom of which lay several carefully arranged skeletons of the Indians who had built the mounds many hundreds of years ago—how many teen hundred? someone was saying out loud even as others in the fraternity revel now gathered at the railing, tossing bottles, some empty, some full, into the abyss.

"Nonononono my Daddy'll—" someone else was shouting.

"Help him," the girl was saying, meaning for Quinn to hold a boy's legs while he tottered high above on the railing and began to urinate into the pit.

Quinn held him tight, responding with his grip to the screams of joy and fear around him. A resiny mist settled on his lips. He looked up—the boy's face was a mask of bulging eyes and clenched teeth—he let go.

Thomas Tulis

from the series Construction of Suburbia *and* Aspects of New Roads

Chattanooga, Tennessee, fall 1993

Chattanooga, Tennessee, fall 1993

Chattanooga, Tennessee, fall 1993

Chattanooga, Tennessee, summer 1995

Chattanooga, Tennessee, fall 1993

Chattanooga, Tennessee, fall 1993

Chattanooga, Tennessee, summer 1995

Chattanooga, Tennessee, summer 1995

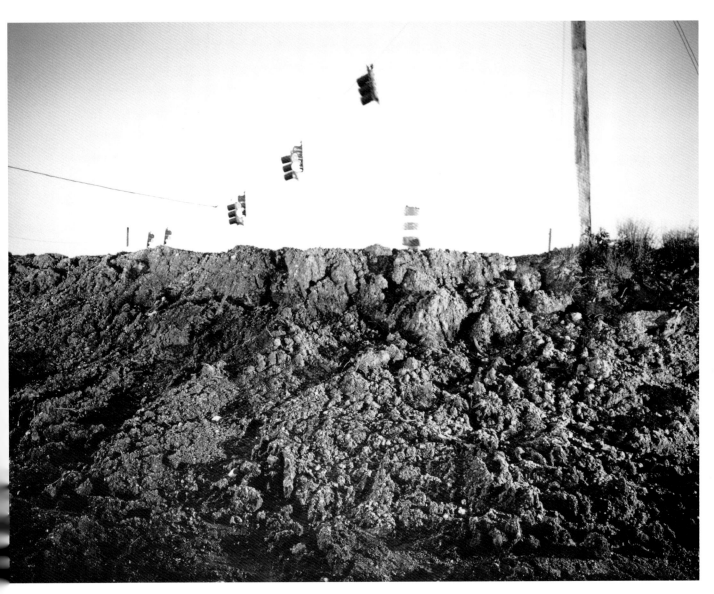

Chickamauga, Georgia, summer 1995

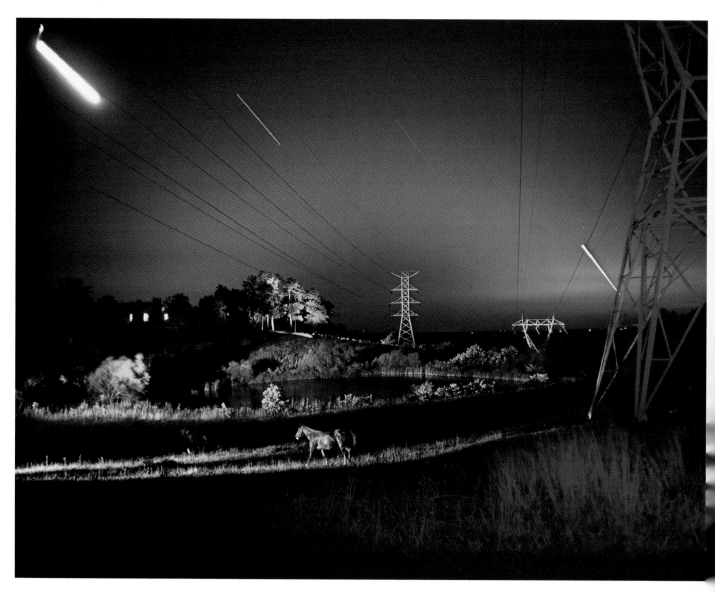

Dusk, Lookout Mountain, Georgia, summer 1989

Afterword

Toward a Creation Myth of Suburbia

Allan Gurganus

Panoramas are not what they used to be.
—Wallace Stevens, "Botanist on Alp (No. 1)"

In the beginning in America, stores were very scarce.

The country was all country. "Wild," being everything, did not *know* it was.

One athletic squirrel, sticking just to treetops, could scamper from the so-called Atlantic to the so-called Pacific and if—three-quarters of the way across—the creature failed to find one juniper shrub for nine hundred miles of scorched alkaline earth, then a hike wouldn't kill him.

No one squirrel proved sufficiently focused to cross so huge a country. But certain powerful birds sure flew it. Being American birds, they were like us—already half-jaded, looking down on the unbelievable. They were eager to be fed and to stay amused, in that order. They assumed this paradise would stay this green and vast forever.

Man soon hacked out trading posts; then towns; cities sprouted smokestacks as tree substitutes but—the reverse of trees—they actually proved poisonous. (You know this.) The rest of the land—unused—remained out there, our psychic capital, choices we need not make for now. Not yet plowed, no longer wilderness exactly, but simply the places in between.

All this occurred before the idea of "development" developed.

Even after the beginning, they were still a trillion little places without form, and void. They were good, waiting yonder in the darkness untameable. I mean

weedy lots, the borders to borderlands, acreage seemingly transitional for keeps, the poor soil staked only by volunteer sumacs, goldenrod, and scrub pines—places ragged, breathing, necessary. They made the uninvited margin around your life and sadness and high energy. They somewhat slept *for* you.

The history of suburbia is the history of these lots—lost.

Those I wish to sing here. You mind? They are now nearly extinct. And I'm telling you plain, when they went, Our Insomnia resulted. No one speaks of them, in part because they never had a name.

Shall we call this one "a cave that is the incubator for foxes"? That one might be titled "low hill becoming the rocks near a brook." We could name this "the wildflowered corner field that people use as a barefoot shortcut to get from these two so-so condos back there to the highway's convenience store"? Or what? Such spots need a title . . . especially now they're nearly gone.

Once upon a time in America, stores were like the nation's citizens, not yet pack animals. Privately owned, they stood off independent, jealous; they demanded single loyalty. And between such emporia of comestibles stretched—just saplings, glinting streams, the uneventful miles between significance. Such miles gave you time to be nowhere in particular. In the days before car phones, such miles offered a person time not to be too forcibly or charmingly *any*body for a few dozen minutes every day. Soul-saving, the space and time offered by such sweet blanks.

This was a time when people either plowed the country that stayed open as a window; or they lived in some planked vertical city they could shut behind them like a door. There was room enough around each citizen. It was like your natural-born halo, the clean air allotted you. There were fewer people. You could see them coming *at* you. Fights were rarer. Those that happened took longer to start, and so meant more, ending.

You were born either a town-dweller restaurant-goer, or the early-rising farmer who grew the beans for city restaurants. And thus it was, for a long time. Till the "grand mal" convulsion of one War.

This is where my dad comes in. The only child of farmers, he got drafted, flew a bomber. Some small portion of Dresden's ancient architecture is not there today thanks to Dad—a Presidential Medal winner.

One big war was thrown in Europe, plus Asia. The boys from our large ruralish nation went; many died; but their side unmistakably won. These great-great-some grandsons of settlers (see Dad) came home victors. Such boys craved knowing that they hadn't fought for nothing. War, being too literal, makes its soldiers terribly lit-

eral civilians. Boys wanted a patch of land they understood as fully Theirs.

They were bored to be the sons of farmers, after seeing France and all. Soldiers returned and found that most businesses were already owned by people like their fathers, conveniently too old to go and fight. Our heroes under thirty wanted something better, newer, theirs. No old house, no antiquey street, no farm or company with a mortgage and therefore a history.

Their girlfriends, named either June or Fran, had been waiting. (They had not sat under an apple tree with anyone else.) A family seemed logical, having one, and soon. A new national chance of this scale—it required readjusting what was called the Big Picture. After the Big War, soldiers craved fresh-cleared land, plus a house where no one else had ever lived.

Even before these guys bombed Europe so darn well, admit it, Europe was a ruin. Whereas America stayed forever "In the beginning. . . ." There might be the chance to have sons of your own. To get your home's landscaping nice. Someday ahead maybe you and the Mrs. would take snapshots of your kids wearing Christmas things in June, so you could choose in advance the cutest shot to go on a processed card saying "From Our House to Yours. . . ."

If many of these soldiers had been fully Southern before the War, they certainly sounded less so now. GIs' half-educated land-proud parents took this personal. (Win the war but lose your language—was that a bargain?) But their sons felt tired of being razzed about double names and accents. Boys hadn't even *known* they spoke so slow and strange. Not till the division's swart New Yorkers tried to mimic them each night. Once you know, you know. And if your outfit laughs at you ("Y'all's pappy be makin' moonshine, Bobby Earl?"), however much you grin to get this over with, you never do forget it.

Sure, these lank experienced boys loved their farm-owning Carolina homefolks. Sure, they still swore by their boyhoods' three-gaited pony named "Old Blaze," by Mama's sweet potato pie, etc. Sure, they were proud of all they'd learned to do with their hands. (In the hard Thirties, they'd had to, helping out around the place.) They felt glad their tractor-fixing skills had let them work the B-52's—because those sure did break the doggone Nazi will!

Returning soldiers still felt pride in their own ancestors, ones who'd worn gray uniforms, who fought to hold onto their swamps and rocky fields, but who lost legs and arms (and slaves) and most everything else. The present heroes' accents seemed—to their mush-mouthed disappointed parents—pitifully diluted. But such boys couldn't help notice that, while they'd won a huge and global war, their famous worshiped grandads had only lost a little red-clay local one that they themselves'd gone and started, the dummies.

Fellows home from the Big One—as they already called it, with a definite dicksome swagger—felt themselves to be New Men. They were feeling very sexual, and, luckily, so were June and Fran. Veterans acted stunned to be alive; many bore scars like my father's. His back had been burned while floating in an Atlantic set on fire. "My scrambled eggs," he called this fifteen-inch compress of terrible rubbery yellow marks.

Hot summer nights before we got central air, he'd wake up shrieking, "Put it out! Put me out, Joe!" Dad once blacked Mom's jaw by accident at 4 A.M., trying not to drown in the ocean of a bed he dreamed on fire.

Once home, ex-enlistees often sounded loud—as if still hollering above advanced munitions' concussion. Hard-drinking chain-smokers, they lived it up now. In Paris, they'd stood taller and more manly; they were more popular than mere runty Frenchmen. Home, they still felt international. **Had they not kicked butt big-time?**

Guys were ready for what they all called "a piece of the pie." These GIs called the sexual act with some willing wartime girl "a piece of ass." Getting that was very nice but it was really only practice for "a real piece of the action, my big ole chunk of the American pie."

To eat that pie, you need to cut it.

And this is where the land-between came in.

Let medical history show:

This is where Our Present Insomnia Epidemic began.

A continent—having once been this complete, alone—had not understood it needed anything. Then "Anything" arrived. If the Garden of Eden went to seed the day its First Couple got shoved out, the Paradise American "fell" the second its first caretaker slogged chuckling ashore.

Columbus, in his journal, describes awed Indians bringing him fruit and "certain dried leaves," tobacco. And he admits at once imagining financial gain. How? By enslaving his hosts.

In the beginning, what doth it profit a man . . .

Picture yourself waking in paradise. Silver-white angels appear incandescent midsong before you, chanting your welcome. And, you are already mulling, "Think what I could charge for these as call girls in Los Angeles!"

You have just read the short history of America.

Q: What makes people so greedy and short-sighted?
A: Being Human.

Q: What makes some among them so exaggeratedly,
 impenitently, hungrily human?
A: Being Americans.

Bankrupts, religious refugees, second sons, all white men—claimed it. They split it into useful fractions whose outer edge was briefly called Frontier. Settlers figured, just their being here created it! So river fords became trading posts. Then Industry made bagpipes out of little towns, pumping them up with coxcombing smokestacks and small houses where the new-to-cities workers lived. Soon, despite the broad safe spaces in between, farmers distrusted the city fellers, and the city slickers made jokes about how dim most rustics are. You could get their pretty daughters to do anything you liked and with the dumbest tricks. And so they made a moat, each of them, around their principalities. And thus ended the first day.

In the South such moats were often very deep ones, because its early settlers were few. Bogs, briars, bugs, and heat discouraged newcomers' getting far. The margin in between meant just more bug-filled briary wilderness. Long distance makes good neighbors.

Now millions of soldiers and their beloved Junes and Frans needed a space that was the South but not the *starter* South. Not the wilderness, but neither should it be a patch too treeless. Something just a short drive from town, but not town itself. And certainly no plain hook-wormed work-ridden farm, its one mud-colored pond stocked with bass and bream that—after four long years of war—were still no longer than your hand.

The New People's New Place would have to have the clubs and churches and hobby shops of a metropolis. But it must be safer than those filthy dangerous Cities: parking lots roamed by juvenile delinquents, dopers, B-girls, and stinky trashcans needing hosing off. The new place would be safe for kids, with plenty of land—and enough former peanut fields so your sons could scatter baseball diamonds in most directions. American land grew argyled with grassy diamonds.

Bomber pilots, grounded, imagined an aerial map of safety. They didn't want a home too hidden. You had to get it out in the open, and looking "free" . . . , free from tree-root country, free from city grime and broken glass. Free, too, from a

past that held you back. These boys had grown up inside a Depression. They'd whipped that first. And now they'd gone and won the War and survived: And, hey, they *wanted* something new for it. Nothing used and old like Europe. Europe was over.

They wanted something good-sized, well-made, priced right, sleek, not-previously-owned, and producing pleasures never-earlier-known. It could be cut into, like pie.

They wanted America.

(Plus eight to nine hours' sleep a night. Though they soon learned to live on four to six.)

War paid for the college degrees of farm kids who'd never seen a college. It shook things up. Till 1940, the upper class still ran so much. Classwise, the U.S. had stayed 1840. But now, who was who, owning and expecting what?

Uniforms could make even skinny, bespectacled Harvard boys look manly, and rougher; uniforms gave the sexy, from-nowhere, working boys an unaccountable "class." You couldn't "place" them without their usual cheap jackets, bad haircuts, their flashy plaids battling stripes. Suddenly one size fit all, formed upon bodies of ideal young men. Khaki was a cookie cutter, and suddenly these rude kids, right-face, were tailor-made, improved, if only briefly. Boys looked indistinguishable this distinguished.

Once home, they wanted homes like that—uniform. They came back and made the world look like some nice prewar town in a book. Like the planned streets, behind high fences, trikes in yards, of a nice big army base.

Q: Who was Suburbia's major Architect?
A: World War II.

Where a mass need exists in a capitalist state, clear-thinking moneymakers note the universal urge. They scatter, snapping up the necessary, marginal land—cheap acres untitled and, so, wasted, being stuck only *between* real destinations. Come morning, you'll find excellent-looking ads in papers. They promise to meet an appetite recognized the night before. It does move fast. Everything soon had tail fins and was torpedo-streamlined. Even the ladies' bras. Money could be made. The famous pie was being divvied up and you did not want to miss out on your own big sweet heaping slice, now did you?

My father had the down payment. Hooray! His farming parents helped with it, 2K from them, their life savings sunk glumly into War Bonds the day he joined.

Dad, good at poker, had saved 2K overseas. His wife, June, an heiress, brought 4K and some blue-chip stocks with her. Soon Mom and Dad drove everywhere, looking for a place they knew they'd know, on seeing it. How would they know? The goosebumps. And location, location, location.

The spirit of free enterprise now moved upon those zones betwixt town and not-town. (If the hidden quail and deer and foxes and poisonous snakes and single turtles nearly as old as this tempting busied nation, if these animals had only known, if they'd possessed enough ready cash and a good travel agent, they would've leased a big boat to elsewhere.)

And verily, the profit motive soon divided soil-depleted ma-and-pa farms into their terminal crop: lots. Many young couples, having married when the faraway war got won, now needed shelter, fast. They were living with his folks. The old bed upstairs squeaked real bad. A civilian booby trap. Dad's own farming parents rested down there in their bedroom's dark, listening, leering, only half-amused. They didn't talk, but their Protestant, nonspeaking looks and nudges in the dark, said, "Well, I never. . . . There they go again."

Richard and June could not make any loving noise. They really wanted to. They soon found and founded a safe place for that. And verily, its name was Suburbia.

Former fields soon warranted major entrance gates. You never saw such building going on. Long walls grew, miles of them—meant to keep out only prying eyes. Walls big enough to divide Berlin from Berlin now supported just the sprigged ivy planted every twenty feet.

Walls can make the land that walls enclose mean more. Good fences make good neighborhoods.

With a small Veterans' Home Loan, plus your whole sad family's savings—you could not afford an entire Estate yourself, but collectively, you guys sure managed. "Blackberry Plantation," "Provost East Lake Tarlton Manor," "Brinsley Court Mews Brooks." To kids my age, such names sounded like fake family crests . . . sold to the gullible as their own personal histories. My parents found them poetry.

Fortresses and frontal bafflements rose overnight, some serpentined, several actually domed. At 4 A.M., lighted fields were still adrift with car-lot pennants snapping to make the vacant lots look less so and more cheering. Postwar, a gateway's metal spikes were meant as both its heraldry and defense. And verily, last year's productive goober fields became quick and gladdened, veined with roads, sewered suddenly.

The top price—though steep—still seemed doable. And man and wife (a couple very close to me) saw a new place, and felt that it was a pretty darn good

one, even as these go. And my parents shelled out 8,000 big ones, a substantial down payment, on a single treeless acre and its fresh-paint four-bedroom rancher, gabled roof, oak floors, chalet-detailing.

And they noticed wide swaths of their arms' own goosebumping. And verily, they found, in this new development called Eden (Lots) that the model home was unlocked. And they ducked in there before the staff got back from lunch, and in a fully-made-up bed (nonsqueaking), they listened to themselves demonstrate active athletic love between handsome young married adults, victors. And . . .

"This is the place," Dad said, down.

"I feel that, yes," my mom said, up.

And verily—even before the Bermuda grass sprouted correctly on try number three, my rangy blondish folks stood in the front yard of their future. They stood there smiling at a sunset just where the curb was said to be going soon. Arm in arm, ignoring my older brother and me beating each other senseless under the backyard's new red swingset and yelling, "My trapeze turn, my trapeze turn, dickhead," the folks nodded and felt content, abidingly. All their earthly money had been sunk here, a place that our own off-ramp called "Eden (Lots), NC's Newest Desirable Professional Devlpment. Yours, starting in the low fifties."

And, lo, my parents said, while watering the mud that they felt deep down really longed to be a lawn, "We are home forever now, boys. Notice things more, okay? Lots to be grateful for out here. Lots." My dad smiled hard at the horizon. He was thirty-four. And well formed, great looking, scarred, and very sad about something I still don't understand. He never told us. They considered that brave then. Instead, we just felt it everyday. The only thing that always made him happy was this ideal house, this perfect yard. Well, it *would* be perfect.

The GIs founded a civilian order—so orderly it verged on martial law. Every house was necessarily white; every car parked out front proved, coincidentally, a blue car; except that pink Nash Rambler, belonging to the Gravers, who were weird anyway. Order pressed beyond the comforts of conformity. The soldiers' model was the Big Band—guys' uniforms, horn-swings, music stands, made to absolutely match. Edicts were issued about which three particular bushes, on a street this fortified, would do.

If I had a dollar for each subsequent yelling match, each fight trying to keep itself quiet lest the next-door neighbors—also yelling (often about the same thing)—should hear. If the kids were remunerated for what good disciplinarians War

makes of its former soldiers: "Spare the rod, spoil the child." If I could only annex some of the funds spent to undent Buick bumpers bashed during drunk driving, then winked at. If I could only pay off the unhappiness locked up in that faked IOU called "assured happiness." If only we could go back and make adjustments in how dangerous it was. If we could just open the danger valve a notch or two. To deprive beloved children—with the most perfect of intentions—of any and all danger, that seemed a worthy goal; but it proved extremely dangerous.

If I could only chart the frustrations of a Mom (IQ 143) asked to feel "creative" sticking multicolored toothpicks into small blocks of orange cheese spread on a tray Sputnik-shaped. If I could now retrieve just half the nights Dad spent at the office, helping *pay* for all the formicaed grandeur he provided us. The nights he worked, instead of being here with us. *In* the good life. He had left the U.S.A. in order to save the U.S.A.—and Daddy was still paying for us from afar.

There is some logic here. It is yet trying to come clear. Is this the revenge on us, and on our sleep—the revenge of those wild, ragged, native American, sacrificed Spaces In Between?

"A cave that is the incubator for a generation of foxes"? It rests directly under the Henleys' washer-dryer. "Low hill becoming the rocks near a brook" now meant the highly difficult Hole Eleven at Tudor Overlook Golf and Racquet.

If our suburb's walls implied an Eden, those same walls predicted its loss. You make a gate, you must leave through it. Ripening from that first day forward, a kid's single hope—"I'm out of here." Looking back, the falling away seems predictable as gravity. But none of us quite saw it coming. Not then. Not there—not being so young and lively and expectant as we were back when War was done and gone, when prosperity and clean air stayed our birthrights—and Eden (Lots) ours forever *in the beginning. . . .*

You risked creating so much safety around your kids, you rendered them allergic to it. That's what happened. But the fallout would come later. Still, looking back, the mayhem—a younger generation's professed hatred of property as theft— seems zoned from the start.

Night fell hard on these former fields. Forests before being fields. Can acreage—deprived of such titanic trees—still feel phantom pains in missing limbs? Now a block of homes, each called a "Royal Regent." Night out here was still the country night; full of bird cries, unknown croaks, a wildness invisible by day. And, overhead, all those army surplus stars.

Dad would drive home soon. The kids had been called inside, to wash their hands for dinner and report on how much homework yet needed doing and double-checking. And though the sun was not quite down, in each separate house, someone kept moving from lamp to lamp, turning each light on, preparing for darkness. There was a lot of it around.

Contributors' Notes

Richard Bausch was born in Fort Benning, Georgia, and grew up in and around Washington, D.C. He received his BA from George Mason University and his MFA from the University of Iowa; in 1975 he returned to George Mason University, where he now holds the Heritage Professorship in Writing. He is the author of twelve books, novels, and story collections, including *The Fireman's Wife and Other Stories, Violence,* and the recently published *Good Evening Mr. & Mrs. America and All the Ships at Sea.* His fiction and essays have been widely published and he is the winner of numerous awards including a Guggenheim fellowship, an NEA fellowship, the PEN/Faulkner Award, the O. Henry Award, and a Hillsdale Prize in Fiction.

Fran Bitett Beck was born in Brooklyn, New York, and in 1969 moved to Florida, where she lives with her husband and two sons. She received BS and MS degrees in art education from the State University of New York, New Paltz, and the Pratt Institute in Brooklyn, respectively. She has taught art and photography to adults and children. Her photographs have appeared in *Photo Review* and *DoubleTake* magazine, and she is the recipient of a South Florida Cultural Consortium Award.

"I enrolled in a photography class at Broward Community College, then later at Florida International University. My teachers and mentors Mirta Gómez and Eduardo Del Valle changed my point of view and helped me focus my work, become more specific with my photography. The result is my project on the relationship between people and their pets, photographs taken in Florida from 1992 to 1995. The subjects are former students, friends, relatives, and their pets.

Jonathan Bowen, born in Lillington, North Carolina, and raised in the Virginia suburbs of Washington, D.C., received his BA in English from George Mason University and his MFA from the University of Virginia. He is the author of four plays and numerous short stories, some of which have been published in the *Antietam Review, Florida Review,* and *River City.* He is currently working on a novel while he works full-time at a public relations firm.

"I began 'Pulling Jane' with the idea of giving an honest rendering of a reformed alcoholic's first days of sobriety. In the story the father finds his daughter sleepwalking in the kitchen. In her sleep she says, 'Help me. I'm dying,' and he chooses to take what she says as a literal request. The rest of the story simply describes how he sets out to protect his daughter, a task created and shaped to distract him from his more immediate task—staying away from alcohol."

Eric Breitenbach was born and raised in the northeast but has lived in Florida since 1981. He holds a BFA in photography from the Rochester Institute of Technology as well as an MS in instructional technology, and teaches photography, film, and video at the Southeast Center for Photographic Studies at Daytona Beach Community College. His awards include two NEA Southeast media fellowships. His photographs are contained in the permanent collections of the San Francisco Museum of Modern Art, the Center for Documentary Studies at Duke University, the Polaroid Corporation, and the Norton Gallery of Art. Breitenbach has been a photographer and filmmaker since 1977, and since 1981 he has concentrated exclusively on Florida: *The Florida Documentary Project, The Alligator Book, Orlando at the Millennium,* and *The Sanford Documentary Project.*

"Traveling through Florida making photographs I became aware of what one might call 'a New South.' This New South seems bipolar. Away from the coast, Florida is indeed the old, deep South complete with oppressive heat and humidity, oak trees dripping with Spanish moss, genteel hospitality, and the occasional Ku Klux Klan chapter. On the coast it can look like New Jersey—except for the palm trees. The coast is populated with Northerners, many of them elderly, who have come south to seek the good life and

avoid shoveling snow. Interstate 95 in coastal south Florida resembles the Cross Bronx Expressway; Fort Lauderdale looks like Chicago, just newer and cleaner. Any trace of the old South here is long gone.

In America, nothing ever stays the same."

Mary Ward Brown was born and still lives in what was once the farming community of Hamburg, Alabama, twenty-one miles from Selma. She is one of two permanent residents left. Her collection of short stories, *Tongues of Flame*, written after she was fifty-five, won the Ernest Hemingway Foundation Award and the Lillian Smith Award. She continues to write short stories, hoping to produce another collection.

"When my husband died I cried for a year, but I knew other widows who couldn't cry at all. I wondered how they stood it undiluted by tears. I think that's where the story began, but it was all mixed up with what my husband's suffering—undeserved, I felt—did to my religious faith. At the time I knew several members of an intense religious group who thought they had answers to all the great mysteries. Years later, when the story began to take shape, all I had for sure was a widow who couldn't cry, and a clear picture of the ending, a tear on a glass-topped table. It took more than a year of writing and rewriting to get from dry-eyed widow to sparkling tear."

Robert Olen Butler lives in Lake Charles, Louisiana, where he teaches creative writing at McNeese State University. Since 1981 Butler has published seven novels and one collection of short stories, all to critical acclaim. Among his many awards, the story collection *Good Scent from a Strange Mountain* received the Pulitzer Prize for fiction (1993). His stories

have appeared in publications including the *New Yorker, Harper's, GQ*, the *Hudson Review*, the *Virginia Quarterly*, and the *Sewanee Review*, and have been included in four annual *Best American Short Stories* and five annual *New Stories from the South*. Butler has recently written screenplays for Twentieth Century-Fox and Warner Brothers.

In talking about the South, Butler refers to a character in his story: "I've traveled Mr. Khanh's route to the Houston airport from Lake Charles many times. Those stump-grinders and baton-twirling academies—so deeply rooted in this place—probably had as much to do with the inspiration for this story as anything else. I worry for my own memories one day, and in this I am, as in so many ways, similar to the Vietnamese immigrants in *A Good Scent from a Strange Mountain* from which 'The Trip Back' is taken."

Alan Cheuse received his degrees from Rutgers University, including a doctorate in comparative literature, and teaches at George Mason University in Virginia. He is the author of ten books of fiction and nonfiction, among them the novels *The Grandmothers' Club* and *The Light Possessed* and the short story collections *Candace* and *The Tennessee Waltz*. He is also book commentator for National Public Radio's *All Things Considered* and producer and host of the syndicated The Center for the Book/NPR short story magazine for radio *The Sound of Writing*.

"Each of my three wives has been Southern, the first Savannah-born, the second from Kentucky, the third from Tennessee, and so all of my adult life I have been married to the culture.

That's how the Southern landscape became for a good long while the step-landscape of this New Jersey–born fugitive. The kernel of the story 'Dreamland' I found in a visit I made, while between marriages, to Moundsville, the ancient Indian ruins just a short ride from Tuscaloosa. I'd been advised that when down that way I had to eat barbecue at a famous local restaurant. No one warned me about the mysterious connection I'd feel between the bones of the dead tribesmen and the way some people live now."

Mitch Epstein was born in Holyoke, Massachusetts, and lives in New York City. He attended the Rhode Island School of Design and the Cooper Union, and is the recipient of an NEA fellowship. His photographs are in collections at numerous museums, including the Museum of Modern Art and the Metropolitan Museum in New York, the Corcoran Gallery in Washington, and the Bibliothèque Nationale in Paris. He is the author of three photography books, the most recent, *Vietnam: A Book of Changes* (1996). As a filmmaker, Epstein has worked as a cinematographer, production designer, and co-producer for the critically acclaimed films *Salaam Bombay!* and *Mississippi Masala*.

"By chance, in 1990, I got a glimpse of Versailles, the Vietnamese American community in east New Orleans. Standing on a nearby levee, I looked out and thought I was hallucinating—what lay in front of me were the gardens of a Vietnamese village. But they were on reclaimed bayou land in southern Louisiana. In 1992 I began to photograph in Vietnam, going there six times over three years. As I became more involved with Vietnamese life, I felt it was necessary to

go back to Versailles to try to understand the relationship between Vietnamese in Vietnam, Vietnamese in American suburbia, and Americans. I tried as well to understand the very meaning of diaspora."

Marita Golden attended American University and later received a master's degree in journalism from Columbia University. She lives in Maryland with her husband and son and commutes to Richmond, Virginia, where she teaches in the graduate creative writing program at Virginia Commonwealth University. Golden is the author of *Migrations of the Heart*, an autobiography, and the novels, *A Woman's Place, And Do Remember Me*, and *Long Distance Life*. She is also the editor of *Wild Women Don't Wear No Blues: Black Women Writers on Love, Men and Sex*, coeditor with Susan Shreve of *Skin Deep*, and founder of the Zora Neale Hurston –Richard Wright Award for emerging African American college writers of fiction.

"I wrote the novel *A Woman's Place* as a way to commemorate the role that friendship had played in my life and the important role that bonds between women play in creating and preserving identity and community. I wanted to reflect as well on the meaning of the experience of becoming a woman in the early seventies for my generation of African American women, many of whom found themselves part of, and sometimes at odds with, institutions that had been off-limits to their parents because of segregation."

William K. Greiner received his BFA in photography from Tufts University and an MBA in finance from Suffolk University in Boston. His work has been published in the *New York Times, DoubleTake* magazine, *New Orleans Art Review*, and *Photo Metro*, among others. His images can be found in numerous permanent collections including the Addison Gallery of American Art, the Corcoran Museum, the Museum of Modern Art in New York, the National Museum of American Art–Smithsonian Institution, the Bibliothèque Nationale in Paris, and the New Orleans Museum of Art.

Greiner spent three years photographing the bedroom communities outside New Orleans, where he was born and lives today. "I came to live in a suburb of New Orleans again by accident. I got married and needed a bigger house, and the house I found one day while making photographs was perfect for us. People find ways to stamp personality on their property, for example, my wife has an English garden; it looks chaotic but really everything is totally planned. Someplace between what is urban and rural lie the houses, yards, sidewalks, driveways, and cars that represent people's expectations and desires."

Allan Gurganus was born and reared in North Carolina; he is the author of the novel *Oldest Living Confederate Widow Tells All*, the story collection *White People*, and *On Tattered Wings*, a forthcoming collection of four novellas. *Widow* won the Sue Kaufman Prize from the American Academy of Arts and Letters for best first work of American fiction. Gurganus has also received the *Los Angeles Times* Book Prize and the National Magazine Prize. Several years ago Gurganus returned to North Carolina, where he lives and is at work on his next novel, *The Erotic History of a Southern Baptist Church*.

Gurganus says, "What surprised me in writing about the Suburbia of my semi-wild Carolina youth? How many of its memories I had suppressed. Perhaps fifties suburbia is, to American history, what Darwin's legendary 'missing link' is to his contested theory. A hideous, pitiable, transitional either-or. The distance between suburbia's erotic ideals and its bitter conformity, becomes a rehearsal for the whole national experiment. What scares me now? 'Clam-diggers,' a transistor radio shaped like a rocket, my switchblade, encased in pink and gray mother-of-pearl. How much I suddenly can't help remembering!"

Nanci Kincaid was born in Tallahassee, Florida, but claims Alabama as her home state. She has also lived in Virginia, Massachusetts, Wyoming, and North Carolina. She has an MFA from University of Alabama and is the author of two novels, *Crossing Blood* and *Balls*, and a story collection, *Pretending the Bed Was a Raft* (forthcoming). A recipient of an NEA fellowship and other awards, her poems, essays, and fiction have been published widely, with several stories appearing in the annual anthology *New Stories from the South*. Kincaid teaches fiction writing and "Reading Race" at the University of North Carolina at Charlotte. She is at work on a new novel, *Against Regular*.

"When Americans speak of 'unfathered children' we like to think of children of unwed mothers on welfare, underprivileged children—some of the useless fathers in prison, selling drugs, robbing liquor stores, or laying around in a drunken stupor. A couple of years ago I overheard my daughter

and her friends from white middle-class or upper-class families telling the short dramatic stories of their lives. None of them had a father living at home on a full-time basis; their parents were divorced or their fathers' lucrative jobs required they live out of state. I listened in amazement to their stories, the longing inside their anger and wounded indifference. They divided their fathers into two basic groups—those who sent money and those who wouldn't. 'My father doesn't know me,' was the echo. 'My dad loves my brother, but he doesn't know what to do with me,' one girl said. 'My dad doesn't know how old my sister and I are. He gets it mixed up all the time,' said another. 'When I try to talk to him, he just wants to buy me something to shut me up,' said another. So if these girls are not entirely unfathered, they consider themselves unfathered. If it is true that we learn our roles from our like-sex parent, and our value from our opposite-sex parent, then culturally speaking we may be in big trouble. As far as I know, mothers are still teaching their sons that they are pretty wonderful. But I'm not sure what the absent, unfather is teaching his daughter—I'm afraid that it's that second-best has to try harder; that men are prizes to be won; and sometimes, even when you win the prize, it was not what you'd hoped for."

Julius Lester was born in 1939 and spent his youth in the Midwest and the South. He received a BA in English from Fisk University. He is the author of twenty-four books, including fourteen children's books, one book of poetry, and two novels;

he has won the Newbery Honor Medal and the Lewis Carroll Shelf Award, and he was a finalist for the National Book Critics Circle Award and the National Jewish Book Award. His books have been translated into eight languages. Lester teaches at the University of Massachusetts at Amherst in Judaic and Near Eastern studies, English, and history. His most recent novel, *And All Our Wounds Forgiven,* is about the civil rights movement.

"Over the years I thought about a novel centered on the civil rights movement, trying out different characters and plot angles in my mind and discarding them because they weren't quite 'right,' not that I knew what 'right' was. In the spring of 1992 an image came to me: there was a black woman lying in a hospital bed, unconscious. She was the widow of a slain civil rights leader. Sitting next to the bed was a white woman who had been the mistress of the civil rights leader. She had come to talk about her relationship with the black woman's husband. I knew immediately that I had found the 'right' characters. I went back to a short story I had written in the early seventies, 'In the Valley of the Shadow of Death,' about a civil rights worker named Robert Card. Much of that story worked its way into the novel. After telling the story of the movement through the lives of the black widow, the white mistress, and Bobby Card, I realized something was missing. I went back through the novel inserting the voice of John Calvin Marshall, the slain civil rights leader. It was his story, too. It was by far the most difficult part of writing the book. The voice in the opening pages of *And All Our Wounds Forgiven,* excerpted for *A New Life,* is the voice of Marshall—after his death.

"I am frequently asked if John Calvin Marshall is a fictional portrait of Martin Luther King, Jr. Marshall is like Dr. King only to the extent that they were both forced to carry the archetype of the Savior/Messiah. For me, *All Our Wounds Forgiven* is less about the sixties and more about the faces of courage worn by love, and that forgiveness requires a terrifying courage and a terrifying love."

Bobbie Ann Mason is the author of two collections of short stories, *Shiloh and Other Stories* and *Love Life,* and three novels, *Spence + Lila, In Country,* and *Feather Crowns.* She is the winner of the Ernest Hemingway Award, the Southern Book Award, the O. Henry Award, the Appalachian Medallion Award, a Pushcart Prize, a Guggenheim fellowship, and an NEA fellowship. Her work has been selected for *Best American Short Stories.* Mason says her place is Kentucky's Jackson Purchase region, the far western area that Andrew Jackson purchased from the Chickasaw in 1818. Its language, cultural heritage, and landscape are all deeply identified with the South.

"'Tobrah' was inspired by a child I saw on an airplane in 1986. The little girl was about six, and her engaging personality captivated many of us on the plane. She reminded me of Shirley Temple—a little too good to be true. She was very exotic looking, with dark skin and blond curls.

I started writing in my notebook about a woman on an airplane who suddenly has a child to care for. It took me three years, off and on, to work out the story. The child I had seen was so striking, she overwhelmed my efforts to imagine a fictional child, one who would live on the page rather than in my memory. I learned once again how hard it is to go from observed fact to imagined reality. The child I had seen turned out to be different on the page, as she started emerging in her own right. Yet if I hadn't seen the real child on the airplane I wouldn't have thought of the dead father in Oklahoma, the childless middle-aged woman, the name 'Tobrah.' All these things came to me immediately as a result of seeing the child. But it was the real child that I had to forget in order to discover, and come to know, the character residing in my imagination. In writing fiction, I experience this again and again, and it never seems to get any easier."

Connette Pearl McMahon was born in Salisbury, North Carolina, and grew up in nearby Granite Quarry. She is a recent graduate of Duke University. Currently, she is pursuing the degree of doctor of medicine at the Duke University School of Medicine.

"In *Friends and Family,* I photographed black families in Butner, Durham, Salisbury, and Granite Quarry, North Carolina. I wanted to photograph these families as they went through their daily routines to present a perspective of black families that is very different from the negative images constantly portrayed in the media.

What I discovered in making these photographs transcended my original purpose. I began to see more clearly how individuals make up a family,

the way each person fills or creates a niche. I even found a new way to view my own family and a new flexibility in my responses to people's personalities and opinions."

Nic Nicosia lives in Dallas, Texas, where he was born. His photographs have been exhibited widely on the East and West Coasts and published in a variety of newspapers and periodicals including the *New York Times,* the *Los Angeles Times,* the *Dallas Morning News,* the *Village Voice,* the *Chicago Tribune, Life, Newsweek, Forum Internationale, De Gentenaar,* and *Artforum.*

"The pictures included in *A New Life* are from portrait commissions. In 1989 I began accepting requests for portraits from collectors of my work and others who knew of my history as an artist. Since that time I have photographed individuals and families internationally. The selection of portraits shown here are of people who live in the South."

Patricia D. Richards was born in California and into the United States Navy. A few months after her birth, her father was discharged from the service, and the family moved to the suburbs of Seattle, Washington. Richards holds an MFA from Southern Methodist University and an MS from the University of Southern California. She teaches photography at Tarrant County Junior College in Fort Worth, Texas. Her photographs have appeared in the *Simmons Review,* the *Photo Review,* the *Photography Center Quarterly, Exposure,* and *Espejo,* among others. Several of her images are included in the book *Feels Like Home* by Cheryl Moch.

"In December 1979 my husband took a job with a company that moved us away from family and friends to Plano, Texas. We moved into a brand-new four-bedroom house on Early

Morn Drive in a neighborhood called Shadow Run. Our house was one of two hundred and fifty that all looked alike. The neighborhood, like many in the Dallas area, was carved from cotton fields on the flattest land I had ever seen. 'Flat, flat, flat' echoed in my head like a mantra. Coming from Seattle with its mountains, rivers, trees, and hills, I was accustomed to looking up to find a familiar landmark. Here, there weren't even any trees. When I looked up, all I saw was sun. Meanwhile, my children were becoming part of this place. They had found 'home' on this southern blackland prairie; a home I was still seeking. I got out my camera and started making pictures.

As my children have grown, so has my need to photograph them here. It is the 'down time' that interests me most: the time between events; the time when nothing seems to be happening; the time that comprises most of our lives."

Margaret Sartor was born and raised in Monroe, Louisiana, and now lives in Durham, North Carolina, with her husband and two children. She is a research associate at the Center for Documentary Studies at Duke University and an editorial adviser for *DoubleTake* magazine. Her photographs have been previously published in *Aperture, Esquire,* and *DoubleTake.* She is the editor of *Their Eyes Meeting the World* by Robert Coles and (with Alex Harris) of *Gertrude Blom: Bearing Witness.* She is currently working on a book and exhibition of the photographs of William Gedney.

"I began to photograph my family and hometown in 1985, soon after my father died. Without his defining presence, I set out—quite literally—to find my place in the world. I began where I started from, in the backyards and driveways of my childhood, picturing faces I've known and watched since I can remember. For me, the photographs are a kind of autobiographical tightrope, a tense connection between my ongoing life and my memories. And like the bulging scrapbooks of my growing-up, where I chose images and artifacts to cut and paste and make a story, the photos in this book present a world that is real, but also imagined, seen through the dark glass of my own particular time and history."

Clarissa Sligh was born in Washington, D.C., and grew up in Arlington County, Virginia. An artist, photographer, writer, lecturer, and teacher, Sligh's work has encompassed broad and diverse experiences, from computer programming at NASA's Manned Space Flight Program to financial analysis on Wall Street. But she has always wanted to make art. Sligh's photography is held in collections in the Museum of Modern Art in New York, the Australian National Gallery, the Corcoran Gallery, and the George Eastman House. She is the recipient of an NEA fellowship, an Artiste en France fellowship, the National Women's Caucus for Art Annual President's Award, and the International Center for Photography Infinity Award. Her photographs have appeared in *Aperture, Afterimage, Heresies*, the *Village Voice, FOTO, Ten-Eight*, and *Artforum*. She is also the author of two artist's books, *Reading Dick and Jane with Me* and *What's Happening with Momma?*

Sligh writes: "I was born in Washington, D.C., because it had become illegal for midwives to deliver babies in Arlington County, Virginia, and the local hospital did not accept 'colored patients.' Our 'blue-collar' and 'Negro' neighborhood was separated by high wooden or concrete-block fences from the whites who surrounded us in what was called the suburbs of Washington. I attended public school and in the tenth grade, became the lead plaintiff in a class action school desegregation case. I have lived in many places since my childhood, but I always return to Virginia. The change that destabilized my old neighborhood seems to have come more slowly to many other places. In my work, I research the old South and explore the new South in an attempt to learn something about myself."

Lee Smith grew up in southwest Virginia, and this Appalachian upbringing has been important to her work, especially to the novels *Fair and Tender Ladies, Oral History, The Devil's Dream*, and *Saving Grace*. She teaches creative writing at both North Carolina State University and, with a Lila Wallace Readers' Digest Award, the Hindman Settlement School, Hindman, Kentucky. Smith has won numerous awards including the O. Henry Award, the Robert Penn Warren Prize for Fiction, the Weatherford Award for Appalachian Literature, and the John Dos Passos Award. She has lived in Chapel Hill, North Carolina, for over twenty years, following briefer stays in Alabama and Tennessee. She is the author of twelve books; the newest is *Christmas Letters*.

"In my opinion, two of the good things about the much-maligned new South are microbreweries and outlet malls, both of which I love. My favorite outlet mall is the huge one in Burlington, North Carolina, frequented by tour buses from out-of-state and all kinds of weird people such as myself. I had gone there one day to buy some towels in Linens 'n Things but nobody would help me—all the sales staff was in the back of the store huddled around one of the salesgirls, who was interpreting their dreams out of a little book she had purchased at the checkout counter at Food Lion. I was immediately enchanted, of course; I forgot all about my towels and stood in line to get my dreams interpreted. A little while later, I wrote this story. I often think of Anne Tyler's remark that she writes fiction 'to have more than one life.' I do, too. I have never been anybody at all like Melanie, for instance; but it was really fun to be her for a while. The older I get, and the more settled into this one life I become, the more I appreciate the chance to do this. It is one of the enduring pleasures of writing fiction."

Mark Steinmetz holds an MFA from Yale University and has taught photography at Columbia College, the University of Tennessee, and the University of Georgia. He is the winner of a Guggenheim fellowship, a Camargo fellowship (France), and a Tennessee Overhill Experience Documentary Commission fellowship. His work is held in collections in the Los Angeles County Museum of Art, the Museum of Modern Art and the Metropolitan Museum of Art in New York, the Bibliothèque Nationale in Paris, and the New Orleans Museum of Art.

"I moved to the South in the fall of 1991 to accept a one-year appointment teaching photography at the

University of Tennessee in Knoxville. Before then I had never even been in the South and had known about it mainly through its great writers. I fell in love with east Tennessee right away. There was so much chaos. The weedy walkways, the humidity and its softening effect on the light, the lawlessness of the place all excited me. I still love being and photographing in the South, and I'm staying here. Now I live in Athens, Georgia.

"At first I photographed scenes somebody from outside the South might think (or wish) typifies the South—those backroads scenes of gothic loveliness. Soon, though, I shifted my concern to the more ordinary regions that one can find just about anywhere in America. I wanted to show the nature of the edge of the American city and its reflection in the minds of its inhabitants. I wanted to create an atmosphere of insecurity. More than anything else, these photographs describe my own relationship to the world. They say more about me than the people I have photographed."

Thomas Tulis was born and raised in Chattanooga, Tennessee. He studied drawing at Carnegie-Mellon and is a painter as well as a photographer. His photographs have appeared in *Photo Review, New Mexico Photographer, SHOTS, American Photography, Aperture*, and other publications, and his work is held in permanent collections at the Museum of Modern Art and the Schomburg Center in New York, the Corcoran Gallery, the Houston Center for Photography, the New Orleans Museum of Art, and the Mint Museum.

"I was born in the South and still live here and make pictures here. I try to divide my time equally between painting and photography."